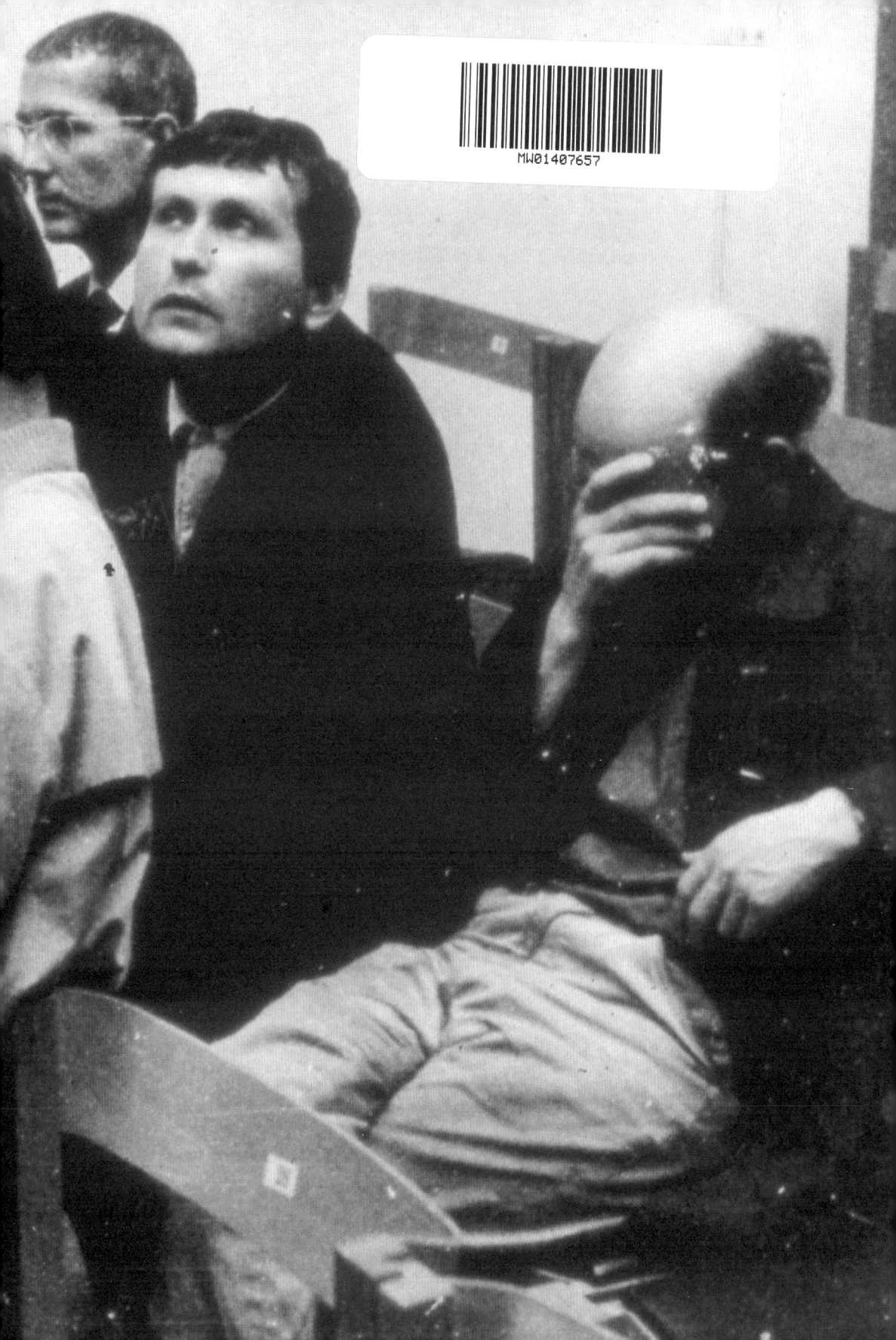

GUSTAV METZGER

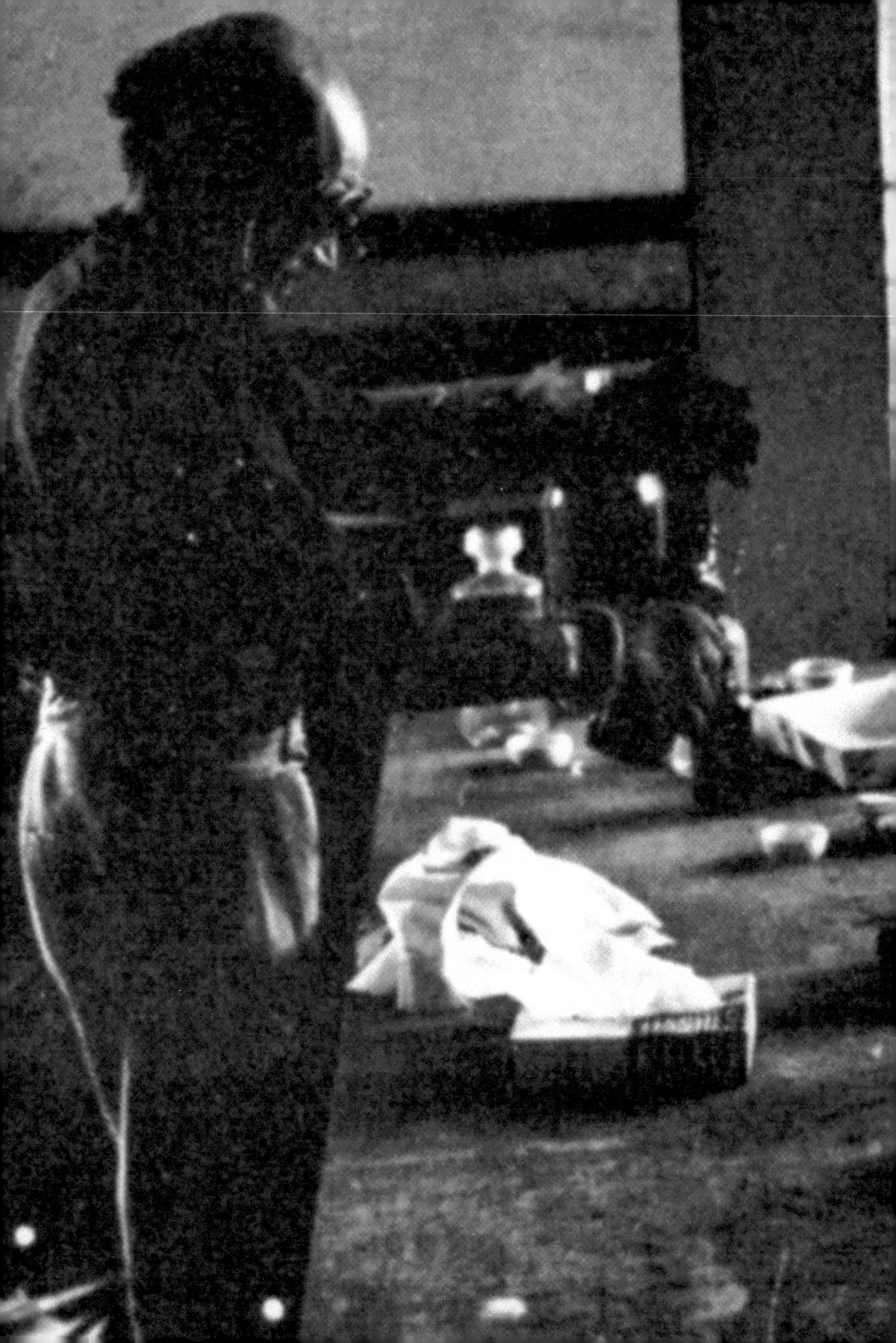

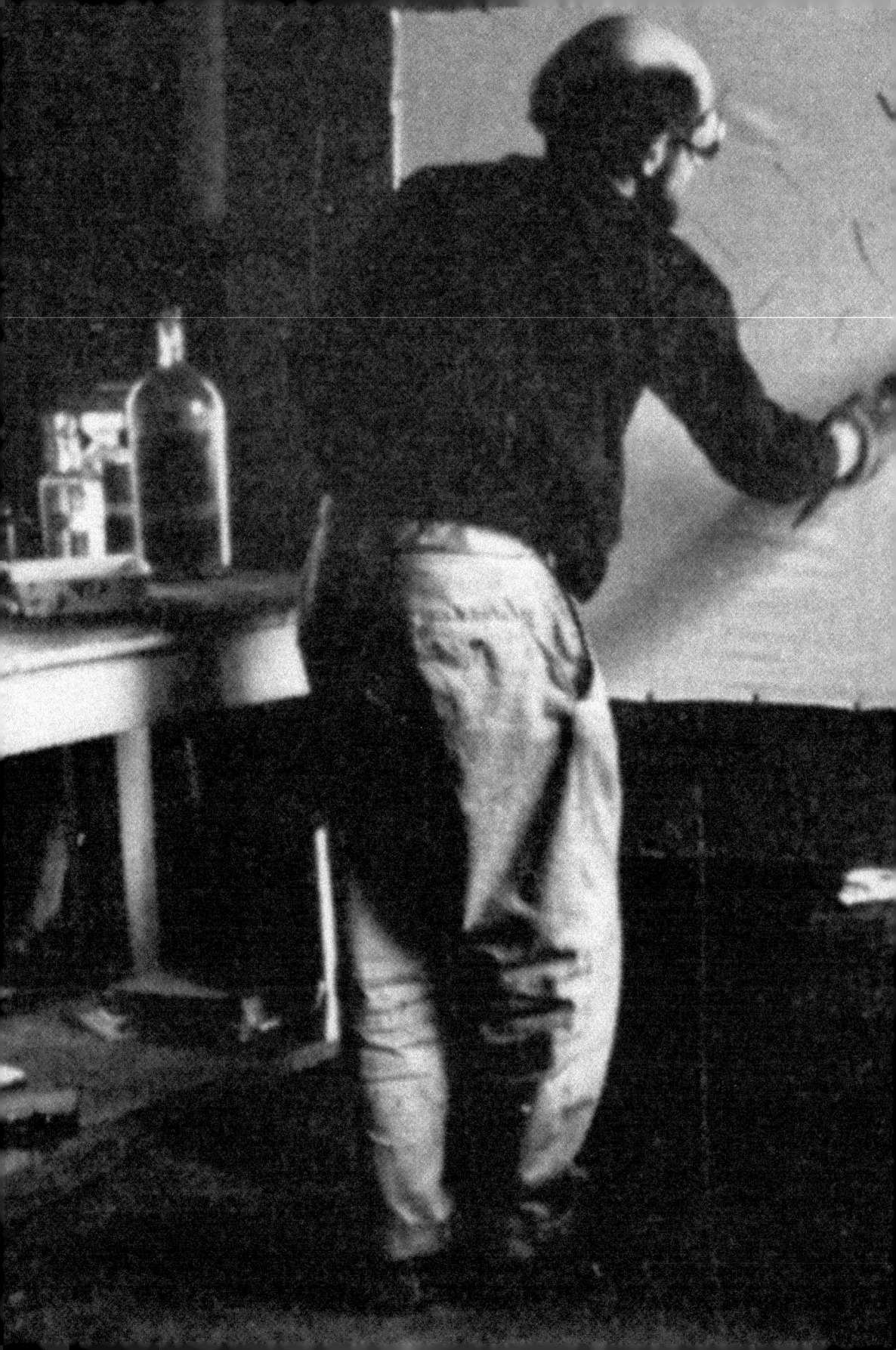

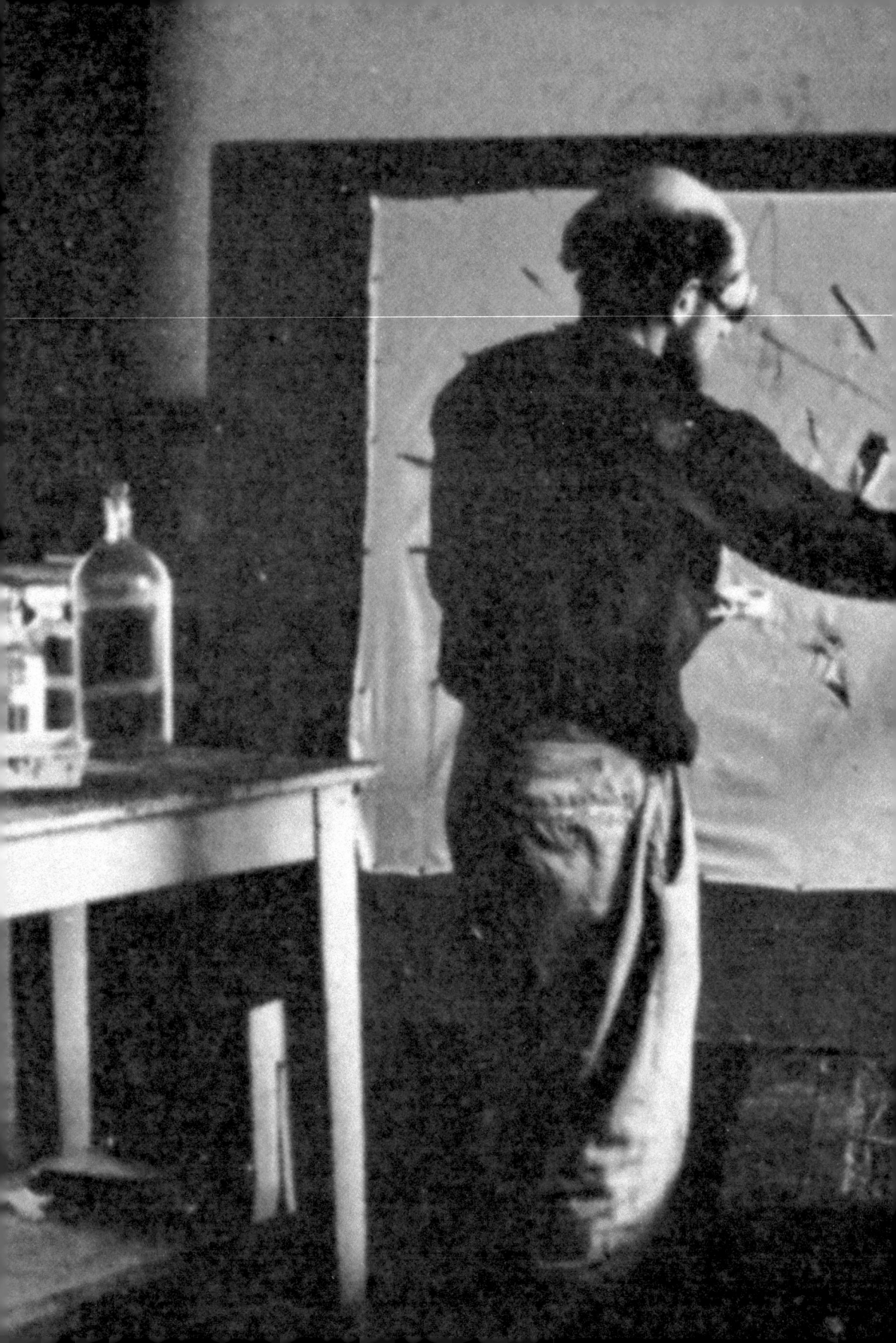

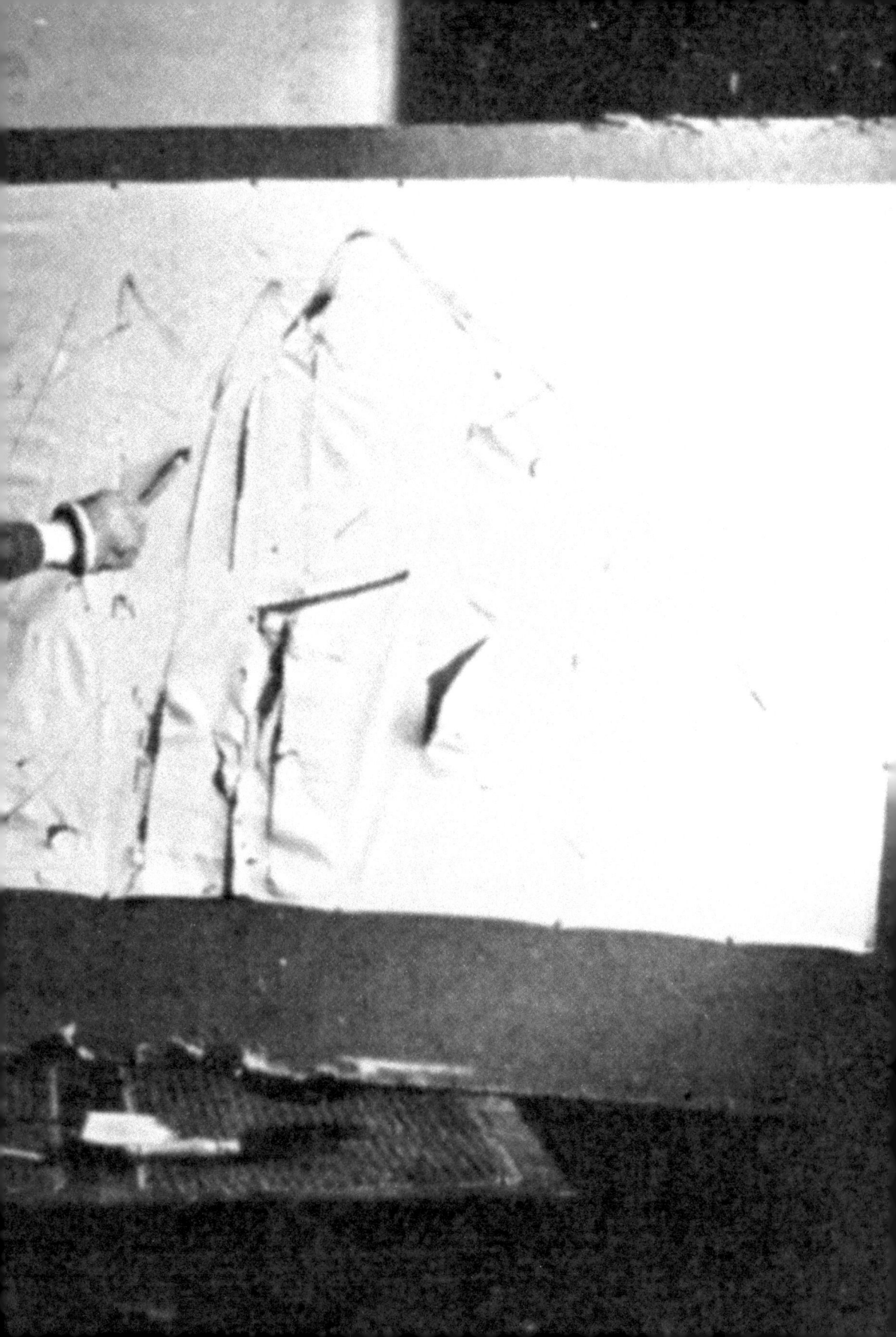

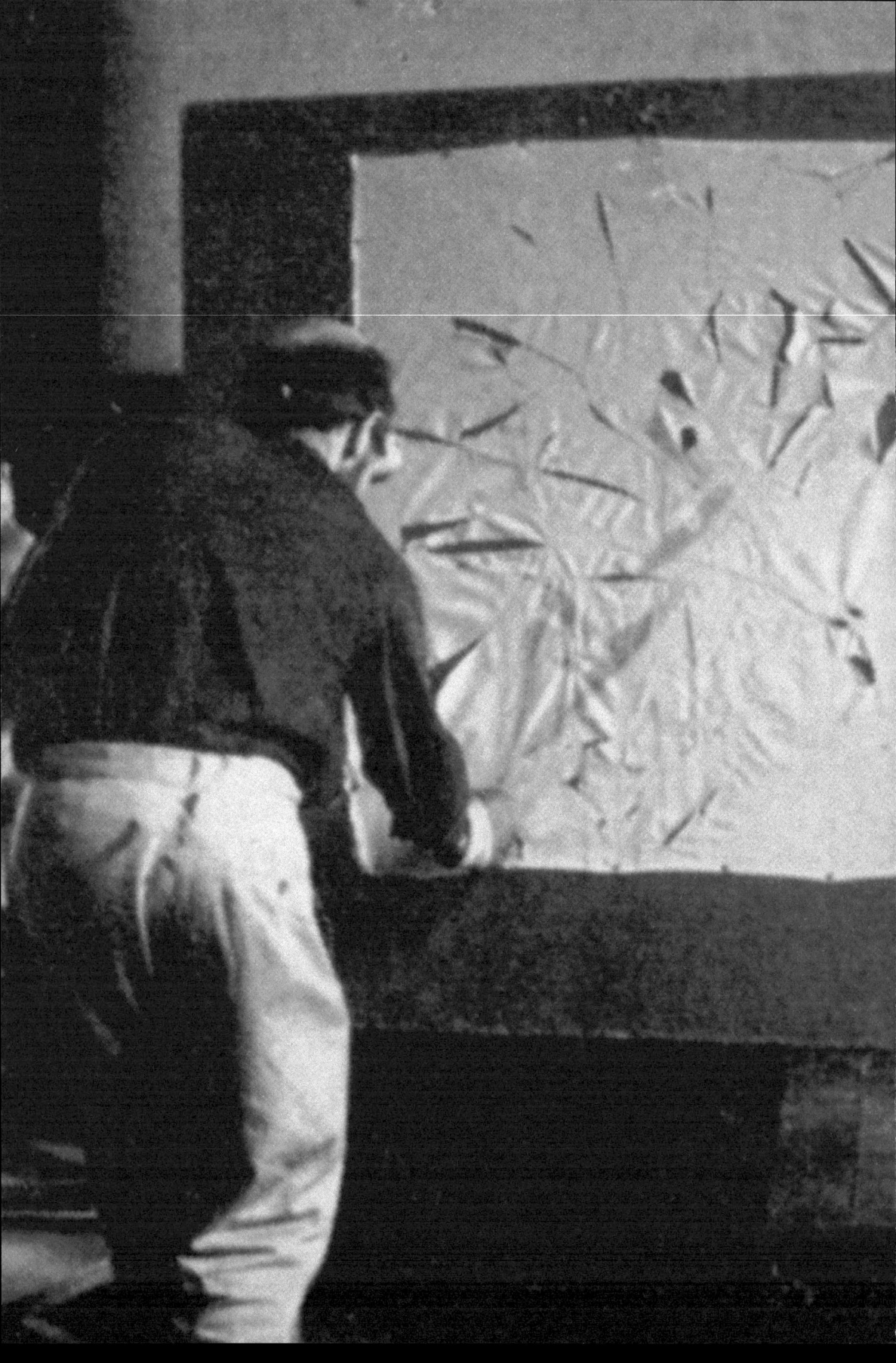

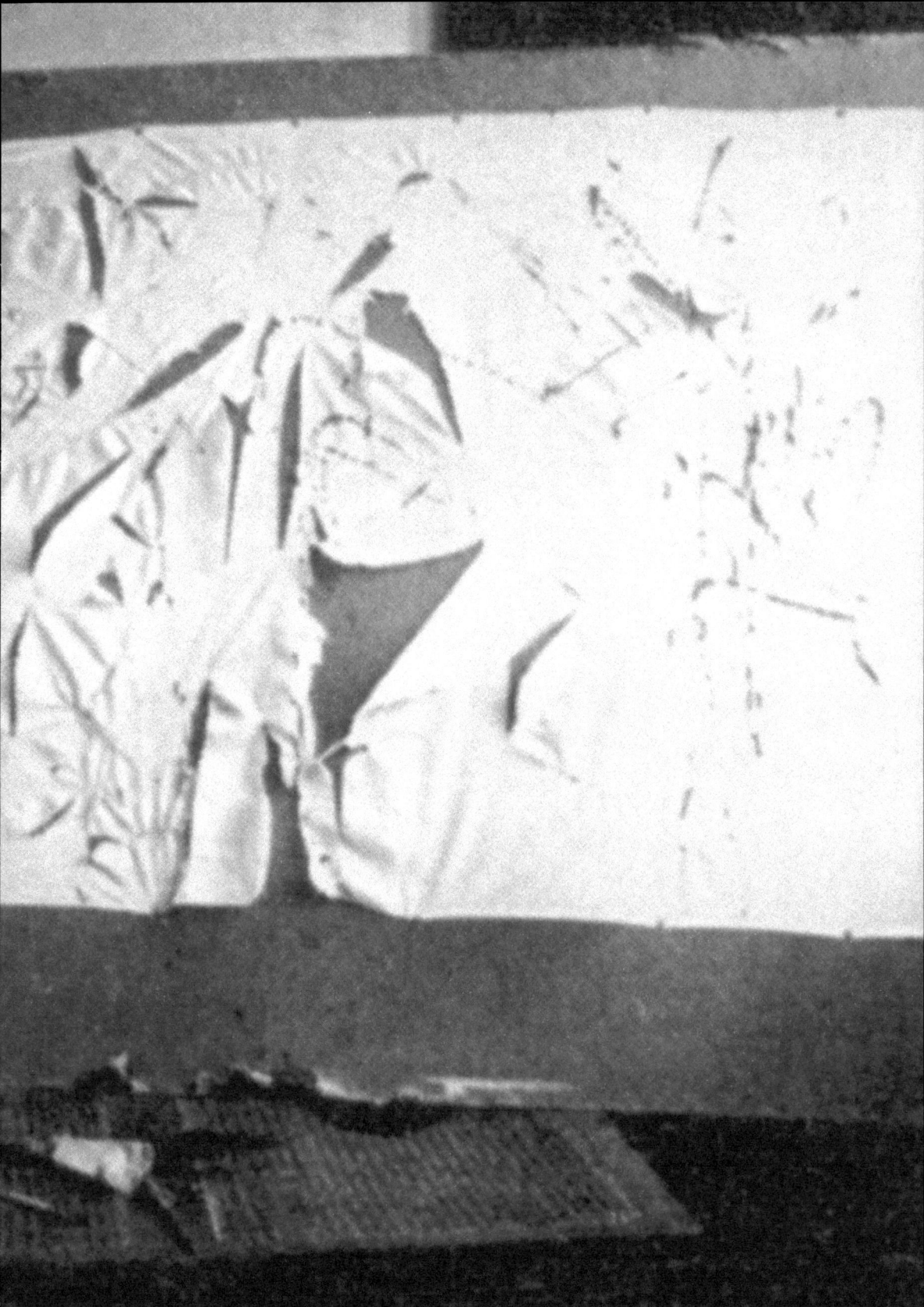

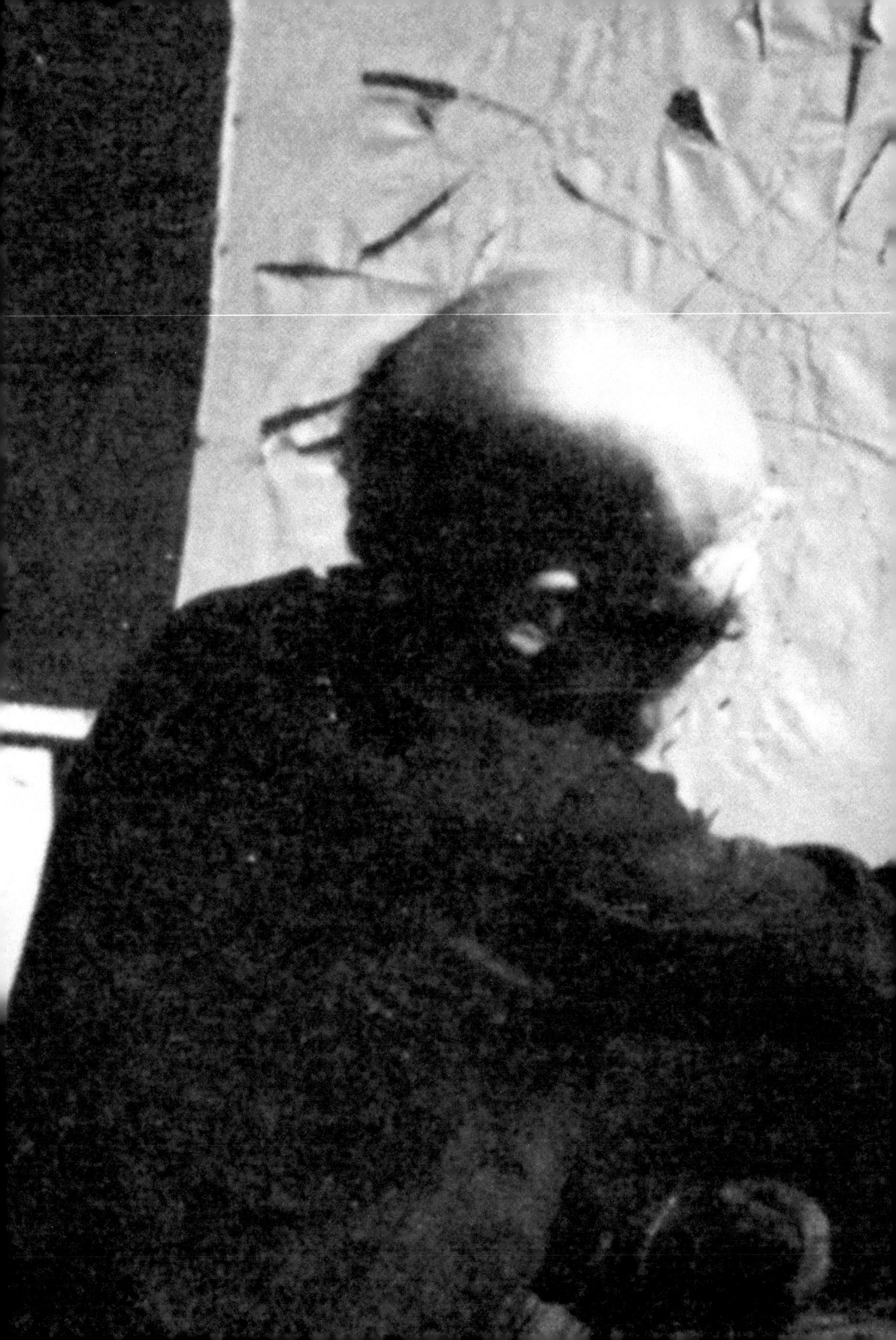

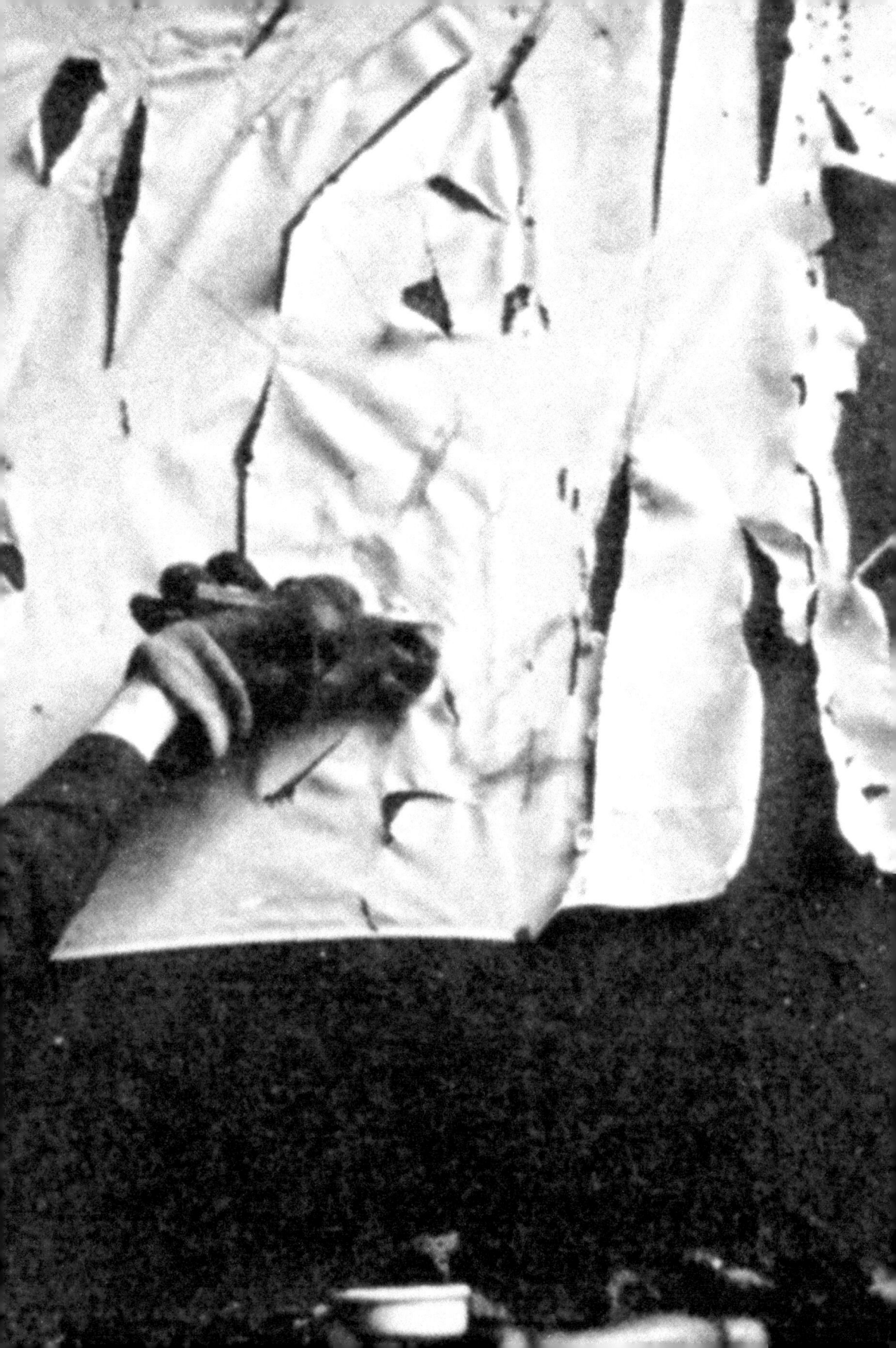

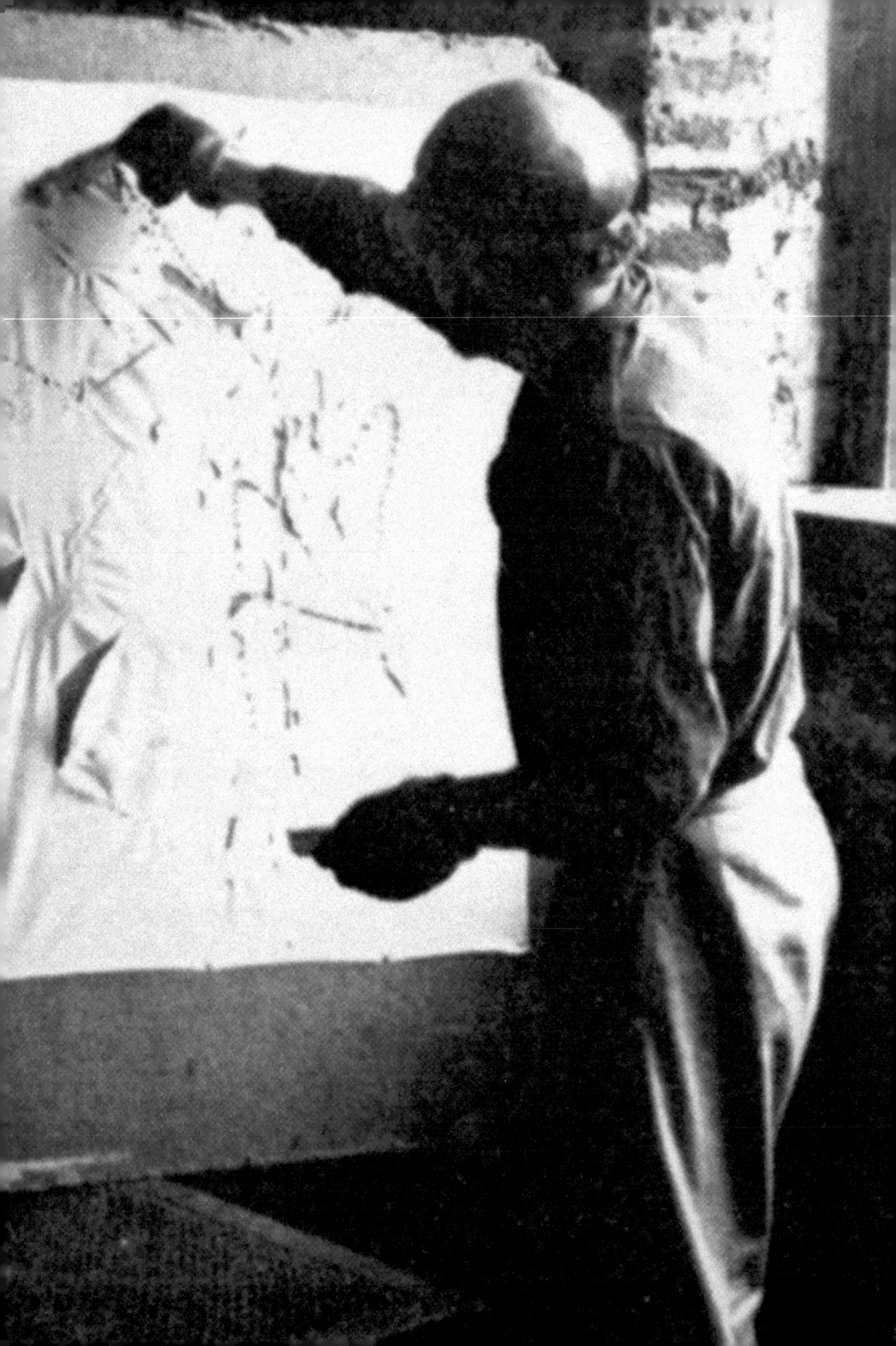

GUSTAV METZGER
INTERVIEWS WITH HANS ULRICH OBRIST

Edited by Karen Marta

Hauser & Wirth Publishers

Contents

Preface 16

1 Beginning with Nothing 23

2 Monuments to Destruction 49

3 Extremes Touch 91

4 Years Without Art 123

5 Confronting the Past 151

6 Damaged Nature 185

7 Facing Extinction 217

8 Going Back to Go Forward 237

Chronology	268
Acknowledgments	280
Index	282
A Note on Sources	285

Hans Ulrich Obrist

Preface

Metzger with a gas mask, preparing to spray hydrochloric acid onto nylon canvases as part of a public demonstration of auto-destructive art, South Bank, London, July 3, 1961

Marina Abramović, who joined Gustav Metzger and me for a conversation during the 2009 Manchester International Festival and is a great admirer of Gustav's work, wrote a beautiful poem for his memorial in 2017:

> THIS PLANET CREATED GUSTAV.
> GUSTAV WAS A HUMAN BEING WITH RARE QUALITIES.
> HIS MISSION WAS TO TEACH US TO SEE THINGS
> DIFFERENTLY.
> WHEN WE BLOW A CANDLE, BUDDHISTS WONDER WHERE
> THE FLAME WILL GO.
> NOW GUSTAV WILL KNOW THE ANSWER.[1]

The story of how I met my friend Gustav is also the story of my own beginnings. In the 1990s, when I was early in my career, having just curated *The Kitchen Show* (1991) in my student apartment in St. Gallen, Switzerland, and having moved to Paris for a residency at the Fondation Cartier, I was invited by the Henry Moore Sculpture Trust to do a lecture series that would travel to Belfast, Dublin, Leeds, Manchester, and Glasgow.

That's how, on the last stop on the tour, in the basement of the Glasgow art space Transmission, I met and was captivated by a group of vibrant young Scottish artists, including Christine Borland, Roderick Buchanan, and Douglas Gordon. After the lecture, we all went out to a bar together. Douglas told me about Gustav and his work in the 1960s around the Destruction in Art Symposium (DIAS, 1966). Then, soon after this, Norman Rosenthal told me about his ICA exhibition of political German art, *Art into Society – Society into Art* (1974), whose catalogue included a contribution from Gustav.[2] My interest was piqued.

I began to research Gustav's life as best I could. What I found out was that he was born in Nuremberg in 1926 and was highly political from a young age. As early as 1959, Gustav wrote his first manifesto on auto-destructive art, a public art form that sought to hold up a mirror to a social and political system that he felt was progressing toward obliteration. Auto-destructive art, he wrote, was "an attempt to deal rationally with a society that appears to be lunatic."[3] I was struck by this radical thinking, which characterized so much of Gustav's life. As part of the Campaign for Nuclear Disarmament, he questioned established structures, aware of the human potential to destroy but also believing in the possibility for change.

The more people I spoke to about Gustav, the more I learned how influential he was. If you ask the artists of the Happenings and Actionist movements of the 1960s how they met one another, many tell

you that they met thanks to Gustav—that DIAS brought together people working in a movement that, until then, was very dislocated and spread across Europe. All this made me more determined than ever to find Gustav and speak with him. I searched and searched for a way to contact him for years, but, because he didn't have a permanent address, my attempts proved fruitless.

Then, in 1995, I guest-curated my first exhibition at the Serpentine Gallery, which became the ongoing *Take Me (I'm Yours)*.[4] It was interactive and highly tactile, giving visitors the opportunity to do what is usually forbidden in a gallery: touch, pick up, and even carry away the works. I remember being in the office the day after the opening and hearing that there was a gentleman downstairs who had seen the exhibition and wanted to speak to the curator. I went to see who this was, and a man in his sixties told me his name was Gustav Metzger. He had no idea I had been trying to get a hold of him until he saw how excited I was to finally be meeting him in person. I invited him for a coffee, although Gustav only had a cup of boiled water—a habit I eventually picked up from him. As we spoke, he explained that he had enjoyed *Take Me (I'm Yours)* and had been involved in a similar type of participatory exhibition at Gallery House in the 1970s (*Three Life Situations*, 1972). When I asked if he would be willing to do an interview for my Interview Project, he agreed right away.

Ever since my teenage years, I have been interested in recorded artist encounters. I remember reading *Lives of the Artists* by the Renaissance painter and architect Giorgio Vasari in the library near my childhood school. The fact that Vasari didn't separate artists and architects, and that he not only wrote about their work, but also their inner lives, was a revelation to me. It prompted the idea that I could meet my own contemporaries and learn about their lives firsthand. As I continued pursuing this idea, I read David Sylvester's *Interviews with Francis Bacon* (Thames and Hudson, 1975). Before reading that book, it hadn't occurred to me that you could speak with the same artist again and again and again, and this revelation led me to my own method of interviewing. I had, by the mid-1990s, already met with many artists, but Gustav was one of the first artists I forged such a long, ongoing interview relationship with.

For our first interview, we met at Waterloo Station and he took me to the Cosmo café, which, as Gustav explained to me, was very popular with immigrants who were in exile in London. He told me that he had come to the UK with his brother as part of the *Kindertransport* during the Second World War and that most of his family had been killed in concentration camps. He had arrived as a Polish citizen but traveled on a stateless passport after the war, and this café held significance

for him as a place where the immigrant community could gather. I was touched that he would welcome me into this very personal place—and I quickly realized that all of the research I had done couldn't prepare me for the generous spirit and radical intelligence of this man. Our conversation that day was unforgettable, and, after that, we never really left each other.

During this period, Gustav was rarely engaging with exhibitions, but, around the time of our first conversation, he staged an amazing show of his Historic Photographs at workfortheeyetodo, a bookshop gallery that brought art and poetry together. It was accompanied by a book for which Andrew Wilson collaborated with Gustav on a selection of his writings (*Damaged Nature, Auto-Destructive Art*, 1996). At that time, I was assembling *Life/Live* (1996) at the Musée d'Art Moderne de la Ville de Paris.[5] The exhibition highlighted a generation of young British artists in the context of radical pioneers who paved the way for them, such as John Latham, Barbara Steveni, and David Medalla. We invited Gustav to participate and, astonishingly, he agreed. It was the first major museum exhibition he had been a part of in many years.

Included in that show was *Earth Minus Environment* and two works from his Historic Photographs series: *To Walk Into – Massacre on the Mount, Jerusalem, 8th November 1990*, and *To Crawl Into – Anschluss, Vienna, March 1938*. Vertically and horizontally covered in cloth, these works were only visible to spectators when they crawled or walked into them. There was no possibility of viewing or consuming these photographs as mere images; there had to be a confrontation on different terms—a confrontation with history. As we watched visitors in Paris interacting with these pieces, the relationship between artist and audience seemed to shift perceptibly, and I knew it was urgent to encourage Gustav to continue bringing his work to a broader audience.

Gustav was still very difficult to reach. He would usually call me from phone booths in London subway stations, and sometimes, by the time I got the message and rang the number back, he had already left, and some other person waiting for a train in the underground would answer and say, "There is no Mr. Metzger here." Because of these logistical challenges, it would often take us months to connect over the phone. However, we maintained our correspondence, with Gustav writing me letters in which he beautifully described his work.

Things changed in 2006, when I was invited by Julia Peyton-Jones to take on the role of Co-Director and Director of International Projects at the Serpentine. My new address in London made it easy for Gustav to just pass by. During this time, our collaborations intensified—Gustav's commitment, both to his work and our friendship, was epitomized for me when he came to the Serpentine's first ever Marathon event. Rem

Koolhaas and I interviewed artists, architects, scientists, and writers nonstop for twenty-four hours—but Gustav was the only person who stayed till the very end. Three years later, we put on the Serpentine exhibition *Gustav Metzger: Decades 1959–2009*, which showcased fifty years of Gustav's epiphanies and inventions, his connections to politics, science, mass media, and history, many of which were re-created from his notes and memories due to the ephemeral or auto-destructive nature of the original pieces.[6] Gustav always maintained that an artist is not so much a creator as a destroyer, and that the artist's role is not to add something to the world of objects but to make fewer things—a radical stance that I came to appreciate more fully during this exhibition. We also conducted many more interviews between 2006 and his passing in 2017.[7]

Our interviews ended up producing their own spin-off projects, and we would give public talks together in addition to larger panel discussions, where Gustav and I would often be joined by a third person. These talks included our discussions with Yoko Ono about her participation in the Destruction in Art Symposium. I came to understand how much Yoko really admired Gustav, not only for his tremendous contributions to contemporary art, but also for his politics of radical environmentalism, and how she was a great supporter of him over the course of his life. As she said for his memorial service, "Gustav was an incredible artist. His energy changed the world."

My story of knowing Gustav is a crescendo. What began as a serendipitous meeting eventually grew into a creative partnership. The *Extinction Handwritings* he began in 2015 and continued to make for my Handwriting Project are just one example. Gustav also showed me that an artist has the agency to transform an entire institution. When an institution is working closely with an artist, their presence, their values, and their energy all become intertwined. Little by little, Gustav integrated his environmental agenda into the Serpentine by convincing us not just to make a show about ecology, but to put that mission at the heart of the institution. This followed Gustav's belief that "we must become idealists" as we try to create a different future for our planet. As a result, Gustav and I put on the Extinction Marathon with the Serpentine team in 2014, which brought together a diverse group of people and invited them to explore climate change, all while sharing visions for the future.[8] We also collaborated on the worldwide call to action, the *Remember Nature* project, which began on November 4, 2015, asking artists and students to create work on issues of environmental destruction and pollution. For this project, Gustav wrote a rallying call that, I believe, still resonates with us today. He said, "We have no choice but to follow the path of ethics into aesthetics. We live

in societies suffocating in waste. Our task is to remind people of the richness and complexity in nature, to protect nature as far as we can. By doing so, art will enter new territories that are inherently creative, and that are primarily for the good of the universe."[9] Indeed, although we saw each other often, time spent with Gustav always felt urgent. Gustav had a seismic impact on whoever met him. He challenged us to action. He defined his own trajectory with work that continues to resonate on many different levels and for each new generation that encounters it.

I feel that meeting and befriending Gustav was, in many ways, fated. I met him during a very formative period of my life, and his influence forever changed the way I think about curation and the power of art. Every word of these interviews is a moment I hold near to my heart.

NOTES

[1] Metzger's memorial was held at Tate Modern, London, on April 10, 2017.

[2] *Art into Society – Society into Art* was organized by Norman Rosenthal, then curator at the Institute of Contemporary Arts, London, and the writer and curator Christos M. Joachimides; see p. 131 for Metzger's recollection of their encounter.

[3] Gustav Metzger, "Auto-Destructive Art: A Talk at the Architectural Association London by Gustav Metzger" (1965), in *Gustav Metzger: Writings 1953–2016*, ed. Mathieu Copeland (Geneva: JRP|Editions, 2019), 103.

[4] The first *Take Me (I'm Yours)* exhibition, at the Serpentine Gallery, was curated by Hans Ulrich Obrist with Julia Peyton-Jones and Andrea Schlieker.

[5] *Life/Live* was curated by Laurence Bossé and Hans Ulrich Obrist with the Musée d'Art Moderne de la Ville de Paris's director, Suzanne Pagé.

[6] *Gustav Metzger: Decades 1959–2009* was curated by Julia Peyton-Jones, Hans Ulrich Obrist, and Sophie O'Brien.

[7] See "A Note on Sources," p. 285.

[8] The Extinction Marathon was curated by Hans Ulrich Obrist, Gustav Metzger, Jochen Volz, Lucia Pietroiusti, Ben Vickers, and Claude Adjil.

[9] Gustav Metzger, call to action for *Remember Nature*, a project instigated by Metzger and co-curated by artists Jo Joelson and Andrea Gregson with Hans Ulrich Obrist and the Serpentine Galleries, London, November 4, 2015, https://www.serpentinegalleries.org/whats-on/remember-nature/.

1

Beginning with Nothing

Gustav, I want to start by asking you about the beginning—or maybe in your case, beginnings. It seems to me that you had many different starts, many different paths that led to your work. How would you trace your beginnings?

> The childhood experience is something that one never escapes. Certainly I haven't escaped it, and I don't want to escape it. There was a lot of turmoil. Rootlessness, too. The first need of life is to find out where one is, and that took me well into my thirties. It started with being deeply concerned with politics, and being directly impacted by the political horrors of the Second World War, being a part of history. One of the earliest memories is from my childhood in Nuremberg. We were living in a house in Fürther Straße, which is a big, linear road from Nuremberg to Fürth. We were at the beginning of that road, Fürther Straße 37. One day, when I was just a child, I went out onto the road to join a group of people marching by. It turned out to be a political demonstration—I think more left wing than right wing, at least, as this was before '33. It was, I believe, my first appearance in politics. But my parents were very worried and took me back home as quickly as possible, and I was grounded for several days.

You made your first political appearance as a child?

> Yes, but let's go back to the origins of my involvement with art, which, as you say, had many beginnings. My first memories of this encounter, as a young child in Nuremberg, revolved around the city's famous fountains. I would sneak into the town center whenever I could and wallow in the immensity of this kinetic art. The movement of form, color, and sound has been important to all that I have done since. At the same time, I was raised in an Orthodox Jewish environment, so there was a fascinating clash in my youth in Nuremberg, which has a profusion of churches and cathedrals, between art and the Jewish insistence on the prohibition on images. This is at the center of my work: on the one hand, opening up to the world and, on the other, closing off from it.

When you were just twelve years old, you witnessed the violence unleashed by the Nazis while you were still living in Nuremberg.

> In the turmoil of that period, my mother said to me, "Go to the synagogue, and ask your father to come home quickly." I didn't know what was happening. So I went and asked someone to send him out for me, and when they did he was stopped by some Nazis in the street and they took him away. I saw my father marched off—he didn't see me, but I

saw him. And there was nothing I could do. I was desperate. My two sisters were also being marched off somewhere else in our town at the same time, which I only found out later. So if you ask me how I first understood extinction, it was because I saw it with my own eyes, as a helpless child. Even then, already, I felt guilty. I felt guilty at having obeyed my mother and unwittingly sent my father to his death. I should add that my mother and many other relatives disappeared later also. My sisters were able to escape from death, first to Sweden and then to England. Meanwhile, my brother Mendel and I were sent to England as part of the *Kindertransport*.

And so you went from Nuremberg to the UK. Were you sent to live in London originally?

Well, my brother and I arrived at Harwich from Holland by boat with five hundred other refugee children, in early 1939. After a few weeks on the coast, we were transported into London by bus. My first experience of London was characterized by thousands of car lights as we passed through the traffic—I had never seen anything like it before, this many cars and people. The next strong memory I have is that every Sunday evening a bus would pull up in front of our hostel in Kilburn, and twenty or so refugee children would be taken to the grandest cinema in London—the Gaumont State Theatre in Kilburn. We were given the best central balcony seats with compliments from the manager. I didn't stay in London very long, but I have these strong memories from the time, which made a lasting impression on me. I knew I would be back again.

You went back to study art only a few years later. Did you feel that you came to art or that art came to you, at such a young age?

I think it's necessary to discuss the experiences I had before becoming, or trying to become, an artist in order to explain this—and to answer your first question about my many beginnings. You see, during the war I was in Leeds, an industrial city, where I studied cabinetmaking. My brother Mendel was also in Leeds at a technical college set up by the Organization for Rehabilitation through Training and Œuvre de secours aux enfants, designed for young Jewish people to train in crafts—the idea being that they could then eventually go to build a new state in Palestine. My brother was in the electrical engineering department and I joined the woodworking department. It would've been a three-year course, but too many people had to join the war effort and the program collapsed. A lot was in flux for me in this period. I was

considering an artistic or creative path already, and I was lucky that I had the opportunity of repeatedly visiting a great art gallery on the outskirts of Leeds, which exists to this day, called Temple Newsam. It was there that I first came across what in Germany, at that time, was called *entartete Kunst*. As a child, before leaving Germany, there was no chance of me seeing such things, unless I had gone to Munich for the *Ausstellung "Entartete Kunst,"* which would have been impossible. It was a great culture shock to be exposed suddenly to art forms that, on the other side of the continent, were forbidden territory. I also first saw the paintings of John Piper and Graham Sutherland. Seeing an exhibition, in 1941, of Sutherland's latest works, depicting bombing and shelters, had a tremendous impact on me. Here was this reality, presented like a stage with firebombs going off—death and destruction.

Was that the initial impetus to take up painting and life drawing—to study under someone like the Cubist and Expressionist David Bomberg?

It was certainly an influence, but it was just one of many interests of mine at the time—my initial impulse wasn't within visual arts at all. I wanted to become a composer.

Did you play an instrument?

Well, that was part of the problem. I went to the head of the technical academy to ask his advice, and he said to me, "If you want to be a composer, you have to spend years learning at least fifteen instruments." So I took a few months of piano lessons in my free time, but then I had to give it up. I thought, "Here I am in the middle of the war, without any means. How can I start to learn?" So I decided to go to work instead, and found a job at a furniture factory. While there, I met a young man who was a keen Trotskyite. He introduced me to left-wing politics. That was very exciting, and something I had known I was interested in for some time. He gave me some books and I read Lenin for about two years, and some Marx—I became something of a communist. So at sixteen and seventeen, I was intensely engaged in revolutionary politics, with left-wing socialist-communist ideas and ideals. And even when I gave up the idea of becoming a political animal, I maintained my interest in politics, and in revolutionary politics. This early excitement still influences me constantly. That's the basis of my continuing criticism of art and society.

And during that early period of political engagement, did you also begin to become involved with what would have been the very nascent environmental movement? How and when did a concern with nature enter into your thinking?

> Well, it was precisely during that time that I moved from the furniture factory in Leeds to work just outside the city on the Harewood Estate. That was from '42 to the spring of '44. They accepted me as a young assistant in the joinery department and that was a very important part of my life, as it brought me into contact with nature, and an almost medieval way of life. The history of the Harewood Estate, which was hundreds of years old, was such a palpable contrast to my time in Leeds and even Nuremberg. I lived in this tiny village, and each morning I walked through the forest to the joinery department, passing through a beautiful landscape. Then also, there were darker moments that also influenced me. One month in the winter, everybody who worked on the estate had to help with the hunt by beating the trees and bushes to scare the game birds into the open so they could be shot. I hated watching the hunt and that was the reason why I became vegetarian—which I still am to this day. My political ambitions were still strong at this point, and so I moved once again, this time to join a Trotskyite and anarchist commune in Bristol. That was in '44, for six or seven months, and it was there that I realized politics wasn't for me—partly because of my contact with the people there, who were really rather extreme and, I felt, not quite modern.

So this was the stage when you turned away from politics. How did you begin again?

> I knew I would always maintain the feeling of responsibility that is central to left-wing politics and the connection I felt toward the horror of the Nazi period. But I also knew I had to make a choice, a clear and definitive choice. I gave up the idea of being a revolutionary and that was when I began on the path of art and sculpture. For me, art would turn out to be a continuation of the political ideals I had as a result of my early life experiences. I wanted to change the world, to change art; I wanted to work in art to make changes of some kind. But finding this out was circuitous, too; it took a while to find the right step forward.

What was the first step you took?

> Well, after leaving the commune in Bristol, I cycled to Champneys nature-cure clinic outside Tring, Hertfordshire, where I had arranged

a job in the garden. The whole place was organic—the gardens, the food, everything. It was a major experience for me to live like that, a continuation of my time at Harewood in some respects. There is a living chain between this experience and my later environmentalist work, which has become more and more important to me as time goes by and as society becomes increasingly "organic," which I think has been as revolutionary a change as any in the history of humanity. It was while I was living at Champneys that I did my first carvings. One of the first things I did as an artist was to go down to a stonemason and buy a small piece of stone, which I took and started carving on my own. This felt concrete to me, something an artist would do. I was given a little chalet in the grounds and I set up a studio there. They were quite small stone carvings, strongly influenced by Barbara Hepworth and Henry Moore. I eventually had to leave them behind as they couldn't be moved. And this interest in the work of Moore, alongside my early exploration of stone carving, led me to the beginning of my studies as an artist in January of '45, at the age of nineteen.

You contacted Henry Moore very early on, isn't that right?

Yes, I wrote him a letter during this time and asked whether I could meet him and perhaps become his assistant. He agreed to meet, and told me to come to the National Gallery in London on such and such a day. So I went and talked to him. Moore was very kind, but also very firm, and he said, "I can't give you any kind of offer, because I'm waiting for my former assistant to come back from the army. And anyway, I think your next step should be to go to an art school and do life drawing for a number of years." And I thought that seemed like good advice—that's how I acted then, upon instant ideas. So I knew my next step would be to spend a few weeks looking around for an art school.

It's incredible that you met Henry Moore at such a young age—and that he directed you in this formative way. It's interesting to consider what might be different if you had studied under him rather than David Bomberg.

Yes, but I think I would have found my way to Bomberg anyhow. It was inevitable.

But even then, you still had many other starts before you found Bomberg. There are so many chance encounters that led you there—like a tangled system of roots running along and finally converging.

It's true. Just a few weeks later, I went to the Ashmolean Museum, where I thought I might study, at the Slade School of Art, which had been evacuated from London to Oxford during the war. When I went to see if I could study there, I met this young man—he was a couple of years older, big, and very striking looking—who just happened to be coming down the stairs as I was going up. We spoke for a few minutes and he said, very matter-of-factly, "Don't come here. It's a rotten school, find somewhere else." He didn't know who I was, and I didn't know who he was—we were both young people—but I realized later that it had been the Scottish artist and sculptor Eduardo Paolozzi—we had met just by chance! So anyway, I decided that if a student thought that about the Slade, then I'd go to Cambridge—where I subsequently studied for six months, in '45, alongside my brother, who came down from Leeds. He was a year older and had already been taking some drawing classes, so he was quite advanced—although we were both interested in sculpture mainly. After six months, we decided to look at schools in London. My brother and I worked at the Sir John Cass Technical Institute in Aldgate on a bomb site, carving large bomb-site stones. This meant we needed to find life-drawing classes taught in the evening, after work. We decided we should attend three or four different ones.

What was it like to return to London after your years away—after the quiet life you led in Harewood, for example? Did the city have the same, almost overwhelming, effect on you as it did when you arrived as a child?

London was—and is—absolutely important to me. It always affected me. But you have to remember, it was entirely different back then. I can remember walking once late at night from those big squares around Victoria all the way to Brick Lane, near where I lived. It was just like walking in a village. This was in early '46, during the winter. There was just the moonlight, and I don't remember seeing any cars or people. That's my early experience of returning to London. It was very beautiful—even the bomb sites had a certain beauty, a calmness to them. But, as much as it could feel like a village, London also offered the possibility of engaging with the ideas that drove me. At the time, those were Dadaism and Surrealism and Constructivism and Futurism—all the "isms." I'm glad I came into contact with them when I was very, very young. I immediately started going round to the art bookshops on Charing Cross Road and buying books. I had very little money, but back then you could buy the publications of the British Vorticist Wyndham Lewis for one shilling. Zwemmers had a cellar with hundreds of them,

which had become damp, so they were being sold at a discount. I bought as many as I could.

Did you make a choice to seek out David Bomberg, then, as a leading figure of some of those "isms"—and certainly a major influence on Wyndham Lewis?

> Not at all. Once again, it was chance, a new beginning, that brought me to Bomberg. It was not that I sought him out; I didn't even know his name. One day, my brother and I went to a school—the Borough Polytechnic—to study life drawing. We went into the class and began drawing, and there was this man who was totally unique, different from any other teacher I'd had. Let me start with my first impression: he was a small man who looked sort of unprepossessing, who walked around the room carefully. At first, I didn't think he was anyone special. But within a few weeks, I realized that this was not an ordinary person. He was charismatic, he had enormous experience, and he did his utmost to teach everyone, literally everyone, in that class whatever was possible for each of them. And this began my eight years of attending his classes. Even when I lived outside of London and had to travel in for two hours just for his class, I would do it. I can't be positive enough about Bomberg—but whatever I say, it still can't possibly convey the level of significance he had for me and for so many others.

David Bomberg was an artist of many forms and styles—someone capable of tuning in to a shared trait or idea and then working from there. Was that what was so unusual about Bomberg's approach to teaching?

> What struck me most at the beginning was the physicality he employed—I'd never seen that before. Bomberg encouraged his students to use their bodies, to interact physically with the work. I was introduced to drawing techniques that were completely different to what I had been doing in Cambridge—where we simply followed the outlines of the figure, to make a realistic interpretation. Bomberg said, "Forget about that! Go for the structure! Go for the center, and use the full weight of your body!" That was the beginning of my move toward the end result, toward dealing with the central, salient points of the figure, rather than with the details—going to the heart of the matter. That's Bomberg, at his core. Things could be improvised, and always happened with energy. There would even be evenings when the model didn't turn up, so Bomberg would ask, "Would you come and be the model for tonight?" And a student would do it, without question. Frank Auerbach, who was in the class with me, was the model several times.

I have portraits of Auerbach because of this, who is now of course a world concept, a world image.

Can you tell me more about this new physicality—would you say it pushed you toward an inadvertently Expressionist approach?

When I started my studies with Bomberg, I was hooked on early printing; I was fixated by it. I remember I got a ticket—I must have been quite young—to see the British Library's incunabula. So this comes through in my work from that early period—printing and graphic arts—combined with what I was gleaning from Expressionism. *Self-made* is a good term for what I was doing. Marks just appeared. I would pick something up and throw it in without planning. Maybe that's what you mean, about an inadvertent Expressionism—it was the natural result of how we were working. This related to Abstract Expressionism, certainly, and very intentionally—connected to the developments going on in America at the same time, in '45 and '46. Bomberg was an Expressionist, in a way. He emphasized that it isn't just the hand, but everything going through the entire system that's then expressed on the page or the canvas. My fellow students Leon Kossoff and Auerbach perhaps embraced this system of approach more than anyone else, including me. But the Abstract Expressionists definitely influenced me. Willem de Kooning, for example, had an important impact on my work.

Working alongside Kossoff and Auerbach as you did, did you feel that you all pushed each other in new directions? Did the students share ideas or influences?

No, not really. They would disappear at the end of the evening. During the last year, in 1953, I would accompany Bomberg to Hampstead, where he lived. That's another reason for me not having talked much to Auerbach and Kossoff. I would just stand there and go off with Bomberg to his house.

So you and Bomberg were especially close. Where do you think this bond came from?

We had so many similarities and that made us, exactly as you say, form a strong bond. Bomberg was also raised in an Orthodox Jewish family. And he was interested in politics, just as I was. In the 1940s, there was this upsurge of interest in politics, with Spain and communism and the rise of fascism in Europe. Bomberg was very involved with that and it was one reason we got on so well. Intuitively, he realized that I

> was interested in the same things he was. When we first met, he wasn't active in politics, but he had been active in different political aspects related to art, like the Artists International Association, and other groups. Auerbach and Kossoff had no point of contact with Bomberg in this respect. But then politics never came into the classes.

Politics didn't enter the classroom, despite what was going on?

> No, never.

Bomberg was this incredible figure, straddling so many important eras in British art history—was that something he exposed you to?

> As you say, Bomberg was, at a very early age, a leading figure in the British avant-garde; he was a vital part of the most significant developments in twentieth-century art in Great Britain. That was important to me and all the other students. He was history. He was a direct link between the pre–First World War and the post–Second World War avant-gardes. He encouraged us all to go to see exhibitions, particularly at the Leicester Galleries, for example—and we could go in for free if we said we were his students. Jacob Epstein, who I greatly admire, had annual exhibitions there and was often hanging around. He always had this huge cloak on—a very large figure, a very powerful impression, but I never, ever talked to him. He had a very hard life, as you know. He came here as a totally poor person. He was struggling to get established. A lot of people didn't like him because he was so original, so distinctive, and so Jewish on top of all that. Then there was Wyndham Lewis, whose Vorticist manifesto interested me—even though Bomberg was particularly fond of telling us that Lewis had asked him to sign it and he had refused. In fact, Bomberg told us lots of stories about Lewis, who apparently was a bit of an anti-Semite, as was French sculptor Henri Gaudier-Brzeska, in particular. In fact, there was a real fight between Gaudier-Brzeska and Bomberg, which actually became physical at some point. So yes, Bomberg opened me up to many artists who would greatly impact my work—artists he was friends with or had known for many years.

A link with history, exactly—a "living link." I'm wondering if art became a means to integrate the various influences and experiences that informed your early life—a space that allowed for searching, false starts, even for contradiction. Were you still, as a young artist, particularly as the war ended, finding "where you were"?

Well, when I was young I wanted art that would lift off, that would levitate, gyrate, bring together different—perhaps contradictory—aspects of my being. So yes, in a sense. I was trying to convey the search for—the need to encapsulate varying kinds of contradictory elements, the urgency of stopping sharply—the twist and razor-sharp endpoint. After such an experience, whether as artists or spectators, we expand, reconnect with a normality that's not the same as it was. Because normality, once changed, can't ever be the same. I felt that as a viewer when I saw work by the artists I admired—and I wanted to achieve it myself. Maybe this was some version of my previous, political life coming to bear on my art—I knew that art could force a change, not in a metaphorical sense, but in a real, practical one. One of the deepest experiences I had in those days was seeing the Picasso and Matisse exhibition at the V&A after the war in London, where wartime subjects came through, particularly Picasso's painting *The Charnel House*.

The Charnel House is very interesting in this context, with its compositional changes left visible on the canvas. After donating it to the National Association of Veterans of the Resistance, in 1946, Picasso demanded that the painting be returned to him so he could continue working on it. But the canvas today shows nearly no signs of change—and I think it's the unfinished quality that activates it as urgent, that reminds us destruction is forever ongoing.

The Charnel House was shown in relation to actual imagery of the concentration camps—bones and skeletons were juxtaposed. That had a tremendous impact on me, as, of course, did the actual photographs we were confronted with.

Picasso once defended art as inherently political, saying painting is "an offensive and defensive weapon against the enemy." It's interesting that, just after the war, you went back to continental Europe. Did you feel this took you one step closer to facing destruction, to understanding what your work could do—perhaps not as a weapon against the enemy, but as a mode for forcing responsibility?

Both my brother and I went to the Continent in the summer of '48, as I had received a grant to study at the Royal Academy of Fine Arts in Antwerp. Toward the end of that summer, I did some drawings of Antwerp, seen from across the Scheldt river. I did at least one painting where you saw the town, which I entitled *Antwerp After a Nuclear Attack*. It was a very warm summer and I was thinking constantly about destruction—the present reality of destruction and the inherent threat

of something even more existential. I would spend hours and hours in the street drawing children who just went by, and I would say, "Stand still for ten minutes." And they would stand there as I drew them. They were all very, very sad—all almost crying. So these were very emotional images, and in some ways the beginning of my interest in destruction as an artistic theme. This took on even more significance for me as I continued to travel, first around France and then back in the UK. I'd like to go back to the phase in my experience which has dominated my life ever since—

Please, tell me—

It happened in the northernmost part of Great Britain, just around this time, in 1950, I think. I had spent three months traveling in and around Scotland, by boat, hitchhiking, whatever was feasible. I ended up in Shetland, the northernmost part of Scotland, and spent three weeks there. This was a key turning point in my life and in my career, even more so than Antwerp. The stillness that I experienced there, the lack of pollution, felt like finally I was able to wash a coating of dust off my skin. I had started a notebook and one night I wrote down what I thought were the most dangerous elements in modern society: pollution, noise, cars. Cars were affecting the entire world, especially Great Britain. And this is where I first had the idea to attack the car.

You've never mentioned this time in your life to me before—even though we've spoken many times. I'm very interested in how youthful experiences shape artists' lifelong preoccupations—as Friedrich Nietzsche once said, "Everything unutterably small or great in your life will have to return to you." It's fascinating to hear that you first became aware of the effect of cars so early and, importantly, by noticing their *absence*.

Yes, and understanding what the world might look like not overrun by automobiles planted a kind of seed in my mind. Then, many years later, I saw *Shoah* by Claude Lanzmann. I'm jumping ahead now, but it's an important step toward answering your earlier question. Well, that film, it talks about the Nazis' first experiments with gas vans—this was before the gas chambers—they were hermetically sealed vans that had their engine exhaust pipes diverted to the interior compartment, so the occupants would be asphyxiated. When I saw that immensely powerful film, I realized why cars had obsessed me from such an early age. I had been obsessed by something that had happened, but without me knowing it. A subconscious understanding, you could say. And

that informed, I believe, my fierce rejection in the Shetland Islands of cars, which I knew were transforming the human race—the way we appear, the way we experience things. This extreme revulsion that I developed was founded subconsciously by my childhood experience of guilt at having sent my father to the death camps. That's what *Shoah* made me realize, that the seeds of so much of my work were first planted during this experience in the Shetlands. So I kept searching for how to deal with destruction and extinction, and also for "where to be." I was totally unprepared, but I was looking for something new all the time; even from the beginning of my studies with Bomberg, I was attuned to the avant-garde, the next step. The next step in art, and my next step. And this has always been the case: I want to paint for the next step, for something beyond at least my present capacities. That's what concerns me.

Theodor Adorno famously said that to write poetry after Auschwitz is barbaric. There have been times in your life when you've stopped painting for years—was this first break in your work politically motivated, a rejection of aesthetics in the face of such totalizing horror?

Between '53 and '56 I didn't paint at all, I was searching, but this wasn't politically motivated. If anything, I felt—and still feel—that facing up to reality and engaging in struggle is the most necessary path for the artist and the intellectual. It's the path that I started on when I was sixteen, living in Leeds during the war, and it's a path I believe I've adhered to, one way or another, ever since. Sometimes refusal may be a way to face up to reality, but that wasn't what I was doing during these years.

So it wasn't the active form of political refusal, which you would later explore during your famous art strike from 1977 to 1980?

No, this pause had to do with Bomberg, with my disappointment in Bomberg. You see, he had become a kind of father figure to me. We had been so close, since I was just nineteen years old, and he had supported me as a friend and mentor. I rebelled occasionally, as any teenager does with their father, but we had such a strong bond. Then, in 1953, a few of his students formed a group called the Borough Bottega—I was the driving force behind it.

This was after the first group of Bomberg's students—the Borough Group—had already disbanded. That group lasted from 1946 to 1951, at which point tensions were running so high between Bomberg and

the students that it completely splintered apart. Were you concerned about repeating this?

> I should have been, but at the time the idea was simply that we students should do something together to recognize Bomberg's work. It was a long summer, and it took us a dozen meetings to go through the idea and to establish a constitution and arrange an exhibition, which was held in October and November of '53. But soon I realized that Bomberg wanted a special place in the group for himself and his family, which wasn't right. I had wanted the Borough Bottega to put him on the map, but as the meetings proceeded, and as we formed the constitution, I realized that he was trying to dominate the group in this extraordinarily egotistical manner. I couldn't accept that. So I resigned—although even then I said, "Look, I'm resigning, but that doesn't mean I don't want to continue supporting you." I didn't think this would cause any problems. But then I got a letter from Bomberg saying that he could no longer have any contact with me—it was short and direct, something like, "You've taken up too much of my life. Goodbye."

It's incredible that he cut you out in such a punitive way.

> Certainly, and the way he ended the relationship had a profound impact on me, as you can imagine, on my ability or desire to paint. So from '53 to '56 there was no new work—I was quite poor and kept myself isolated from the world.

During that time you were working as a used-book seller in East Anglia. But then very soon after, you began to formulate the manifesto for auto-destructive art. Why did you return to making art?

> In '56 I was living in a wonderful, huge house, all by myself, in King's Lynn, this small market town in East Anglia, as you say—and one room was set up as a studio. I felt that if I had a studio, I should paint seriously again, and started with some experiments. These were abstract works, not figurative, although there was a small series I did during that period, painting very violent images of this little table in my studio. They looked a bit like explosions—in browns and blacks—very strong. The atom bomb came in as a reference for those, even though their subject matter was so modest.

I've seen those works, which are remarkable. They seem related to the physicality that you describe learning from Bomberg—bringing the full force of your body to bear on the subject at hand.

> Yes, they were explosive. But then, after that, there was a real turning point. I was painting on boards, essentially, rather than canvas, with a palette knife for two or three years, but the material wasn't hard enough. So I realized I needed to buy some metal. I bought three sheets—quite big, and gray, of course. Then I took my palette knife and painted, and I inevitably kept incising the metal as I tried to paint. For the first time, I felt this added a kinetic element to my art, and kinetics became so important. On one of these paintings, the best of them, I picked up a piece of chalk and made some marks. That was something I'd never done before. It was less than a year before my first manifesto on auto-destructive art. So these chalk marks on the painting, and the painting itself, were the real turning point for me toward auto-destruction in my work.

So that was the specific moment when it all changed—which you can point to as the origin of auto-destructive art.

> Yes, certainly. That was the first moment—of course, everything we've discussed, all the moving around and making new beginnings, that all contributed and led up to this. It wouldn't have been possible otherwise. But it was the foundational moment, you could say. And then, in '59, something else happened that pushed me further. There was a very modest café in Covent Garden, at 14 Monmouth Street, where the proprietor, the artist Brian Robins, would ask artists to exhibit. Just after I moved to London, when all of this was swirling around unformed for me, I took the opportunity and showed three paintings there. One day I was sitting around the café with two young people. After they had shown me their work and I had shown some of mine to them, one of them said, "I think we should make an exhibition of paintings together, and once it opens, we'll burn them." That was a kind of spark for me. It wasn't the first time I had thought of destruction, but it was the first time I felt it articulated as a specific idea. Within a month or two, I had the idea of creating a sculpture that would disintegrate over the course of the exhibition. The idea was to have some kind of built-in chemical or mechanical system that would allow you to see the transformation after two or three weeks.

The origin of your auto-destructive pieces—like the acid nylon paintings that followed soon after—was not an idea, but a work, a sculpture. The manifesto followed the work, rather than vice versa.

> Exactly. Based on the idea of that sculpture, I began to develop the theory that would become the first manifesto of auto-destructive art,

in November 1959. From that point onward, I didn't stop thinking about the idea of auto-destructive art.

You had found where you needed to be.

I had found where I needed to be. And I was ready for the next step.

The Metzger family, Nuremberg, Germany, 1938. From left: Gustav Metzger's sister Erna (Esther), brother Mendel (Max), mother Feige (Fanny), Gustav, and his sister Chaja (Klara)

From left: Metzger's sister Erna (Esther), mother Fanny (Feige), and father Juda Metzger in the transit camp of Zbąszyń, Poland, after their expulsion from Germany during the so-called *Polenaktion*

Gustav Metzger with his brother Mendel (Max), Hemel Hempstead, UK, ca. 1940

Four Metzger siblings, 1943. Clockwise from top left: Chaja (Klara), Erna (Esther), Mendel (Max), and Gustav

Gustav Metzger, ca. 1946

Mendel (Max) Metzger as an art student, ca. 1946–48

Mendel (Max) Metzger following his move to Paris, ca. 1950

Graham Sutherland, *Devastation, 1941: An East End Street*, 1941

Mendel (Max) Metzger, untitled sculpture, ca. 1946

Gustav Metzger, *Reclining Figure*, ca. 1946

Gustav Metzger, *Head of a Man*, ca. 1952

David Bomberg, *David Bomberg*, ca. 1937

Wyndham Lewis, front cover of *Blast: Review of the Great English Vortex*, no. 1, June 1914

43

Gustav Metzger, untitled, ca. 1948–49

Gustav Metzger, untitled, ca. 1948–49

Gustav Metzger, *Table*, 1956

Gustav Metzger, *Table*, 1956

Gustav Metzger, *Table*, 1956

46

Gustav Metzger, *Painting on Galvanized Steel*, 1958

2

Monuments
to Destruction

I always like to talk about unrealized projects with artists. We know so much about the unrealized projects of architects, for example, but very little about those of artists. In your case, there's a particularly complex relationship between the visible and invisible, as, so often, your realized projects intentionally included their own destruction. Can you tell me about your unrealized projects?

> Yes. First there are some unrealized projects that were simply too big to be realized. These are from early in my career, like the floating piece of metal in front of the National Film Theatre or the liquid crystal projections on the side of the Festival Hall.

Those are from the early 1970s?

> Yes, there were a few projects like that from 1970 or 1971. One involved a piece of metal that would float on the Thames in front of the National Film Theatre, going up and down with the water. At night it would be lit up and would reflect the light. Then there was another project, again in front of the National Film Theatre; there's a space now where book dealers sell books. Well, I proposed a cube of newspapers that would start on the ground underneath Waterloo Bridge and would build up to a solid mass of papers that would eventually hit the underside of the bridge. All these projects were rejected. Actually, I went to the Greater London Council, the governing body of London, which was situated in the County Hall, just up the road on the South Bank, to see if I could make it happen. I told them I wanted to do certain projects, but they replied, "You can't." That was the answer. Except when I told them the idea for the floating metal. Then they said, "If you can get permission from Trinity House, you can do it." So I went as far as seeing Trinity House, the maritime regulatory body, and to my surprise they gave me permission. Then I was advised to contact Alistair McAlpine. His firm was building the National Theatre, and he, as you may know, was a great patron of the arts at the time. But it wasn't possible in the end. The one major public project from this time that I did realize was the *Monument to Bloody Sunday* opposite the Institute of Contemporary Arts in London, which was a memorial for Bloody Sunday in Northern Ireland.

It existed and was realized.

> Yes, but the realization was simply the turning round of an existing building's function, as it were. This building housed a kind of war cabinet, a top-secret British institution, and I turned it into something that

would be completely unacceptable to the establishment it housed—just by renaming it as a monument to this event. By the way, this was made almost immediately after Bloody Sunday, which took place on January 30; it wasn't a historical look back. It was hot in the news when I presented this project in the spring of 1972.

Were there any other unrealized projects from that period?

Mostly projects related to auto-destructive art—none of which have been realized. In fact, none of them have been considered by anyone except me. But what's behind them is the desire to materialize an idea, and an ideal, of auto-destructive art. They're all just words on paper, and words that I've spoken in lectures or private discussions.

That leads me to a larger question about your practice—would you say that the auto-destructive concept as a whole is an unrealized project?

Yes, so far. The only realized works were the acid nylon paintings, where I sprayed acid onto screens of nylon as part of a public demonstration, so that the screens began to deteriorate and disintegrate in front of the audience. These are realizations of auto-destructive art, but they're not perfect realizations. The perfect realizations are monuments. You have to remember, the acid nylon paintings were made by hand, but the essence of auto-destructive art is that the hand doesn't play a part in it, except in the construction of the original sculpture. Then it's all automatic. You leave it. The artist no longer touches the work.

You've always been reluctant to use the word *utopia*. Ernst Bloch, who Adorno says restored honor to the word *utopia* with his book *The Spirit of Utopia*, quoted a line from Brecht to explain it: "Something's missing." The whole notion of utopia being defined as something missing is fascinating. Would you say the acid nylon paintings are utopian, in that sense?

I will be quite frank with you. Utopia is not a concept that I'm concerned with. I've used the term *utopia* only very rarely. I've kept shy of it. In fact, it's a word I find rather disturbing; it's so laden with all kinds of past movements. To me it seems unusable. We've been knocked on the head so many times now, we've been disillusioned, we've gone the wrong way, we've followed paths that didn't go anywhere, and so we've had our fingers burnt in relation to utopia. I try not to use the word. I'm concerned with the ongoing discussion about it, insofar as I read a fair amount—not so much books anymore, but newspapers, and I listen to

discussions on the radio where these subjects come up. On *Night Waves* on BBC Radio 3, for example, you get this again and again on art and politics, so I follow the discussion. But for me, *utopia* is a foreign word, and I'm quite frankly suspicious of its use. I actually—to discuss another project—felt very hesitant about taking part in the Venice Biennale utopia project you curated for these reasons.

Maybe you can tell me about the image you did submit for Utopia Station. It captured a destroyed archive—part of the *100,000 Newspapers* installation, which went to Lyon afterward.

> That's right. In the strangest way, the image I submitted for Venice actually does relate to utopia, because you have chaos—and if you'd been in the installation it captured, you would have seen that the chaos was far greater than what you see in the photograph. There were piles of things disintegrating within the installation, newspapers almost turning to dust. It's this twisting form—it looks like it's turning in on itself and then proceeding upward, so it's like a finger pointing into the future, you could say. It was the most amazing photograph of what was an extraordinary setup.

And the title of the show, *100,000 Newspapers*, was also somewhat utopian, as that number far exceeded the actual extent of the installation.

> That's true. We didn't have that many papers, but we had at least 10,000.

And you personally have an extensive archive of newspapers?

> Extensive, very extensive. I haven't bought as many these last two years, because I bought so many before that it's becoming untenable. It could be seen as an archive, I suppose, but I think of it as an accumulation. One day I might exhibit it, perhaps.

The *100,000 Newspapers* exhibition was about many things—but it touched on destruction, as we've just been discussing. The newspapers decayed over the course of the exhibition like living things—until they became abstract shapes, singularly and collectively.

> Yes, that's right. And the auto-destructive projects I mentioned before are utopian in the sense that they were concerned with the realization of something in the future—and that future never happened, and may never happen. So they're utopian in that sense, or in the technical sense, if you like. Certainly you can call them visionary. These are visions,

visions of vast monuments, as I describe them—Pharaonic monuments to man's capacity to destroy.

You first wrote your manifestos of auto-destructive art in 1959 and 1960, when humanity's capacity for destruction was blatantly obvious and the atomic bomb was a specter of extinction hovering above the world.

Yes, the specter of total annihilation. I was very involved with this. I was an early member of the Committee of 100, an anti-nuclear group in England founded by Bertrand Russell. Its first manifesto, if you like, was written by Russell and the Reverend Michael Scott; the two men worked very closely together. And I was more or less physically in the middle of these two men as they came down the stairs from Russell's modest house in Chelsea to deliver it to the press—a very hungry press, I might add—outside. They ended this powerful manifesto along the lines that, if we change and survive, there's a great future for us. I still remember the last line clearly: "If you cannot, nothing lies before you but universal death." It seemed to me at the time that you can't get closer to extinction than when the possibility of everything being destroyed is predicted by two very great men such as these. So that's where we were in 1960. Today, we are actually, in some ways, in a worse situation, in a swamp, as there are far, far more nuclear weapons in the world than when this manifesto was presented. And when this universal test comes about, the animal kingdom will not be spared. The plant world will not be spared. It will be universal. And we are still left with this threat, with this prediction—we have fought it, but never successfully.

Can you tell me about the moment, amid all this existential fear, when the idea of auto-destructive art came to you? I'm very curious about moments when an idea crystallizes or an invention happens. How, in 1959, did this idea arise?

I can only talk around that. It has very much to do with the way of my life at the time. After living in King's Lynn for seven years, I moved to London in 1959. I faced a very difficult period in my life—both economically and socially. I had already reached a strong dissatisfaction with the materials of painting. I needed something tougher to work against than board. The previous year I had done a series of paintings on mild steel. As I told you, I used a palette knife to scrape and incise the steel, but this didn't satisfy me entirely either. I wanted to use some of the machinery I was reading about in the *Financial Times*—presses of tremendous power that respond to a minute fraction of an inch. I wanted to make sculptures with these machines, controlling them as

an organist does his instrument. It was months after I had given up that plan, partly because of the extreme difficulty of realizing it, that I hit on the idea of auto-destructive art. Looking back, I see that I had exhausted the medium of paint on canvas. The artist wants power—up to the power of atom bombs, if one is to respond in any meaningful way. And speed and complexity—auto-destructive art as I envisioned it would give the artist forms that move at various speeds, that melt or freeze, fly in any direction, are ordered by a computer and/or the spectators, can be completely composed or entirely random, etc. It was a theory and, in 1960, with the acid-on-nylon technique, I had found the first realization of that theory—some people said it reminded them of Jackson Pollock's drip paintings.

So it materialized from frustration, but also a long period of rumination—of trial and error. A moment of precarity in your own life generated a mode of making that embraces uncertainty.

As you say, these conditions of uncertainty and despair were essential to the idea—but it came also in connection with an antidote to isolation, which, at the time, was the community at 14 Monmouth Street. And then one day, I walked in Fulham where I was living and stumbled onto a cardboard box discarded on the street. I opened the cardboard box and saw inside something very beautiful: a construction in cardboard. And I was just completely bowled over by it. There was a feeling of great elation. It's a terrific feeling when you break through something that you don't quite understand—something big. So I showed this box and its construction to Robins, and he was as thrilled as I was. And we immediately decided to have an exhibition called *Cardboards*. And this was the start of my career. This exhibition and this particular work started me actually participating in the contemporary London art world.

I think of the cardboards as readymades—which you have called auto-creative art, a kind of counterpoint to auto-destructive art.

Yes. That's exactly right. I had this realization: that some of the finest works of art being produced at the time were the rubbish dumped on the streets of Soho in the evenings. I thought, "This is our folk art." Auto-creative art is art of change, growth, movement, it aims at the creation of works that grow in volume and extend by reproduction. Works having a limitless change of images without image duplication, for example. My early, fervent exposure to the Jewish religion is important to understanding this, because Judaism urges the protection and stimulation

of healthy kinds of growth. If you look at the first manifesto of auto-destructive art, auto-creative art actually receives more prominence, so there's a side of my activity that has to do with growth and opening to the endless in life and art—and auto-creative art doesn't have the ideological constraints of auto-destructive art. I wrote, even then, in 1959, that thousands of new techniques could be developed in auto-creative art, among them living flesh as a technique of sculpture. I had a vision that the biological sciences, bio-engineering and revolutionary forms of technology, which were in their initial stages at the time, could develop and become important for auto-creative art.

Did the idea for auto-creative art come to you first, before auto-destructive art?

No, they were concurrent ideas—in my mind, one cannot be separated from the other. In those few months, these ideas simply came into my mind and percolated, both of them together. And then these thoughts were also greatly enriched by an idea of the two young artists at 14 Monmouth Street that I've mentioned before. When they said, "I think we should make an exhibition of paintings together, and once it opens, we'll burn them"—that led me to the idea of making a sculpture for the London Group's annual exhibition, which would transform or degrade during the two or three weeks it was being exhibited. Based on the idea of that sculpture, I began to develop the first manifesto, in November. It was one sheet of paper consisting of seven short paragraphs, published with the help of Brian Robins in November 1959. From the time of writing that first manifesto, I saw auto-destructive art as a movement—I wrote not just for myself, but for others who might join me.

You've written many manifestos. Can you describe that process for me—how do you approach that work?

As I was working through the possibility, the potential of each auto-destructive and auto-creative art—I tried to create the maximal freedom for each direction to, as it were, fulfill itself. It's a bit like sculpture: you chisel a bit off and it changes the whole picture. Then you go on chiseling until you're satisfied, and then it's done. As you know, I started as a sculptor and my first interest was only in sculpture. It never occurred to me that I might be painting one day.

At least, not until you met Bomberg.

Studying under Bomberg changed this opinion, yes. When I came to his

class, in the first instance, it was a drawing class, drawing from life, and occasionally drawing St Paul's Cathedral. We would come together on a Saturday morning under his direction and draw St Paul's. But anyway, I bring this up because the act of chiseling was something I was attuned to. And the chiseling away of the theoretical basis took place before the publication of the first manifesto in 1959.

Was it a full-time job, a full-time activity?

Oh yes. It became an obsession. It was also a race against time because it was obvious that, if I had a good idea, somebody else would have a good idea, and that's exactly what happened. The Swiss painter and sculptor Jean Tinguely came upon a similar idea and worked feverishly in the garden of the Museum of Modern Art in New York to get his ideas and his work together. I won this particular race because I got my second manifesto out before Tinguely, and there was an article that quoted it in the *Daily Express* two days before his demonstration in New York. I knew the date of his opening. And I knew that he was being given a lot of support.

You had a deadline, so to speak, as you wrote—the urge to beat Tinguely.

It was a physical need to get it all down, to get it out of me, to make something of a coherent whole. The knowledge and ideas were a constant inner pressure. There was a need to get it right. There were several manifestos and they came together into a whole. Tinguely is a very important artist and his work certainly spurred me on, too, of course.

Did you ever meet him?

Yes, but only one year before his death, in Basel. When I met him, he was on the point of traveling to Moscow for a big retrospective of his work, and, a year later, he died. It's such a pity that we didn't spend more time together. It's my fault. When I met him, he gave me four telephone numbers where I could reach him. But I didn't use them.

In your writings, you define the concept of auto-destructive art as a whole thinking process culminating in "monuments to destruction." The philosopher and poet Édouard Glissant once told me that the purpose of architecture has often been to create monuments, but that the architecture of the future should be concerned with the aesthetic of the invisible—that we need monuments to the invisible to combat the colonial tradition of memorial architecture. Did you see "monuments

to destruction" as actively combatting monumental architecture at this scale?

> I could talk at length about this—these monuments were very much an attempt to convey the horror and the potential of our world, the potential and the excitement of our world. And since I wrote that first manifesto, remarkably, this idea has survived. People are still interested in the subject. Auto-destructive art is primarily a form of public art for industrial societies, which perhaps relates to Glissant, yes. It's material that's undergoing a process of transformation in time. Ideally, the spectator responds to the time, material, and process as a unified experience. In designing a work, the artist sees these three factors as one and could be compared to a choreographer. In terms of realizing such monuments, they can be created with natural forces, traditional art techniques, and technological techniques. The amplified sound of the auto-destructive process can be an element of the total conception and the artist may collaborate with scientists or engineers in order to realize the overall work.

The artist as a choreographer working with time, sound, and natural forces makes me think of *Energy Fields*, a performance piece that Carmen Beuchat discussed with me. Carmen staged the piece in 1972 in Gordon Matta-Clark's space in New York at 112 Greene Street and asked Juan Downey to modify a device used to automatically open bank doors so that its ultrasonic waves would respond to the performance, playing a tone when a dancer activated the musical field.

> You're right to mention the mechanical or technical side here. As I say in my manifesto, an auto-destructive piece can even be entirely machine produced and factory assembled. But the essential constraint that I'd like to focus on is that auto-destructive paintings, sculptures, and constructions have a limited lifetime. This might vary from a few moments to twenty years, but it has to be limited. When the disintegrative process is complete, the work is to be removed from the site and scrapped. This is very important.

This finite lifetime—was that in response to the pervasiveness of capitalism and the art market's role? Does auto-destructive art aim to abolish the capitalist system?

> That's the central idea. Auto-destructive art mirrors reality and is clearly related to capitalism in decline. It's also a weapon of social change. Large self-destructive sculptures, made with the latest

technologies, rotting and falling apart in public, can modify the attitude of many people to war, waste, and destruction, and undermine a suicidal faith in the benefits of technology. But they certainly don't appeal to the art merchandiser—they're intended as slow time bombs to be placed somewhere public—the closer to the center of capitalism or luxury the better, such as Bond Street. Of course, capitalism changes and there are different definitions of the capitalist system at different times. Auto-destructive art must be aware of these. For example, there was "corporatism," and then you have terms like *global economy*. In principle, however, they refer to the same problem: the "market economy"—another term that was very popular at the end of the 1970s, early 1980s. There's always this attempt not to use the term *capitalism*.

In the sense of a euphemism or an evasion?

Exactly. Today it's a system that has triumphed globally. *Global economy* is the current term. But the problem, which is capitalism, is still there. We have to be opposed to all these terms and to all these developments. Capitalism is just power and domination. The trouble is that there aren't enough people in the art world who think like this. That's why I formulated auto-destructive art not only as an art of protest, revolt, and acceptance, but also a very public one. I'm in agreement with a lot of people on the left who believe that's the concern of art—to reach people—and people at different levels of society, including the people who have very, very little.

So eschewing the gallery system was a critique of capitalism, a refusal, but also a means to work publicly and insist on art as accessible—so also, literally, to avoid being boxed in or closed off?

Yes, exactly. The works I had in mind when preparing my first manifesto and all my other manifestos were always large-scale so that they could have a direct impact on the population—more than you would have in private art galleries. My initial interest in art was sculpture, as you know, and sculpture very largely consists of public art. So, from the beginning, even before writing the first manifesto, I would say my chief concern was the creation of large-scale public works. And that was the central point of my auto-destructive art projects—that they would be incontrovertibly there, and tens and tens of thousands of people would see them. This is at the very center of my change from painting to auto-destructive art and public art. The two are linked in my mind and in my writing.

The finite lifespan of these works also ensures they remain outside the commercial gallery system—there is, by definition, nothing to sell.

> That was exactly what informed my decision to put a time limit on auto-destructive artworks, so they couldn't be appropriated by gallerists and would only make sense as large, public pieces. Of course, there's a risk, no doubt, that someone might try to preserve one of the remnants and display it in a gallery—that's why I've been very clear this wouldn't be acceptable. Nobody benefits from such preservation, and so I was quite brutal in saying it's got to be scrapped.

Do you feel the same way about auto-creative art, or can that be handled differently?

> That can stay. Auto-destructive art is laden with ideology, with dos and don'ts, with hopes and despair. Auto-creative art, on the other hand, opens up the possibility of art remaining very much as it is. It doesn't say you have to destroy it, it just says you can use it. It has possibilities, in emotional terms, of joy and liberation. It operates on a different plane and its intentions are different from auto-destructive art, which is a puritan manifestation of this world and puts limitations on the kind of art that you can make.

In a sense, auto-creative art is self-sustaining and therefore future-oriented, while auto-destructive art remains rooted in the present moment. In a 1962 article, you wrote that "auto-destructive art emerges from the chaotic, obscene present."

> It came from the idea that society is deteriorating—and so is the sculpture. Why should an artist make sculptures that survive the destruction of civilization? Is it not rather insensitive of artists to go on making works that are supposed to be permanent? I would say that the answer is yes. Just as it's insensitive of architects to go on making grand big surfaces so exposed to all the threatened horrors. There are examples in nature of animals laying and looking after eggs that will never hatch. And artists today have this problem in an extremely complex form. Artists are acutely aware of the social reality, but are sensitive to the vulnerability of their works to annihilation. They see little point in producing art in this situation, but they go on doing so.

Do you have a term for this mentality?

It's a neurosis. We might call it the "neurosis of the sterile egg." The artist in the field of auto-destructive art can, to some extent, escape this particular conflict. And if the artist doesn't want to give their work to a society as foul as ours, then auto-destructive art acts as a kind of boycott. The artist refuses to embody his or her finest values in permanent works—to be bought, enjoyed, and appropriated by the class that the artist detests and which is largely responsible for the catastrophe in which we exist.

It could be called a campaign, then. It's very political.

Very political, yes. Auto-destructive art is concerned with values of art but is conscious of the fact that, to save society, people must act beyond their professional disciplines—in fact, must use their professions to change society. To go on limiting oneself to achievement strictly within the rules of a profession laid down by a society that is on the point of collapse, is, to me, a betrayal. A thinker, scientist, artist, or architect who blithely accepts that which capitalism, science, technology, or society has to offer here and now, without the deepest probing and most ruthless criticism of the material and ideas that he or she is using, is guilty of burying the world.

"Burying the world" is such a poignant way of expressing what others might call a lack of attention—it's the eschewing of an ethics of care. I wonder if this relates, in your mind, to Sigmund Freud's psychoanalytical notion of the death drive?

Well, I believe that people want destruction to a large extent as self-expression, as a release of tensions, as a form of therapy. When people can afford to destroy, they destroy. Auto-destructive art offers to channel some of the aggressive drives in society into directions that promise release of tensions without the utter destructiveness of future wars. We want monuments to the power of man to destroy all life. Monuments to Hiroshima—where the material is squirming, writhing, where heat-bursts puncture the material. We are concerned with a Pharaonic vision. From within a society, from within its strongest center, at its most brutal point, this Pharaonic vision emerges, using all the resources of a society, its physical power, its technical peaks, its callousness toward human life (coupled with the most sensitive response to nature, both human and nonhuman)—to make monuments to itself. Like the huge public clocks in the Middle Ages: monuments that reveal, by elimination of matter, the amount of time left to us. I spent my childhood surrounded by the public kinetic art of the

> Middle Ages and Renaissance—the fountains, clocks, and automata of Nuremberg and Strasbourg. Like Pharaonic or Aztec art, we want art that serves an absolute vision. The obsessive involvement with death. These monuments, coming from the technical center, should stay alert to tension, keyed up as no other art when our societies enter their final phase. Not decoration. Not concern with ephemera, not attempts to please.

So they are mirrors held up to our most violent human actions, technologies, and secret desires.

> Auto-destructive art reenacts the obsession with destruction, certainly. I've said before that it mirrors the compulsive perfectionism of arms manufacturing—polishing to destruction point. Auto-destructive monuments contain brutality, the overextended power, and the nausea and unpredictability of our social systems. But there are other directions in our societies. There are forces that oppose war, and work for disarmament. Auto-destructive art contains the contradictions of our situation, it reflects all of that back. And in that way, it's an instrument for probing the consciousness of masses of people on issues of peace and war. The polluted fabric of auto-destructive art can be a screen where people project innumerable fantasies, and this kind of play can be of the greatest therapeutic value.

You've never mentioned the public clocks of the Middle Ages to me before, as an inspiration. Perhaps we can discuss the aspect of time in auto-destructive art more generally.

> Well, time is at the very center of the idea. Time, and a way of demonstrating it: demonstrating time, showing time, getting people involved with time. In that sense, it relates to music and dance, which are art forms I've been very involved in—not as a performer, of course, but as a spectator.

But what about changes in time—the change from one moment to another? After all, your monuments aren't static sculptures, but are continually in a state of transformation.

> Definitely. In disintegrating and growing art, time ceases to be unidirectional. At "one instant" *of* time, the work may be going in ten different directions *in* time. The anisotropy of time. The transformation of material is at the very center of this—material changing its form, shape, and meaning. You respond to each changing form, and to the

interaction between changing forms, in a particular manner. At least, you can respond if you are sensitive enough, if you are concerned enough. Because of the time in which such a sculpture decays—whether over days or weeks or years—there's the opportunity to react differently to the various transformative effects. This is at the center of my concern. This is the enlargement of the scope of art. And that includes time. Time is involved in everything.

Would it be fair to say that you make time monuments rather than space monuments?

Yes, that's the point. That's the beauty of it—that so many factors are integrated. It's also why I describe auto-destructive art as an extension of capacities. The problem is that people haven't understood this yet. They haven't gone deep enough into the potential that's opened up by auto-destructive art. That's why it's still not there.

This is a bit like unbuilt architecture—paper architecture.

Yes, but it's bigger than that, because unbuilt architecture is still architecture. With architecture, something can be designed from a very small model or a sketch—and that sketch might have been made during a lunch or coffee break. The tallest building in Western Europe, the so-called Shard, maybe began life as a sketch on a serviette, and now it's very big. But here, with auto-destructive art, we have something unbuilt that has never existed—that would never exist unless it were made along the lines I've proposed. It's a kind of tragedy. *Tragedy* is a term I use sometimes.

I want to remind you of a quote, "The artist works like the architect," from a 1965 lecture you gave at the Architectural Association on the idea of auto-destructive art.

I'm glad you brought that up. That was a very important lecture in which I attempted and, I think, succeeded, in summing up what auto-destructive art and auto-creative art are about, the essence of it all. After, the text of the lecture was printed and distributed by the students. There were two hundred copies, and when they had gone, I organized a second edition of one thousand copies. I spoke about the relationship to architecture and, among other things, how the architect gets a fee relative to the cost of the building. I suggest the artist should be treated in a similar way—given an income that is agreed on in principle by society. In one breath, I do away with the endless struggle of

the artist who never gets paid, or, if he does get paid, receives a pitiful sum. I think it's totally unfair to expect, as society does, the individual artist to sustain himself in daily life and to create something. This is no existence. If art is created in a vacuum, it usually stays in a vacuum, and so artists accumulate work and don't make enough money to survive. For me, art was, from the beginning, not just something I wanted to do, but something that had to be an ongoing social transaction to create a beautiful whole. I concerned myself with the overall, entire focus of an idea from conception to realization. And that's exactly why I didn't succeed—because nobody else thought like that. The people who give out commissions don't think like that.

This system would free the artist from commissioned works, from the "neurosis of the sterile egg" that you mentioned earlier.

Yes, because today we're in this predicament whereby artists are expected, endlessly, to create new works, often the same works done again and again in different guises so they remain salable. But artists need a challenge; they need to feel they are being stretched. And that's how auto-destructive art and auto-creative art came about, by my need to go beyond that which exists. And I can tell you, in my case, it was a physical need: my body ached to go further into the unknown. It wasn't just my mind. What I want is a total immersion in the capacity of the human to go beyond what exists. The artist needs to go into the unknown. It's an existential need.

And as you said before, that came directly also from a physical frustration. A need to break away from the canvas and board to something harder. Was there a distinct moment you felt you achieved that?

It was a process to reach that moment, but yes. The first public acid-on-nylon painting I did in the summer of 1960, I painted with strokes, with brushes. One year later, in the open air, I changed my approach and my technique. Instead of one painting, one screen, I had three screens. And I didn't paint, but sprayed the acid on. It's a completely different way of working and thinking, and it leads to the total obliteration of the artwork. You could see the work in progress, but in the end all you had were some strips left. The landscape behind the screen showed through and was incorporated. The work itself was never frozen in time, and it was never meant to be. That was very important to me.

Is this way of working similar to refusing a fetish? There's a strong parallel to what Adorno said about a permanent critique of the fetish

insofar as your works aren't an accumulation of static objects but the result of active processes.

> You could certainly say that it's a fetish in the making. In other words, as people watch it, I'm making a fetish—which is why I want to be careful not to respond in a simple manner. But certainly, once it's finished, you can't say there's a fetish there except in one's mind. It's done and over.

And, of course, process can also be a fetish. Was this a breaking away, for you, from your previous work entirely?

> Visually, it's not too far from Bomberg. When you look at photographs of that first acid nylon painting, you might think that I was painting in his style. But this is a work that goes way beyond Bomberg, who never conceived of it and perhaps wouldn't have wanted it. In Roy Oxlade's dissertation, there's a section where he refers to my activities at the end of the Borough Bottega and says, "this destructiveness of Metzger is a signal that came out later. When Metzger did this auto-destructive art, he revealed his destructivity." I know that Bomberg's wife regarded my new work as unacceptable, and it's possible that Bomberg might have felt the same way. He died in 1957, two years before I became involved in this. I had to go beyond; it's a rejection of my studies, my education with Bomberg. This is the point: young artists have to go beyond their masters. It's a statement that Bomberg made repeatedly and in different ways himself.

Since the 1950s, your work has always been firmly rooted in the realm of participation. Could you tell me more about this aspect of your work?

> The idea at the center of these auto-destructive monuments is to provide people with another vision, to offer them something they haven't already got—something significant on the aesthetic level, but also on the political plane. This is already a plus. If you see something novel, well, it must be good, I suggest. They see something challenging, so it challenges their perception of daily reality, which is good. It offers them a visual experience they can't get anywhere else. All this is free, because we're dealing here with public sculptures. To respond, to interact—yes, auto-destructive art is concerned with giving that to people, with getting them absorbed in something unusual, and, of course, changing their political views. The last point applies to my work you showed in Paris, doesn't it?

You mean *Life/Live*, which I co-curated with Laurence Bossé?

Yes. For that, I confronted present-day Israel and the Nazi Austria of the past. Of course, some people understand the connections and others don't. My challenge is to make people see connections, to see the differences, and to interact and hopefully transform their being through confronting these very difficult works. That part of my practice began with the earliest auto-destructive art manifestos and continues today.

In your lecture at the AA, I believe you laid out plans for three auto-destructive monuments, as examples for the architecture students. Can you describe the specifics of these?

Yes. Here, let me read what I wrote then. I have it here—so that you can get a sense of the detail of the plans: "The first construction is to be about 18 feet high with a base about 24 feet by 18 feet … It consists of mild steel 1/8th inch thick. The structure consists of three slabs. These highly polished forms exposed to an industrial atmosphere will start to corrode. The process continues until the structure gets weakened by the loss of material. In about ten years' time most of the construction will have disintegrated. The remaining girders will then be removed and the site cleared. This is a fairly simple form of auto-destructive art … [The next] sculpture consists of five walls or screens, each about 30 feet in height and 40 feet long and 2 feet deep. They are arranged about 25 feet apart and staggered in plan. I envisage these in a central area between a group of three very large densely populated blocks of flats in a country setting." To continue: "Each wall is composed of 10,000 uniform elements. These could be made of stainless steel, glass, or plastics. The elements in one of the walls could be square or rectangular and in another wall they could all be hexagonal. The principle of the action of this work is that each element is ejected until finally after a period of ten years the walls cease to exist."

Manually ejected by physical pressure over time by decay, or by a separate mechanism?

I was beginning to be very interested in computer technology in those days—and these were truly the early days of computer development. So I proposed the use of a digital computer that could control the movement of this work. This would be housed underground in the center of the sculpture complex—remember how big computers were at that time. The third project I planned—a 30-foot cube—also included new technological advances. Here is how I described it: "The shell of the cube is in steel with a non-reflective surface. The interior of the cube is completely packed with complex, rather expensive electronic equipment.

> This equipment is programmed to undergo a series of breakdowns and self-devouring activities. This goes on for a number of years—but there is no visible trace of this activity. It is only when the entire interior has been wrecked that the steel shell is pierced from within. Gradually, layer after layer of the steel structure is disintegrated by complex electrical, chemical, and mechanical forces. The shell bursts open in different parts revealing the wreckage of the internal structure through the ever-changing forms of the cube. Finally, all that remains is a pile of rubble. This sculpture should be at a site around which there is considerable traffic."

Very few people would have encountered computers in their daily lives.

> You could say it was a prediction of how those technologies would go on to be eventually deployed. How they would develop and how they would proliferate. Auto-destructive art demonstrates man's power to accelerate disintegrative processes of nature and to order them. At that moment, I connected this to the immense productive capacity, the chaos, of capitalism and of Soviet communism, the coexistence of surplus and starvation, the stockpiling of nuclear weapons, the disintegrative effect of machinery and of life in vast built-up areas, on the person. And it's important to keep in mind that it wasn't an interest in ruins, or the picturesque, but reenacting quite publicly the obsession with destruction, the pummeling to which individuals and masses are subjected—and to which I knew they would continue to be subjected.

Auto-destructive art has had an immense impact, even though these monuments remained unrealized. Its influence was felt not just in the art world, but also the world of music and popular culture. It's an interesting bridge, another way of making this project public. Pete Townshend of The Who, who heard you lecture at Ealing Art College, was inspired by you to destroy his guitar onstage during a performance as an act of confrontation and destruction.

> Yes, but of course there's the biggest bridge of all—my meeting of . . . of . . . I'm forgetting, for some reason—at the Indica Gallery. You know who I'm talking about.

Yoko Ono and John Lennon?

> Yes, exactly, in London in 1966. I invited Yoko—having never met her—to be a part of the Destruction in Art Symposium, and that created a big bridge to the world of popular culture.

How did you find out about Yoko?

> One of the committee members of the Destruction in Art Symposium, Mario Amaya—a young American—told me about Yoko. He wasn't rich, but I think he had some funds, more than most of us. He must have, I guess, inherited some money. And so he decided to start an art magazine, which, as we all know, is a way to lose money, and he lost money. It only lasted about one year, that magazine, which was called *Art and Artists*. Anyway, he created a special edition of the magazine entitled "Auto Destructive," which featured Yoko. So I invited Yoko on his advice—and I remember that she came very late for her own lecture at the symposium, but ran straight in and sat down on stage and just began to speak. It was fantastic.

I remember you and Yoko spoke about this when you saw each other recently. What did she lecture about?

> She spoke about Kinkakuji, the Golden Pavilion in Japan, which was burned and rebuilt multiple times and lives on as an important idea in the Japanese national imaginary. Yoko took this up to explain that you can destroy physical material, but a concept can never truly be destroyed. She told me last time I saw her that she was really amazed and a little nervous entering the room to lecture, because so many avant-garde artists she admired were there to hear her speak.

She performed a piece as well, right?

> Yes, she staged many actions that month and they were all sold out. People would ring up to ask if they could come and I'd have to tell them, "No, there's no room." One night she staged her *Whisper Piece*, where the audience sent a word around the room from person to person. The next night she did *Shadow Piece*, where someone stood on a cloth and Yoko rolled it up to keep the person's shadow. But the one that made the greatest impact was her *Cut Piece*. There's a very nice photograph of her performing that important work. She sat on the stage after suggesting that the audience could come up and cut her clothes off her. And people did, people came up to her and used scissors. I was very tense while this was being performed. I sat in the front row with John Sharkey, who I had also put on alert in case we needed to jump up and take the scissors away from someone. But nothing went wrong at all and the performance was out of this world—everyone was talking about it—because it was very personal, very intimate, which set it apart from many of the other actions that month. I wanted more

female artists present—that was very important to me—but raising the funds was difficult.

You often advocated for more women artists to be included in shows—you've told me that was very important to you. You invited Carolee Schneemann to DIAS, for example.

I did. I invited her and many other female artists. Carolee couldn't find the money to attend, unfortunately.

DIAS was a very important event that reverberated throughout London, but also in the Viennese Actionist scene and many others.

Yes, it arose from the realization that there were so many artists in the world who destroyed things at some point, quite independently of auto-destructive art. The artists weren't working with auto-destructive art. That's quite clear. But the vast majority were using elements of it, physically damaging their work and opening it up.

As in Lucio Fontana's work, in which the canvas is often perforated or slashed?

Fontana, indeed. At least I certainly thought so, until I spoke to him in person once. "Surely there's a destructive element in your work," I said. He repeatedly said to me, "No, I reject this interpretation completely. It's only a constructive process where I liberate space behind the cut. In and behind the cut there is space, which I liberate." Of course, I have to accept this explanation, but I still feel that Fontana is on the edge of destruction. And there's Raphael Montañez Ortiz, who tears furniture, pianos, etc. and who participated in the Destruction in Art Symposium.

What about Alberto Burri? I'm thinking in particular of his Land art piece, *Il Grande Cretto*, which covered the ruins of the Sicilian town of Gibellina that was devastated by an earthquake in 1968. It didn't follow all the stipulations of auto-destructive art, but it was certainly a monument to destruction.

I can't comment on that particular piece, but Burri is certainly close to Fontana. There's a close connection, insofar as they make something that stays, is fixed, and becomes a work of art. And there's John Latham and Bernard Aubertin with their book burnings. You can go on and on and on. The idea in August 1966 was to bring all of this together for one symposium.

You've told me several times about the importance of the exhibition *Breaking the Rules: The Printed Face of the European Avant Garde 1900–1937* at the British Library, which collected the printed materials of the various European avant-gardes from that time. Can you tell me about that exhibition?

> Agitation is a central question we're both very concerned about. As a very young student, I eagerly sought out any avant-garde movement and studied it. That must have influenced my later development, when it came to the point when I began to write manifestos. But this exhibition you mentioned at the British Library was particularly unbelievable. You arrived and went downstairs, where it was necessarily relatively dark to protect the exhibits. Some of them were very fragile and extremely precious and unique documents. So you went down into a cave, a wonderland, where you almost had to feel your way with your hands to get through. Everywhere, to your left and right, and in front of you, there were cabinets with documents—I think more than four hundred documents in total. In addition, there were films from the 1920s and 1930s. It must have been the work of years for the people who developed the exhibition, especially the director of this department.

And what you saw was a collective commitment to agitation?

> Agitation across the board. These documents agitate; they are offensive; they deal with energy and struggle—with ideology. I think this is the word that's essentially lacking in the art world today. I believe that, without ideology, without a conglomeration of ideas, of concepts, the art of the last one hundred years could not have happened. But where is ideology nowadays? Where do you find artists publishing manifestos that might get into the British Library? I'm searching, and I can hardly find them. The conglomeration of ideas in this room, in this exhibition, was extremely affecting and stimulating. I'm sure other visitors felt the same way.

Can paintings and drawings still effect change—or even trigger a state crisis like the one sparked by Théodore Géricault's *Raft of the Medusa* in the nineteenth century, for example?

> This is precisely why I moved away from painting—from Bomberg, if you like—toward auto-destructive art. This is the crisis I've lived through. All those years of my being a student, starting in January 1945, I asked myself how art can contribute to saving society, to changing society. This is what I asked myself every day, more or less, all those

years. And auto-destructive art was the liberating ideal for me. The tragedy is that society didn't recognize this potential. Or, to put it another way, society is clever enough to see the potential and to stop it, because that's how it operates: society is a self-protecting organism. As soon as it, in a broad sense, wants you to stop, they kill or imprison you—they send you to a madhouse or make you ill, or they ignore you. Nobody killed or imprisoned me, although they could have done so, but they certainly ignored me. I'm not blaming everything on the outside, I have my own failures. As I've told you before, I didn't send works to curators and museum directors, like Pontus Hultén, when they asked me. I didn't take advantage of many opportunities. So there's a self-destructive trend in me, too, inside my own person. I accept that and have to live with it.

What do you see as the most obvious art historical precedent for auto-destructive art?

Auto-destructive art is an attempt to deal rationally with a society that appears to be lunatic—and that idea has its roots in the Dada movement, in Russian revolutionary art from 1910 to 1920, and in a direction that is best represented by Moholy-Nagy.

If you look at the literature of some of the major art movements of the twentieth century, the theme of destruction runs through them: Cubism, Futurism, Dadaism.

Oh absolutely, these movements contained explosive, destructive force and the artists wanted to destroy or bend entire social systems. Even Mondrian, who might appear aloof from such issues, said that the importance of destruction in art is underestimated. In 1919, or 1920, Picabia presented a large drawing on a blackboard. Each section was wiped off before starting the next. I see this as an early form of auto-destructive art. For the Dadaists, the aim was to subvert a system that was butchering millions. Yes, their aim was destructive—but destructive of what? Of societies behaving as barbarously as any have behaved in history. The Dadaists in Zurich during the war were prophets and martyrs. And if there's one regret, it's that they didn't destroy enough.

Might you say that auto-destructive art is also an evolution of kinetic art?

It's an evolution and solution—the rigidity and limitations of kinetic art are resolved by the introduction of ideas of destruction, creation,

and transformation. Auto-destructive art and auto-creative art allow for the incorporation of biological time and rhythms. Works are possible that have the characteristics of dance, of trees, of plants, and of living animals. In this sense, they are an advanced form of kinetic art. When a material grows and decays, a tremendous increase in the form of potential is possible. The time factors are also greatly enlarged. Metamorphosis, destruction, and creation are the central features. Instead of painting a scientific view of the universe in ceaseless flux, the artist presents the phenomena that are undergoing constant physical change, and is obliged to use advanced technologies to do this. At the core is the knowledge that a rapidly changing and deteriorating social situation screams out for radical, unprecedented forms of art.

You've described this to me before as producing the aesthetic of revulsion. Can you explain this link?

In auto-destructive art, the artist makes use of revulsion to achieve a form of catharsis in the spectator. So I see them as directly linked. Of the European artists, the most profound practitioner of the aesthetic of revulsion is Grünewald—who had a revival, not surprisingly, after the Second World War. Or in Christian art, the spectator is repelled by the wounds of Christ, but is expected to overcome the impulse to withdraw in favor of an integrative and ultimately accepting response. There's also an important link with theater and the experience of catharsis or the Theater of Cruelty. As well as some work by Picasso—especially the Franco themes, *Guernica*, and the female portraits of the early 1940s, which could be added to this category.

Do you think that these ideas are just as important today as they were when you first articulated them?

Yes. They have stood the test of time very well. The main concern for our present day is the destruction of the world. That, of course, also ties in with auto-destructive art. At different times in my life I have felt the duty to speak out. One, of course, was with nuclear disarmament—which led to my active participation in anti-nuclear demonstrations and in the formulation of ideas in the Committee of 100. These were obsessions. But always, over the past ten years, it has been this theme of the destruction of nature, which, I'm sure you will agree, is becoming the real issue for the world. So auto-destructive art is connected, it won't go away. It's about art changing the world, and me, as an individual artist, facing up to the challenge. I believe that, through auto-destructive art, I've succeeded at least in formulating an idea and an ideal

through which this can come about. In that sense, I'm reasonably content—looking back, and also looking forward to my future works—that I'm on the right track.

Does this mean that auto-destructive art is only just beginning?

Yes, in a sense. And hopefully, somebody who is out there, listening, waiting, may respond to this cry of mine. It's always possible.

Metzger preparing for his *100,000 Newspapers* "public-active installation" at T1+2 Artspace, London, 2003

Metzger carrying the garbage bag that was featured in his Lecture/Demonstration at Temple Gallery, London, June 1960

Bearded man trips over a box and finds a new form of art

"Cardboarder" Gustav Metzger yesterday—and some of his works

IT'S PICTURES FROM PACKING CASES

By JOHN RYDON

A LONDON artist, who considers old cardboard boxes have qualities equal to the greatest in modern painting, is showing his first exhibition of "machine-made art."

He is bearded, 33-year-old Gustav Metzger, German-born abstract artist, who discovered his new "art" when he fell over a packing-case for a TV set in a shop doorway three months ago.

Mr. Metzger told me last night : "I took the packing case to pieces and thought of using them as decorations for my room.

"These carboards are nature unadulterated by commercial considerations or the demands of the contemporary drawing-room."

I stumbled down a precipitous staircase into basement premises in Monmouth-street, Holborn, where a whole wall was taken up with the Metzger "work." Geometrical slabs of cardboard packaging, some with holes in them, hung from nails.

Went on Mr. Metzger : "I don't want to sell any of these ; (a) because I like them so much I want to keep them ; and (b) since there must be a large supply of similar material lying around I don't want to prevent other people getting it free too.

"I'm thinking of making a big collection of these cardboards with the aim of having a really BIG show. I've never seen anything quite like it."

I said I hadn't either.

Mr. Metzger continued : "I should like to have the chance of turning these into architectural decorations. You move them in any way you like.

"There is an inherent harmony and artistic quality all of them."

Then the ex-joiner who h studied at art schools in Brita and the Continent ask whether I was interested hearing his theory of "aut destructive art."

I said I had heard enough.

Article from the *Daily Express*, 1959

Gustav Metzger, *Cardboards*, 1959. Found cardboards, selected and arranged by the artist

Bertrand Russell speaking in Trafalgar Square, London, presenting the aims and principles of the anti-nuclear war organization the Committee of 100, October 29, 1961

Front page of the *Lynn News & Advertiser*, 1958

AUTO DESTRUCTIVE ART

Auto-destructive art is primarily a form of public art for industrial societies.

Self-destructive painting, sculpture and construction is a total unity of idea, site, form, colour, method and timing of the disintegrative process.

Auto-destructive art can be created with natural forces, traditional art techniques and technological techniques.

The amplified sound of the auto-destructive process can be an element of the total conception.

The artist may collaborate with scientists, engineers.

Self-destructive art can be machine produced and factory assembled.

Auto-destructive paintings, sculptures and constructions have a life time varying from a few moments to twenty years. When the disintegrative process is complete the work is to be removed from the site and scrapped.

London, 4th November, 1959 G. METZGER

MANIFESTO AUTO-DESTRUCTIVE ART

Man in Regent Street is auto-destructive.
Rockets, nuclear weapons, are auto-destructive.
Auto-destructive art.
The drop drop dropping of HH bombs.
Not interested in ruins, (the picturesque)
Auto-destructive art re-enacts the obsession with destruction, the pummelling to which individuals and masses are subjected.
Auto-destructive art demonstrates man's power to accelerate disintegrative processes of nature and to order them.
Auto-destructive art mirrors the compulsive perfectionism of arms manufacture - polishing to destruction point.
Auto-destructive art is the transformation of technology into public art. The immense productive capacity, the chaos of capitalism and of Soviet communism, the co-existence of surplus and starvation; the increasing stock-piling of nuclear weapons - more than enough to destroy technological societies; the disintegrative effect of machinery and of life in vast built-up areas on the person,...

Auto-destructive art is art which contains within itself an agent which automatically leads to its destruction within a period of time not to exceed twenty years.
Other forms of auto-destructive art involve manual manipulation. There are forms of auto-destructive art where the artist has a tight control over the nature and timing of the disintegrative process, and there are other forms where the artists control is slight.
Materials and techniques used in creating auto-destructive art include: Acid, Adhesives, Ballistics, Canvas, Casting, Clay, Combustion, Compression, Concrete, Corrosion, Cybernetics, Drop, Elasticity, Electricity, Electrolysis, Electronics, Explosives, Feed-back, Glass, Heat, Human Energy, Ice, Jet, Light, Load, Mass-production, Metal, Motion, Motion Picture, Natural Forces, Nuclear energy, Paint, Paper, Photography, Plaster, Plastics, Pressure, Radiation, Sand, Solar energy, Sound, Steam, Stress, Terra-cotta, Vibration, Water, Welding, Wire, Wood.

London, 10th March, 1960 G. METZGER

Gustav Metzger, "Auto-Destructive Art," 1959, and "Manifesto Auto-Destructive Art," 1960

ACT OR PERISH

A call to non-violent action by Earl Russell and Rev. Michael Scott

We are appealing for support for a movement of non-violent resistance to nuclear war and weapons of mass extermination. Our appeal is made from a common consciousness of the appalling peril to which Governments of East and West are exposing the human race.

DISASTER ALMOST CERTAIN

Every day, and at every moment of every day, a trivial accident, a failure to distinguish a meteor from a bomber, a fit of temporary insanity in one single man, may cause a nuclear world war, which, in all likelihood, will put an end to man and to all higher forms of animal life. The populations of the Eastern and Western blocs are, in the great majority, unaware of the magnitude of the peril. Almost all experts who have studied the situation without being in the employment of some Government have come to the conclusion that, if present policies continue, disaster is almost certain within a fairly short time.

PUBLIC MISLED

It is difficult to make the facts known to ordinary men and women, because Governments do not wish them known and powerful forces are opposed to dissemination of knowledge which might cause dissatisfaction with Government policies. Although it is possible to ascertain the probabilities by patient and careful study, statements entirely destitute of scientific validity are put out authoritatively with a view to misleading those who have not time for careful study. What is officially said about civil defence, both here and in America, is grossly misleading. The danger from fall-out is much greater than the Authorities wish the population to believe. Above all, the imminence of all-out nuclear war is ignorantly, or mendaciously, under-estimated both in the statements of politicians and in the vast majority of newspapers. It is difficult to resist the conclusion that most of the makers of opinion consider it more important to secure defeat of the " enemy " than to safeguard the continued existence of our species. The fact that the defeat of the " enemy " must involve our own defeat, is carefully kept from the consciousness of those who give only a fleeting and occasional attention to political matters.

ACTION IMPERATIVE

Much has already been accomplished towards creating a public opinion opposed to nuclear weapons, but not enough, so far, to influence Governments. The threatening disaster is so enormous that we feel compelled to take every action that is possible with a view to awakening our compatriots, and ultimately all mankind, to the need of urgent and drastic changes of policy. We should wish every parent of young children, and every person capable of feelings of mercy, to feel it the most important part of their duty to secure for those who are still young a normal span of life, and to understand that Governments, at present, are making this very unlikely. To us, the vast scheme of mass murder which is being hatched—nominally for our protection, but in fact for universal extermination—is a horror and an abomination. What we can do to prevent this horror, we feel to be a profound and imperative duty which must remain paramount while the danger persists.

CONSTITUTIONAL ACTION NOT ENOUGH

We are told to wait for the beneficent activities of Congresses, Committees, and Summit meetings. Bitter experience has persuaded us that to follow such advice would be utterly futile while the Great Powers remain stubbornly determined to prevent agreement. Against the major forces that normally determine opinion, it is difficult to achieve more than a limited success by ordinary constitutional methods. We are told that in a democracy only lawful methods of persuasion should be used. Unfortunately, the opposition to sanity and mercy on the part of those who have power is such as to make persuasion by ordinary methods difficult and slow, with the result that, if such methods alone are employed, we shall probably all be dead before our purpose can be achieved. Respect for law is important and only a very profound conviction can justify actions which flout the law. It is generally admitted that, in the past, many such actions have been justified. Christian Martyrs broke the law, and there can be no doubt that majority opinion at the time condemned them for doing so. We, in our day, are asked to acquiesce, passively if not actively, in policies clearly leading to tyrannical brutalities compared with which all former horrors sink into insignificance. We cannot do this any more than Christian Martyrs could acquiesce in worship of the Emperor. Their steadfastness in the end achieved victory. It is for us to show equal steadfastness and willingness to suffer hardship and thereby to persuade the world that our cause is worthy of such devotion.

TOWARDS WORLD PEACE

We hope, and we believe, that those who feel as we do and those who may come to share our belief can form a body of such irresistible persuasive force that the present madness of East and West may give way to a new hope, a new realisation of the common destinies of the human family and a determination that men shall no longer seek elaborate and devilish ways of injuring each other but shall, instead, unite in permitting happiness and co-operation. Our immediate purpose, in so far as it is political, is only to persuade Britain to abandon reliance upon the illusory protection of nuclear weapons. But, if this can be achieved, a wider horizon will open before our eyes. We shall become aware of the immense possibilities of nature when harnessed by the creative intelligence of man to the purposes and arts of peace. We shall continue, while life permits, to pursue the goal of world peace and universal human fellowship. We appeal, as human beings to human beings: remember your humanity, and forget the rest. If you can do so, the way lies open to a new Paradise; if you cannot, nothing lies before you but universal death.

Published by the Committee of 100, 13 Goodwin Street, London, N.4. Telephone : ARChway 1239.
Printed by Goodwin Press Ltd. (T.U.), 135 Fonthill Road, Finsbury Park, N.4

P.T.O.

Spread from an early 1960s Committee of 100 publication featuring the pamphlet *Act or Perish*, with graphic design by Metzger

Metzger practicing for a public demonstration of auto-destructive art using acid on nylon, King's Lynn, 1960

David Bomberg, *Sappers at Work: A Canadian Tunnelling Company, Hill 60, St Eloi*, 1918

David Bomberg, *Vision of Ezekiel*, 1912

Gustav Metzger, first Lecture/Demonstration of auto-destructive art, Temple Gallery, London, June 22, 1960

AUTO-DESTRUCTIVE ART

Demonstration by G. Metzger

SOUTH BANK LONDON 3 JULY 1961 11.45 a.m.—12.15 p.m.

Acid action painting. Height 7 ft. Length 12½ ft. Depth 6 ft. Materials: nylon, hydrochloric acid, metal. Technique. 3 nylon canvases coloured white black red are arranged behind each other, in this order. Acid is painted, flung and sprayed on to the nylon which corrodes at point of contact within 15 seconds.

Construction with glass. Height 13 ft. Width 9½ ft. Materials. Glass, metal, adhesive tape. Technique. The glass sheets suspended by adhesive tape fall on to the concrete ground in a pre-arranged sequence.

AUTO-DESTRUCTIVE ART

Auto-destructive art is primarily a form of public art for industrial societies.

Self-destructive painting, sculpture and construction is a total unity of idea, site, form, colour, method and timing of the disintegrative process.

Auto-destructive art can be created with natural forces, traditional art techniques and technological techniques.

The amplified sound of the auto-destructive process can be an element of the total conception.

The artist may collaborate with scientists, engineers.

Self-destructive art can be machine produced and factory assembled.

Auto-destructive paintings, sculptures and constructions have a life time varying from a few moments to twenty years. When the disintegrative process is complete the work is to be removed from the site and scrapped.

London, 4th November, 1959 G. METZGER

MANIFESTO AUTO-DESTRUCTIVE ART

Man in Regent Street is auto-destructive.
Rockets, nuclear weapons, are auto-destructive.
Auto-destructive art.
The drop drop dropping of HH bombs.
Not interested in ruins, (the picturesque)
Auto-destructive art re-enacts the obsession with destruction, the pummelling to which individuals and masses are subjected.
Auto-destructive art demonstrates man's power to accelerate disintegrative processes of nature and to order them.
Auto-destructive art mirrors the compulsive perfectionism of arms manufacture—polishing to destruction point.
Auto-destructive art is the transformation of technology into public art. The immense productive capacity, the chaos of capitalism and of Soviet communism, the co-existence of surplus and starvation; the increasing stock-piling of nuclear weapons—more than enough to destroy technological societies; the disintegrative effect of machinery and of life in vast built-up areas on the person,....

Auto-destructive art is art which contains within itself an agent which automatically leads to its destruction within a period of time not to exceed twenty years. Other forms of auto-destructive art involve manual manipulation. There are forms of auto-destructive art where the artist has a tight control over the nature and timing of the disintegrative process, and there are other forms where the artist's control is slight.
Materials and techniques used in creating auto-destructive art include: Acid, Adhesives, Ballistics, Canvas, Clay, Combustion, Compression, Concrete, Corrosion, Cybernetics, Drop, Elasticity, Electricity, Electrolysis, Electronics, Explosives, Feed-back, Glass, Heat, Human Energy, Ice, Jet, Light, Load, Mass-production, Metal, Motion Picture, Natural Forces, Nuclear energy, Paint, Paper, Photography, Plaster, Plastics, Pressure, Radiation, Sand, Solar energy, Sound, Steam, Stress, Terra-cotta, Vibration, Water, Welding, Wire, Wood.

London, 10 March, 1960 G. METZGER

AUTO-DESTRUCTIVE ART MACHINE ART
AUTO CREATIVE ART

Each visible fact absolutely expresses its reality.

Certain machine produced forms are the most perfect forms of our period.

In the evenings some of the finest works of art produced now are dumped on the streets of Soho.

Auto creative art is art of change, growth movement.

Auto-destructive art and auto creative art aim at the integration of art with the advances of science and technology. The immidiate objective is the creation, with the aid of computers, of works of art whose movements are programmed and include "self-regulation". The spectator, by means of electronic devices can have a direct bearing on the action of these works.

Auto-destructive art is an attack on capitalist values and the drive to nuclear annihilation.

23 June 1961 G. METZGER

B.C.M. ZZZO London W.C.1.

Printed by St. Martins' Printers (TU) 86d, Lillie Road, London, S.W.6.

Handout accompanying Metzger's public demonstration of auto-destructive art, South Bank, London, July 3, 1961

Metzger's public demonstration of auto-destructive art, South Bank, London, July 3, 1961

Page of notes for Metzger's first Lecture/Demonstration of auto-destructive art at the Temple Gallery, London, June 22, 1960, as used for the cover of Gustav Metzger, *Auto-Destructive Art: Metzger at AA*, 1965/2015, first published on the occasion of his lecture "Auto-Destructive Art" at the Architectural Association School of Architecture

Cover of Mario Amaya's magazine *Art and Artists* 1, no. 5, special issue, "Auto Destructive," August 1966, featuring Metzger alongside Alberto Burri, Lucio Fontana, Yoko Ono, Jean Tinguely, and others

84

Poster for the Destruction in Art Symposium, Africa Centre, London, designed by John Sharkey, 1966

Group photograph of participants in the Destruction in Art Symposium, London Free School playground, Notting Hill, London, 1966

John Sharkey and Yoko Ono at the Destruction in Art Symposium, Africa Centre, London, 1966

Otto Mühl at the Destruction in Art Symposium, Africa Centre, London, 1966

Metzger, Wolf Vostell, and Al Hansen at the Destruction in Art Symposium, Africa Centre, London, 1966

View of the Destruction in Art Symposium, Africa Centre, London, 1966

Speakers at the Destruction in Art Symposium, Africa Centre, London, 1966. From left: Gustav Metzger, Wolf Vostell, Al Hansen, and Juan Hidalgo

Yoko Ono reading at the Destruction in Art Symposium, London, 1966

88

Yoko Ono, *Cut Piece*, 1964. Performance view, Destruction in Art Symposium, Africa Centre, London, 1966

3

Extremes Touch

In 1963, British prime minister Harold Wilson described scientific advances and discoveries as "the white heat of technology." At that point, you had only recently begun working on auto-destructive art, which of course takes a serious interest in how the artist can employ cutting-edge technology—while also picking up on the potential of technology's brutal violence, related to the atomic bomb and Nazism.

> You're hitting on a very central point. There was a time when I was totally fascinated by technology—and science is, of course, a necessary, inevitable part of technology. I was interested at an early stage in computer art, and, as you know, I even edited a magazine, *Page*, the bulletin of the Computer Arts Society, from 1969 to 1972. I was also absolutely fascinated by and involved in developments to do with art and technology and science as they related to auto-destructive art. On the one hand, auto-destructive art is a rejection of the way things are, but it's also dependent on the way things are.

As you once put it, "we must use science to destroy science." You have a very complex mixture of fascination and aversion to science. You have personally resisted innovations like the telephone and computer.

> That's precisely the complex relationship we're talking about—using science to destroy science. For me, that was at the heart of auto-destructive art as a political movement as well as a cultural one. And personally, yes, I am resistant. I have never had a telephone. I rely on the postal mail. This is connected to my rejection of the system of capitalism. I don't own the instruments that keep the system going. I've rejected them, I don't want them; they are not important, we can survive without them. In fact, I believe we would survive far better. It's lunatic the way people behave, the way they interact and the machinery that's in use. It's beyond lunacy.

How do you see the current moment we're living in?

> It's horrific. We're now in the middle of this desperate state, and people are in a dream world, especially the young people who are sort of "in" with things. The age of study is over; they never have to study. They assume life is life as it is, but that's not the case. Of course, it's impermanent—it's just a passing phase—which makes life very interesting. But even knowing it will pass, I still react with horror. It's what I feel at the moment, especially regarding the youngest people—the way they move, the way they interact or don't interact. The mobile telephone is the most destructive element.

Do you ever use computers—not personally, but in your work? You've described unrealized projects that incorporate computers briefly before.

> I did when I was part of the Computer Arts Society at the Royal College of Art in London, but I didn't actually use the computer physically myself. Rather, I worked with a technician who made computer drawings for me, which I then exhibited. You have to remember, this was in 1969, when a technician was still needed to use a computer effectively.

So there are computer drawings—do you know where those are?

> Somebody will have some samples. I don't.

Can you describe them?

> They were made specifically in connection with the big project *Five Screens with Computer*. There were drawings of ejections, and the *Cybernetic Serendipity* catalogue has one of my drawings showing ejections from the screen. Some of them are illustrated by Beverly Rowe, I think, so it's possible to trace that.

Yesterday I was in Zurich and we had a conference and interview with Elaine Sturtevant. Do you know her?

> Yes, I've met her.

She spoke about cybernetics, and she noted how her practice is related to cybernetic circularity. Some years ago I also interviewed Heinz von Foerster, the Austrian pioneer of the field of cybernetics, and he told me that we must remember science and art are inextricably linked. We haven't spoken much about cybernetics in relation to your work. How would you define cybernetics now?

> Quite frankly, although I was very involved with the term in the 1960s and 1970s, I haven't come back to it recently.

Although you did work recently with Bruce Gilchrist and Jo Joelson on a related project, *Null Object*, where they recorded your brainwaves via EEG and translated that recording into instructions for a manufacturing robot. The robot, in turn, created a sculpture meant to represent your thoughts—making visible a process that's already there, concretizing the most basic human function. How did this come about?

> I had known Bruce and Jo previously, for quite some time, and they had been working on revisiting *Event One* via the Computer Arts Society, where I first made those computer drawings.

So they were inspired by your work in the late 1960s, and saw this as a way to connect with those same ideas, but using contemporary technology?

> Exactly. The EEG files were fed to a robot, which carved out corresponding shapes from the interior of a block of stone, which created a void space. In a sense, a three-dimensional computer drawing.

And how did you participate, did you make a drawing while the EEG measured your brainwaves or was it during conversations that were going on?

> I just sat there.

You sat there and your brainwaves were recorded?

> In their house. In their kitchen. Because the idea was that I would try to think about nothing. It was a struggle around trying to empty the mind, and all the while the software recorded this complex shape—so there was an inverse relationship between becoming empty and becoming complex.

Is there a link to Zen Buddhism?

> Oh, there must be. Any attempt to clear the mind has directly to do with Buddhism, but also so much else. Christianity, too. All religions are involved in clearing the mind.

And ultimately Bruce and Jo set up the project, but then were kind of hands-off. So it's almost like autogenesis, auto-poesis ... perhaps even auto-creative art, to some extent.

> Yes, you could say that. They were very inspired, I know, by the *Laboratorium* show you did with Barbara Vanderlinden in Antwerp.

Yes, and the interview I did with Francisco Varela, who spoke about initiating a "science of consciousness" to bridge Western tradition and Tibetan Buddhism, which were both his fields.

> Yes, and Bruce spoke to me about this—particularly about Varela's idea of the body and mind as a "portable laboratory" where experiments unfold.

Could you tell me about the genesis of your own laboratory work—I'm thinking of the 1968 laboratory exhibition at the University of Swansea?

> Ah, yes. Well, as you know, there was a major conference—the Dialectics of Liberation—in July 1967 at the Roundhouse in London. It took place at the same time that John Sharkey and I were on trial in connection with the Hermann Nitsch performance at the Destruction in Art Symposium the year before.

You were convicted, in the end, for your role in putting on that event.

> Yes, even though we were simply its organizers—we even had artists sign waivers saying we couldn't be held responsible for their work or any injuries beforehand. But two people, people from the press, who were at Hermann's performance, called the police while it was happening and a few officers arrived toward the end. John and I were then accused of presenting an "indecent exhibition contrary to common law" and tried over three days at the Old Bailey for this. The real issue was that a number of photographs had been taken during the performance, which captured a very specific sense of it—moments that were very out of context. And we were tried and convicted—only lightly, luckily, as there was a maximum sentence of six years in prison.

Was there any fallout from the conviction, aside from the fifty pound fine?

> We were lucky that it was such a light sentence and that it didn't affect us terribly. Although it did change a personal connection I had, with Lord Goodman.

Lord Arnold Goodman, you mean, who was very influential in England in the 1950s and 1960s—particularly in his role as chairman of the Arts Council of Great Britain? I didn't realize you had a relationship with him.

> Yes, I did. Our contact started much earlier, through a solicitor's office, an established firm run by Mr. Ernest Royalton Kisch. Arnold Goodman was a young man at the time—this was during the war, or just after—and he acted as one of Royalton Kisch's assistants. My brother and I had been recommended for a grant by Bomberg and, in the course of

getting that grant, we were introduced to the solicitor's office. Royalton Kisch and Goodman were in charge of administering the grant for the next two years. A dinner was arranged where Goodman showed Jacob Epstein the drawings that I had been making in Antwerp at that point, and Epstein was very supportive in getting another grant. Apparently he liked the drawings very much. Now, talking of Goodman, the very interesting thing is that, at that meeting, he was introduced to people in the music sphere, the music business. Within a short period of time, Goodman became very active as an agent for people in music. To some extent, this was a turning point in his career, taking these drawings, making contact with one of the great British artists.

Putting young artists in touch with Jacob Epstein?

He got in touch with musicians and built up connections as an adviser, a solicitor for people in music. From there, he went into other arts, and so for him this meeting with Epstein was a kind of introduction to the world of art, which he specialized in for the rest of his life.

And Lord Goodman became a long-term supporter of yours?

Yes, that's a fact. In the 1970s I had difficulties in managing my life, and he offered to give me a personal grant for several years, which was very important for me in terms of survival. On and off I would visit him to ask his advice—what I should do next, or whether I should take a lease on some rooms. But to return to the problem with Hermann Nitsch, where the police came and we were arrested—while this was going on, I went to see Lord Goodman, who was chairman of the Arts Council at the time. I made an appointment to see him at his office, and he became quite aggressive and said, "This shouldn't have happened." I was very shocked and, of course, hurt. I had a feeling that he somehow had to defend some position. I'm not sure at all that he actually had this aggressive stance toward Nitsch or if he was concerned with me being in front of a court at the Old Bailey. I'm not sure if this was his real feeling.

Did you reconcile with him later?

It did cool the relationship between us, and for me it was certainly an important experience. He was actually quite gentle, very quiet, when I first met him. But eventually he got very big, physically, and very powerful and very short of time. Everybody wanted to consult him. But for me he was an important contact, of course, essentially very helpful. He helped me a great deal, even after the issue with the Nitsch event.

To return to that, you were explaining that while you were at the Old Bailey, you spent quite some time at the Roundhouse?

> Exactly—I used to go over to the Roundhouse after the hearings, and one afternoon, a young man came up and asked me if I would like to have an exhibition in the course of an art festival at Swansea University, to open in January 1968. The young man was called John Plant, and he arranged the program. And so I spent several weeks in Swansea preparing an exhibition.

They told you that you could use any space on the university campus for the exhibition.

> Yes, but I didn't know what kind of exhibition I wanted to do, and Plant didn't have suggestions for me. So I went and started looking around the university for a good space. One day I just happened to open a door that revealed a laboratory—a beautiful and pristine laboratory that had never been used, virgin territory. I requested permission to use it and was given the go-ahead.

So your exhibition was the first activity in this space. And the space determined the works that you made?

> Exactly. It was called the Filtration Laboratory and was designed specifically to investigate the flow of air and water. It had extraordinary technical facilities. The jets of water could be controlled to a very fine degree; they could be very powerful or very delicate. The same with the air pressure. So I used these possibilities to make works that already existed vaguely in my mind, but were produced within the context of these opportunities.

Basically, the tools and instruments in this laboratory triggered new works that you probably never would have created otherwise.

> That's correct. I could never have done them, and probably never would have conceived them.

Could you describe some of the pieces? I know the work with a hot plate, for example.

> The water drop piece, which was re-created as *Drop on Hot Plate*, started with the commonplace observation that when water is dropped onto a cooker hotplate, it stays there for a moment before it starts running off

and dispersing. I thought it would be very beautiful to have a drop — the biggest drop that wouldn't disperse and run off. The laboratory installation made that possible: I could take the water from the overhead pipe, direct it down a thin gray plastic tube toward the hotplate, and, by controlling the flow of water, I managed to build up a bubble that stayed for quite a time.

You made the impermanent permanent, like a paradox.

It was very beautiful to have this element of stability, which, at the same time, was rotating like mad — you could see that, from inside, it was explosive. Another work was a jet of water going from one side to another. You wouldn't normally have a jet of water in an exhibition, but I had one in this exhibition space. In relation to the jet, I had a plastic tube hanging down from the ceiling, and the airflow went along the ceiling into another pipe, right along the entire laboratory. I managed to fit that plastic tube into the bigger air pipe, and by putting air into the tube, it began to revolve like a snake around itself, forming a kind of dance. Depending on the volume of air, which I had complete control over just by manipulating a tap, I could make this a very gentle dance, but the more air I put in, the wilder it got. So you had this vertical jet of air hitting, merging with the horizontal jet of water. It was an amazing sight.

And you could regulate it throughout the exhibition to produce different effects?

I could regulate both the water and the air supply.

Was it important to you in this work to break open the disciplinary boundaries of the art practice?

I appreciated all of that, and I was conscious that this was a radical departure, not just from my own practice but from art practice in general. But then there was another refinement. The space was very long, and as you came in you were faced by a long row of windows with venetian blinds. The blinds were down, it was winter, and I noticed that at noon the light would come in at a certain angle, creating an extraordinary rainbow effect. It was quite fascinating.

It makes me think of Andreas Slominski and Damien Hirst, both of whom use rainbows in their exhibitions.

Also Turner and other nineteenth-century artists who were obsessed with the rainbow—Goethe, as well, who worked on the subject.

Were those the main works in the exhibition?

Oh no—another work was concerned with floating three pieces of polystyrene off the ground. The pieces were rectangular in shape. At each of the four corners of the object, a stream of compressed air hit the ground and formed a kind of invisible cushion allowing the polystyrene to float. It remained in place and gave a very restful impression. The beautiful thing about this was that it was positioned in relation to the next work—two of the hotplates. They both appeared stable, yet they were in fact boiling hot, with powerful internal forces, and were complemented by these jets of air hitting the ground and lifting up the polystyrene. So we had three main works and some smaller ones. Then there was also a cube of clear plastic with mica pieces rotating through jets of air inside it. Then, at the farthest end, we built a cubicle where liquid crystal was projected with a controlling system. The liquid crystal was heated systematically and, for the first time, I had a liquid crystal projection, which was ceaseless, hour after hour. It worked quite well. Of course, I had excellent technical assistance—the technical staff of the university assisted me.

In previous conversations, you've spoken about the importance of working with technicians rather than scientists. It's an interesting distinction to draw in terms of your collaborations. How involved were technicians in realizing these pieces?

I managed, partly through intuition, to solve the key issues on my own. It wasn't as if the technicians came up and asked, "Why don't you do this?" They never came up with ideas for individual works. In fact, the chief technician, who was particularly interested and supportive, said the best way to float the plastic would be to lift it up with jets of air from below. I told him I didn't want it like that, but would rather have the air hitting the ground to lift it. He said it would never work. Now I could have asked him to go and work it out for me, but eventually I tested it myself. To his surprise it worked extremely well. In fact, it wouldn't have worked his way, because it would have led to instability—and it would have taken ages to make a system to put the air underneath.

The radical nature of this project reminds me of Alexander Dorner's credo that the museum or exhibition should be an interdisciplinary laboratory. In *The Way Beyond "Art"*, Dorner writes: "The processual

idea has penetrated our system of certainty ... we cannot understand the forces which are effective in our visual production of today, if we do not have a look at other fields of modern life."

> If I can just add an art historical note: there was an enormous discussion, and you can trace it in the literature, around 1966–67, where Anthony Caro and his students at Central Saint Martins were trying to liberate sculpture from the ground, to take it off the pedestal. One of the reasons I made this work was to prove the point that this is really off the ground, and I was very conscious of this connection with Saint Martins and other ideas in relation to sculpture. That was more important to me than an interdisciplinary exhibition—and I feel I achieved something in that this was literally *off the ground*. And since then, artists have become more aware of how scientific advances can be integral to their work, or can transform it. It's no longer so radical to work in this way—for myself, there have been important benefits from new experiments with liquid crystal, for example. It didn't exist as a practical, day-to-day material when I first started working with it, and now it's available—to me, at least. It seems that no one else wants to use liquid crystal, which astonishes me, because it's so beautiful.

Your work with liquid crystals is something we've not yet covered in our interviews. They are obviously a key body of your work—a very important chapter, and one that's exhibited widely now. They were shown in the Tate Triennial, and at the Serpentine. They are a kind of epiphany in your practice, so I was wondering if you remember the day you made this discovery and what triggered it.

> I can't tell you the day but I can tell you how this entire direction started. It started with me going past a newspaper stand in the West End of London, in one of those shops that sells large quantities of journals from around the world. There was one journal in the window, *Scientific American*, and on its cover there was a picture, a whole cover, of liquid crystal slides from a microscope. It was full color and it immediately struck me—I was so startled by the beauty of that image. So I bought a copy and took it home and started reading the article. I can tell you the date of the volume ... it was August 1964. We can check that. I want to photocopy the cover and show it to you soon.

It would be great to have a photocopy. It's interesting that a magazine triggered this long-term project, because newspapers and magazines would become essential to your work later, albeit in a different context.

Yes.

Uli Sigg—who is the former Swiss ambassador to China and a big collector of Chinese art—always tells me that if you read the newspaper well enough, it's all there; the whole world is in newspapers and magazines.

> Yes, it's true. The world is represented through these media and there's this integral relationship between it coming to you and you coming to it. It's a bagatelle, a dialectic, taking in and giving out. It's like breathing; it's inevitable. And so one story, one review of a book on the radio, is almost as complete and comprehensive as reading the book—because the reporters have read the book and taken out its essence to present the enormous work behind the scene. There's a room of fifty or sixty journalists always working away at the next day's newspapers—what a sense of power that image has.

So one can use the research others have already done.

> Absolutely, yes. And now we've got the twenty-four-hour news cycle. There's an urgency involved in the work of newspapers and magazines and radio and television and that urgency is, in and of itself, a stimulant to one's own thought and development.

It's fascinating in this case that you encountered the liquid crystals in *Scientific American*.

> Yes. You asked how it started and that's how it started, so if you want a date it would be around the date of that issue, within a month of it coming onto the newsstands. And then I began to think of using this somehow. It was hard, at first, because I couldn't get access easily to the material itself. And even when I did, I had to find a way of using it just by experimentation—there was no handbook or anything along those lines. By the way, the liquid crystals I used at that point were all given to me as samples. One couldn't buy liquid crystals; but some firms gave me little bottles—and luckily I only needed a small amount to have the effect I wanted.

So there was a real risk in these early days—you had limited supplies and needed to experiment with them to find out the proper formula.

> Yes, I just had these tiny bottles—they only sent me six. I tried them all and one gave me a perfect result just by responding to heat, which I applied by using one of those little gas cylinder torches. I was very

satisfied once I got that effect. You might remember that polarized light is required, and that's where Moholy-Nagy comes back in because he was very interested in polarization. Polarization is the key to the whole projection.

That relates to El Lissitzky, too—they both said in the early twentieth century that artists should always be very close to the development of science.

Yes. Moholy-Nagy and the Bauhaus had a tremendous influence on me in that regard. Now, as you know, in my interview with Clive Phillpot, we talked about the tradition going back to Arts and Crafts, craftsmanship, Eric Gill, etc. Arts and Crafts, of course, led to the Bauhaus; it's a straight line. This is the trouble, I think, with how I'm understood and the difficulty of understanding and the misunderstanding. People don't see how traditional I am, how consciously, deliberately, I align myself with tradition. I want to do the best—and I believe the best is to continue the greatness of the past.

So you see yourself on a continuum, rather than pursuing a radical break?

On a continuum, yes. My aim is to develop the greatness of the past and to integrate with it.

Even as you incorporate the ultra-modern, the most innovative. Moholy-Nagy used materials a few weeks after they were invented also—just as you used liquid crystals right after they were first being discussed.

As quickly as I could. But even moving quickly, that took about a year's time of ... not exactly research, but *looking*, you might say. It was a very difficult period. I was showing light projections from 1963 onward. I think you know all that, starting with acid on nylon stretched on slide frames and projected. That worked very well in black and white so the challenge was to do color projections, which is why I wanted to work with liquid crystals, because I knew they could provide color. And after a year, more than a year, I managed to do it.

So it started from acid-on-nylon work you were doing in the early 1960s as part of your auto-destructive art demonstrations. How did the materials for those large performances lend themselves to black-and-white slide projections?

> In those days you had slide projectors where slides were slid in from left to right and vice versa. Instead of sliding in an image, nylon material was glued onto the plastic slide frame. After an application of acid with a small brush you could observe the acid tearing apart the stretched nylon. This technique was at the center of the first film Harold Liversidge made, *Auto-Destructive Art – The Activities of G. Metzger*.

Minuscule destruction was amplified, then, for an audience to see, using the pedagogical tools of science. It strikes me as a precursor to the techniques you would discover in the Filtration Laboratory. Did these slides develop further before you introduced liquid crystals?

> I developed different techniques as I went along, yes, which were shown at Lecture/Demonstrations. The climax of these was at Cambridge in 1965, when I showed ten different techniques, like a drop of ink into water. The slides were thin plastic boards that incorporated hundreds of tiny holes. The boards were covered with water and I sprayed graphite powder onto the board, and you saw hundreds and hundreds of graphite fragments circulating on the screen. It was all very visual, very dramatic. A physicist in Cambridge helped me with the liquid crystal—we spent weeks working on it together. But when I first tried using it in a presentation, as a projection, it came out as just a smudge; so it was a failure at first. This was the end of '65. At the beginning of the next year I participated in an evening in the basement of Better Books with Frank Popper and there the liquid crystal was shown and it worked perfectly. So we got it perfected in '66. And at the same time I also put on an exhibition of liquid crystals in the window of Better Books, this time leaving the liquid crystals in a cold state, which led to some very beautiful colors.

So in the early stages, in Cambridge, an expert on liquid crystal helped you.

> No, he wasn't an expert—no one really was at the time. But he was a scientist and did his utmost. He helped me a great deal. So that's the beginning. After the show in the window of Better Books I was very keen to continue, so a few months later I arranged with the Hampstead Theatre School to have a small display of the cold liquid crystals, and that's when I designed a poster that had the title "Liquid Crystals in Art" on it. It was a small poster but very attractive; it had a black-and-white image of projected liquid crystals.

That's how the name got solidified.

> *Liquid Crystals in Art.* Yes, that was the name I had for that exhibition. I don't think we had it already when I showed at Better Books. There was no poster for Better Books. And then, as you know, the same year, at the turn into the new year of 1967, they asked me to show liquid crystal projections at the Roundhouse for three big bands—The Move, The Who, and Cream. That was a kind of climax of my work with liquid crystals.

Liquid crystals became the frame and the context for concerts, for music events. It was very ambient. People were surrounded by the music and surrounded by the crystal projections. There's something very immersive about these pieces.

> Yes. That's a beautiful way of putting it.

Was that the moment you had a dialogue with Pete Townshend?

> No, we had met before. This wasn't the first time. We had tried, in fact, to get The Who into DIAS. I had an appointment with Pete in the summer of 1966 to ask whether they could perform with DIAS and the band was prepared but their management didn't want this to happen.

Did you ever work with him on something else?

> No. And the minor tragedy was that when I was projecting liquid crystals for the Roundhouse performances of these three bands, the projection for The Who didn't work. We never found out why exactly.

The crystals didn't evolve?

> They didn't evolve, exactly. The night before, when Cream was playing, it worked perfectly. The team of the concert made a kind of platform right in front of where the band would play. I had twelve projectors, which produced a lot of liquid crystal light, and they were projected the whole night through. Cream played till dawn, and I stayed that whole time, projecting onto them as they went—without any problems. But then the next day, the Roundhouse evening was started by Pink Floyd, who had their own light show. So the liquid crystal projectors were set up, but just waiting until the next act. Then there was an interval of twenty minutes when we went to have a drink and mingle with the crowd downstairs. When we came back, The Who got onstage and the lights went out in preparation. I pushed the button to start our liquid crystal projection and then . . . nothing happened. So as The Who started to play, there was almost no light on them at all. This went on for some

minutes as I raced around trying to find out what had happened. What I discovered was that one or two of the projectors had their slides missing entirely. Probably someone went in during the interval and took a couple of slides out just to look at them or try to copy them, and that ruined it. The first evening, all my projectors were grouped right in front of Cream, on the ground floor, solid. For The Who, we had arranged to have twelve projectors in a circle around the balcony, upstairs, and it didn't work. So after that tragedy, during the next interval, I came back, took all the projectors to the rear, and put them together like I had the evening before—so they projected straight onto The Move—and the liquid crystal worked once more.

That's a fantastic story. You never told it to me before. And one of the reasons why taking the slides out might ruin them is because they are actually thermotropic liquid crystals, right, so they are sensitive to temperature. If the temperature rise is too high, they will simply transform into a fully liquid phase rather than this in-between crystal state, which is why they work best when they're at a lower temperature.

> Absolutely. There's probably a point where it's too cold, but we've never tested that.

And why did you decide to use thermotropic liquid crystals? There are other kinds that don't require a change in temperature to evolve.

> Because it was easy for me to heat them up with a gas torch. We tried different liquid crystals over time and we found these ones were perfect for projection.

And after the Roadhouse, the next display of liquid crystals was in Oxford in 1998?

> Yes, when I was invited to show at the Museum of Modern Art in Oxford, liquid crystals was one of the first projects I put forward and it was agreed on. Oxford was the next step and everything worked perfectly there. It was a magnificent display of liquid crystals.

Yes. I was there for the conference. There was a long break between the Roundhouse and Oxford.

> That's right. But what we haven't talked about was that, back at the beginning, when I put this idea to Bob Cobbing, the manager at Better Books, that I wanted to show liquid crystals in his window and have

an evening where it would be projected, he said, "You should consider patenting your ideas." I thought about it for a few days and I agreed with him and made an application, I think it's called a provisional application for a patent, and I put it in. A year later I got a letter from the Patent Office saying, "We want to remind you that you have this provisional application and you have three months to apply for a patent." So I could have applied for a patent and could have developed it. Which shows you that I treated liquid crystals in a scientific and realistic manner, not just as an art project.

Do you have this letter still?

No. I've got nothing from that period of my life.

So you viewed it as an invention.

Yes, an invention and in my application I discussed a whole range of possible applications.

If one looks up the definition of liquid crystals, they are described as "substances that exhibit a phase of matter that has properties between those of a conventional liquid and those of a solid crystal. For instance, an LC may flow like a liquid, but its molecules may be oriented in a crystal-like way. There are many different types of LC phases, which can be distinguished by their different optical properties. When viewed under a microscope using a polarized light source, different liquid crystal phases will appear to have distinct textures. The contrasting areas in the textures correspond to domains where the liquid crystal molecules are oriented in different directions. Within a domain, however, the molecules are well-ordered. LC materials may not always be in an LC phase (just as water may turn into ice or steam)." It's quite interesting, and it strikes me there must be many other useful applications.

It's very complex. Here's some liquid crystal that I carry around with me, by the way: it's my watch. It's beautiful. Liquid crystal is now in universal use; everywhere. We couldn't live without them. They're in all kinds of displays—TVs, watches like this, computer monitors, etc.

But what you did used them as an extended form of painting, one could say. I have always seen these works of yours as being like living organisms. A truly new way of producing color, form, composition.

I think that's one of the reasons I was so excited by the potential.

The liminality of the material—existing, as it does, between liquid and solid states—also means one never can pin the pieces down. They are always in flux.

> They transform, inhabit two states. I think that gets at the central concept of my life: dialectics, dialectical materialism. This inspiration came from Marx, Lenin, and Trotsky—and so much else that was a starting point of my intellectual development in Leeds, in Harewood, and in the commune in Bristol. In those two years my thinking began. Dialectics has influenced everything I have done, everything in my art, and thought, and activity.

The dialectic between the natural world and the technological world has always been central to your work as well—perhaps beginning with liquid crystals, which are a natural phenomenon employed in and by technology.

> Yes. Liquid crystals surround us in man-made machines, but are also central to our bodily functions. That's a fact. I think of the liquid crystal projections as light fountains, which constantly rejuvenate themselves, and which in turn move us to go deeper into ourselves—we are stimulated and recharged. This is central to my work: the use of art to recharge the human being, who can tend toward depletion or collapse.

One of the early encounters with art that I can remember is seeing Emma Kunz's energy-field drawing on the packaging for her healing powder, AION A, which is sold in chemists in Switzerland. It led me to her work as a healer and a researcher of nature—she would produce these highly complex geometrical drawings using a pendulum as a means to diagnose her patients. She was working toward recharging human beings and recharging nature also, and what's fascinating is that in her practice the therapy itself becomes art. Did you ever directly explore using liquid crystals in such a way?

> Well, I want to tell you something that isn't generally known, but is absolutely key in this discussion about the natural world meeting the technological—about aesthetics and healing. I began to develop, from the mid-1960s into the early 1970s, ideas for a Gesamtkunstwerk, a kind of Bayreuth. It would be immersive. The healing qualities of liquid crystal, the calming effect it would have, was one of the drives for the conception of this project. I prepared all this in detail, with sketches,

and talked to Cedric Price about it. I had hoped he might take it up but he wasn't interested and so it never went anywhere.

How did you imagine the space architecturally?

> You would have entered a chamber where on your left and right there were liquid crystals in the cold state, which look a bit like stained glass, although perhaps more tactile. Then you would have entered a big space where the walls and the ceiling would be liquid crystals, this time projected as they evolve through color changes due to heat. You'd be on the floor and you could also have the floor made with the cold liquid crystals. At your leisure you could be there for half an hour or two hours; nobody would bother you. Then you could walk out into the last chamber, which would be similar to the first, to cool down; the term *chill out* wasn't used when I thought of this, but we could call it a chill-out room. There would be a fee; you would buy a ticket to go in, like in the swimming baths.

That's one of your unrealized projects.

> That's right.

And why Bayreuth, which you mentioned a moment ago?

> Bayreuth is a garden of pilgrimage, part of a pilgrimage into the space of Wagner. Wagner, I'm sure, had the concept of "healing" as part of his project. He was all about affecting through music, through this Walhalla that he managed to build. Except in my vision for this, there would be no music. I never conceived of music as part of liquid crystals, or any of my projects. All my work is essentially silent.

But interestingly enough, in the Roundhouse, it became a backdrop for music, so that was an exception.

> Yes, it was an exception.

I've seen the liquid crystals without music, of course. They resonate with the viewer as something external, but also an immersive space to inhabit. It places the viewer in a liminal state as well—inside and outside simultaneously. Your idea for this therapeutic experience makes me think of *Supportive, 1966–2011*, your project for the Musée d'Art Contemporain de Lyon. Was that an attempt to come close to such an immersive environment?

> It was the biggest liquid crystal display so far, that's true. We had always previously used five screens for liquid crystal installations, but for Lyon we had seven screens arranged in a semicircle. I'm hoping to fulfill the circle completely one day, as the next stage of our work.

So in Lyon it was even more immersive than the three or four screens you used for the Serpentine display?

> Yes, and step by step I am adding to it, coming closer to a circular arrangement.

How were the seven screens arranged?

> People could sit inside on the carpets as usual. There were seven elements, each four and a half meters high, which was quite a step forward. We had the same technician, a brilliant man, Adrian Fogarty, who has worked on liquid crystal with me for a long time now.

So the presentation in Lyon was like a planetarium of some sort.

> Yes, that's right. So that was the biggest project so far. And then there's another future plan—a project in Mexico, where a small group of people, including myself, are working on finding a way to make liquid crystal really accessible, especially to people without means. We are planning igloos, where people could go at the end of the day, over the weekend, in their spare time, and enjoy the color phenomena. We hope this will be realized at some point in the future.

After all these years, in which you've taught yourself the techniques you need and collaborated closely with scientists, do you believe there are still new things to be discovered?

> Oh, indeed, a vast amount.

Gustav Metzger, *Five Screens with Computer*, model for a computer-controlled auto-destructive monument, 1969

Gustav Metzger and Beverly Rowe, sketch for the computer-controlled auto-destructive monument *Five Screens with Computer*, 1969. Each screen was envisaged as a wall that would eject steel, glass, or plastic elements. From *Cybernetic Serendipity: The Computer and the Arts*, special issue of *Studio International*, July 1968

Hermann Nitsch, *Abreaktionsspiel No. 5*, St Bride Institute, London, September 16, 1966, staged as part of the Destruction in Art Symposium

A policeman talking to Metzger at St Bride Institute, London, before his arrest for unlawfully presenting an "indecent exhibition" as part of the Destruction in Art Symposium, September 16, 1966

111

View of the re-creation of Metzger's 1968 exhibition
Extremes Touch: Material/Transforming Art at Kunsthall
Oslo, 2015

Gustav Metzger, *Rainbow*, 1968/2015

Gustav Metzger, *Drop on Hot Plate*, 1968/2015

László Moholy-Nagy, *Light Prop for an Electric Stage (Light-Space Modulator)*, 1930

Cover of the August 1964 issue of *Scientific American* featuring photographs that "illustrate some of the unusual optical properties of substances that pass through a liquid-crystal phase"

Cover of *L'art cinetique* by Frank Popper. Paris: Gauthier-Villars, 1970

Metzger giving the Lecture/Demonstration "The Chemical Revolution in Art" at the Society of Arts, Cambridge University, October 11, 1965, with projections of ink in glycerin

Gustav Metzger, *Liquid Crystal Environment*, 1966/2021.
Installation view, Hauser & Wirth Somerset, Bruton, UK, 2021

Gustav Metzger, *Supportive* (details), 1965–66/2011

Gustav Metzger, *Liquid Crystal Environment*, 1965/2005.
Installation view, Generali Foundation, Vienna, 2005

121

4

Years Without Art

Beginning in the 1960s, you began resisting the progress of the art market as a system focused on the product rather than the process. This is linked, of course, to auto-destructive art, but also aligned with the Fluxus movement that was making its way to the UK at the time. I understand that you participated in the very early stages of Fluxus—were you an official member?

> Actually, this is a bit of a misunderstanding. The essential fact is that, in 1962, the artists Daniel Spoerri and Robert Filliou agreed to organize an exhibition in London called the Festival of Misfits. Ben Vautier, Arthur Köpcke, and Robin Page participated in the exhibition, as well as four or five other people who wound up becoming official members of Fluxus. Fluxus barely existed at that point—certainly not in England. I took part in the exhibition indirectly—and also quite actively took part in an evening at the ICA, where we were joined by Dick Higgins and his wife, Alison Knowles, who were absolutely Fluxus at that time—it has been said that this evening was the very first Fluxus event in England. That's quite possible. But my own participation in both of these happenings was separate from an affiliation with the movement.

But am I correct in thinking that soon after that you had an encounter with Joseph Beuys?

> Yes, but that was in '72, when he came to the Tate.

Did you agree with him about the foundations of the movement and the idea of Happenings?

> We had an important confrontation in 1972. It was a genuine confrontation. We had never met before, and he knew me by name, but obviously not by sight. Otherwise he would have recognized me—but there's a tape of our discussion and you can tell from it that he didn't know who he was speaking to at the time. We talked for at least an hour; we were confronting each other. There were a lot of disagreements between us, and I would suggest that I was considerably more sophisticated in my understanding than he was.

What was the main disagreement?

> Our main disagreement was about development. I suggested that we shouldn't encourage the so-called Third World to develop along the lines of the contemporary First World, and here he tended to disagree. He said, and this is a quote, "If we have goods, we should give them to

the poor people so that everyone will benefit"—which means that he never understood the dilemma facing the West and thought the rest of the world would benefit from developing along similar lines. He didn't understand the crisis that's now so blatant every schoolchild is aware of it. It's evident from the tape in the Tate Archive, which you can find and listen to.

Did you voice your ecological concerns in the discussion?

> Well, we discussed ecological problems, but he didn't understand certain aspects of the crisis at the time. I'm sure he learned as time went on, educating himself and becoming more responsible.

Were there other artists with whom you had a dialogue at the time?

> There was John Latham. I had known him since the early 1960s, certainly since '64. As you know, he developed the concept of Artist Placement with his wife, Barbara Steveni. My problem with him was that I felt he was too close to the big powers; he was prepared to collaborate closely. We had a public dispute.

Did you disagree with the principle of infiltrating existing structures, or the manner in which he suggested it should be done?

> I disagreed with the principle. The article I wrote in response to a major exhibition the Artist Placement Group had at the Hayward Gallery in the early 1970s makes our differences very clear. My position, and the position I took in the discussion with John Latham, was that if you're going to do the work you're planning to do, then you should go to the company you're working with and say, "We're opposed to you! Yes, that's our position. But we're offering to collaborate on specific projects, which could be interesting for us and possibly helpful to the situation in the world." He never accepted the challenge I put to him, which is perhaps one reason why we never worked together. We did have connections, and we were trying to do things together, but they never materialized.

Why did you distance yourself from the Artist Placement Group?

> I sort of dropped out. I wasn't the only one; there were others who dropped out of this orbit, too. Of course, I'm not putting down all of their work. Some of it was constructive, and I like John's own work very much. I like his paintings. I'm also very interested in the destructive

works he did. I was present at a number of them—a kind of participant, in a sense. I take him very seriously.

Didn't the two of you share an anti–Clement Greenberg stance?

Well, I wasn't part of that. I mean, I wasn't invited to the *Still and Chew* event in 1966. I don't have an anti-Greenberg position. I've never taken any position toward critics, of any kind, because I don't think it's my job. Maybe I haven't got the capacity to do so. I'm not like some of the American artists who are polemical in the art field. I'm much more concerned with the outside world than with the inner world of art. It's not my job to attack either artists or critics. I have attacked institutions, but that's something else. I also have to admit that I've hardly read any Greenberg, even to this day.

The work of yours that's most often considered in contact with the ideas of Fluxus and Artist Placement is your floor of the *Three Life Situations* exhibition at Gallery House in 1972. This prefigured the Serpentine group show *Take Me (I'm Yours)* in 1995 in many ways.

I think a good term for my relationship with Fluxus around that time is *interaction*. My life is unfortunately full of gaps and errors and breaks. Certainly, the climax to this interaction with Fluxus was the Destruction in Art Symposium in London, in 1966, where one hundred or so people from around the world came together on the basis of their interest in destruction and disappearance. But I just wanted to say that: it was about *interaction*.

Yes, that's a good word to use.

But to return, that Serpentine exhibition you just mentioned was the first time we met.

Yes—I remember very distinctly a gallery assistant telling me that a visitor downstairs was asking to meet the curator. So I rushed down and discovered it was you. We met in the exhibition and you told me about your work at Gallery House in 1972.

That was the *Three Life Situations* exhibition, in which three artists were invited to open up a building and make use of it. It wasn't derelict, but it hadn't been used, so it was all dusty. There was Marc Chaimowicz, Stuart Brisley, and me, and we were to open up this building to the public. Each of us was given a floor. Stuart Brisley was on the ground floor,

and he did one of his key works, sitting in the dark for weeks, and Marc Chaimowicz had this beautiful kind of ballroom, which he has since re-created, in the Migros Museum in Zurich, for example.

I saw that, yes.

I had the second floor, which was different to the others. The others were large rooms, but on the second floor there was an apartment. It had a bathroom and a kitchen, and then two more rooms. I decided to use all these rooms for different purposes. I displayed models for realized and unrealized projects. There were large photomontages made by a young German artist who was studying at the Slade at the time also.

In another room, visitors were welcome to use the kitchen, where food and drink were available. Did you make use of the bathroom?

The bathroom was actually the most interesting part. I spent some time thinking about the bathroom, which needed a good clean. So I decided to clean it and offer it to the public as a venue. I put up a small notice on paper: "You are free to use this bathroom. Ask for towels downstairs." At least one person actually did use it. Of course, it was a splendid house, and the bathroom was beautiful after I had cleaned it, especially the mirror.

Last time we spoke, you mentioned Wagner and the idea for a Gesamtkunstwerk with liquid crystals. Were you also after a total experience for visitors at Gallery House?

I was certainly after a total experience. In this sense, the bathroom wasn't just a matter of offering people the chance to have a clean-up, but to experience the aesthetics of hot water and steam on the mirror. This relates to "Manifesto World," a text I wrote in 1962, which says that everything, everything, everything can be responded to as art—can be apprehended as art. So that bathroom is, for me, a kind of fulfillment of the '62 manifesto ten years before.

There were also two whole rooms in the house that you dedicated to newspapers.

Yes, in the last two rooms. One of which had SMASH IT as a message on the wall.

That anticipated your contribution of the work *Mass Media: Today and Yesterday*, where visitors could pick out items from a pile of newspapers and make collages, to the 2015 version of *Take Me (I'm Yours)* in Paris. But how did it work with the newspapers in Gallery House? Could people make things out of *Smash It*?

> No, SMASH IT was just a statement on the system—smash the system—written on a wall. The work that dealt with mass media and newspapers was called *Controlling Information from Below*. The objective was to encourage visitors to cut stories out of newspapers and then file them, with the aim of building up a library of news cuttings, which, at the time, was typically an indispensable aid to newspapers and other organizations. Except this library would serve a different purpose: in a society as complex as ours, I argued, change can only happen when people have access to a large store of readily available information—so while I was critical of newspapers and the mass media, I also wanted to acknowledge that they are a source of important and easily obtainable information.

How was this room arranged—were there instructions or did the space itself encourage participation?

> Well, visitors entering the larger of the two rooms were faced by a tall wooden structure in the far corner, which was piled with newspapers and magazines, including a number of foreign ones, and black painted boards rested on the floor to serve as seats and tables. The walls were bare except for the slogan you mentioned—SMASH IT—which was painted in bold black letters. Plus a picture of Lenin from the *Observer*'s color supplement pages. Scissors, paper, and glue were provided and then the smaller room had a filing cabinet and a tape recorder. There weren't explicit instructions though, and some people came and were confused: Where was the art? But other visitors did indeed cut up newspapers and then stuck these and other collages they made onto the walls. To my dismay, no one did any kind of coherent work on the filing system. Instead, they actually wrecked the pile of newspapers and—this was incredible—one afternoon three young women tore up a number of the papers, piled the scraps onto a wooden frame they had placed in the center of the room, and wanted to set the structure alight! Their comments, which were highly critical of the mass media, were recorded on a tape a few hours later in the same room.

So maybe they took the slogan SMASH IT very literally—as instructions for how to engage with the work.

Perhaps. And while it sounds chaotic, it was actually mostly quiet, because, as it turned out, members of the public hardly came in. As you know, exhibitions are mostly not inhabited by visitors. We didn't get many visitors. I spent quite a bit of time there, and we talked—the artists talked. We had to clean the place out, and there was trouble with Sigi Krauss. The name may be unfamiliar to you. He was in charge of the house. We never saw him, not even once. His assistant was Rosetta Brooks. She came in and did some work, but not very much. At one point, we thought we would strike and just stop the whole thing. Things were getting so bad in terms of organization. That would also help explain why we had so few visitors. They just didn't work on it; it's very sad. The Goethe Institute had nothing to say, because they had delegated authority to Sigi Krauss. And all that time Marc and Stuart lived there in the house as much as possible, though I didn't because I was preparing an exhibition at the Architectural Association.

What was the exhibition at the AA?

It was called *Unrealizable Disintegrative Architecture and Other Projects*. It was a relatively small exhibition, and unfortunately I can hardly remember it in detail. There were some models, but there was also a lecture, which was perhaps more important for me than the exhibition. It was a minor thing, though, only lasting about two weeks.

Returning for a moment to Gallery House, I wanted to ask you about Kurt Schwitters. Did Schwitters and his Merzbau, which he described as a "shrine to friendship," influence you?

The influence is quite clear: there were two Schwitters exhibitions at Lord's Gallery, in 1958 and 1959, and I went to both. Each of them was a very, very important experience for me. Of course, '59 was the year I moved out of painting, so there's no question that these two Schwitters exhibitions were significant. Naturally, I knew Schwitters before these exhibitions, but to actually see fine examples of his work was special, and this was in a private house. It was in Philip Granville's house—a private house functioning as a gallery.

But you never met Schwitters?

No.

There's also a direct link from Schwitters to your early cardboard works at 14 Monmouth Street.

> Direct.

Even now there's often a link to Schwitters in your work. We've never spoken about why Schwitters and the Merzbau are important to you.

> Frankly, I'm far more interested in his collages. I've never seen the Merzbau in the north of England. I should have seen it by now. I've only seen reproductions of the earlier one that was destroyed.

A moment ago, you mentioned that you and Chaimowicz and Brisley thought about going on strike from Gallery House, to force the Goethe Institute into taking more action around the work. Did this in any way anticipate your founding of the art strike—that you called "Years Without Art"—a few years later?

> You're quite right to bring this up. Nobody has ever asked me about this connection before and there is a connection. I proposed "Years Without Art" as a three-year strike between 1977 and 1980. But more than coming out of Gallery House, it was really the culmination of feelings I had about not wanting to go into the art world. A general mistrust of the art world. And an interest in New Realism, which was still recent at the time.

Another link between you and Tinguely, then. Pierre Restany, the founder of New Realism, called for a "poetic recycling of urban, industrial, and advertising reality." That speaks directly to your use of newspapers, of course. How did you perceive New Realism at the time?

> At the time, I felt very strongly that New Realism was the most vital movement, even as it took an inevitable course toward increasing commercialization. It was a necessary step toward the next development of art, seeing the world in its totality as a work of art—including sound, newspapers, etc.—as you are right to point out. Whereas galleries, to me, were capitalist institutions, boxes of deceit. At the time, I wrote, and let me quote this here: "The artist does not want his or her work to be in the possession of stinking people—the stinking fucking cigar-smoking bastards and scented fashionable cows who deal in works of art. The artist does not want to be indirectly polluted through his or her work being stared at by detestable people. The appropriation by the artist of an object is in many ways a bourgeois activity. An elect of condescension, superiority to workmen. Profit motive—this is now worth XXXX dollars because I have chosen it. Artists act in a political framework whether they know it or not. Whether they want it or not." And so you

> can imagine that, when I felt I was at that point of being integrated into the commercial realm of the art world, this was incredibly disturbing for me. This really began to dawn on me, to weigh on me, when, in 1972, I was asked to go to Documenta.

By Harald Szeemann?

> Yes. He invited me personally. And there were other exhibitions. In '74 there was this very large German project in London at the Institute of Contemporary Arts and also again at the Goethe Institute. There I was asked—put under pressure, in fact—to participate. There were the two curators, Norman Rosenthal and Christos Joachimides, who had discussions with me for hours, trying to persuade me. Eventually I caved in, but, as you know, I decided not to exhibit, as a gesture. And instead I wrote the text that initiated "Years Without Art," calling on artists of the world to stop making art between 1977 and 1980: three years of not working as an artist. So there you have an extreme manifestation of my rejection of the way things are, and my attempt to go toward some other ideas.

You're proposing an economy for artists and art that's different from the economy of the object. You're refusing the insistence on the object as the necessary product of art. Is that correct?

> Exactly. I believed then, as I believe now, that artists engaged in political struggles act in two key areas: the use of their art for direct social change; and actions to change the structures of the art world. It needs to be understood that such activity is necessarily of a reformist, rather than revolutionary, character. Indeed, this political activity often serves to consolidate the existing order, in the West as well as in the East. The use of art for social change is bedeviled by the close integration of art and society.

Do you think the state and art are inextricably linked—forcing even the most radical art to remain reformist?

> The state needs art as a cosmetic cloak to its horrifying reality, and uses art to confuse, divert, and entertain large numbers of people. Even when deployed against the interests of the state, art cannot cut loose from the umbilical cord of the state. Art in the service of revolution is unsatisfactory and mistrusted because of the numerous links of art with the state and capitalism. Despite these problems, artists will go on using art to change society. Throughout the past century,

artists attacked the prevailing methods of production, distribution, and consumption of art—and in a way that was, in fact, effective. And I saw the "Years Without Art" as a continuation of this struggle, aimed at the destruction of commercial or public marketing and patronage systems.

It was a form of agitation and activism, but activism through refusal. Was it a refusal as a means of change?

> Precisely. There is of course a long history and legacy there. The refusal to labor is the chief weapon of workers fighting the system—and artists can use the same weapon to bring down the art system. So I wrote a notice about "Years Without Art" and asked other artists to participate for a period of three years. The aim being that artists would not produce work, sell work, or permit work to go on exhibition, and would refuse to collaborate with any part of the publicity machinery of the art world. It was meant to be a total withdrawal of labor. I saw that as the most extreme collective challenge that artists could make to the state and to private galleries. The international ramifications of the dealer/museum/publicity complex would make all of these very vulnerable; but artists have forever been in such a vulnerable state themselves.

Did you imagine that it might extend beyond the three-year period? Was there a plan in place for making the strike more permanent?

> I saw three years as the minimum period required to cripple the system, but a longer period of time would create difficulties for artists. That's why I decided on three years as the ideal length. You see, I figured that the very small number of artists who live from the practice of art are sufficiently wealthy to live on their capital for three years. But most people who practice art never sell their work at a profit, don't get the chance to exhibit their work under proper conditions, and are unmentioned by the publicity organs. So the vast majority of people who produce art have to subsidize this work by other means.

And they would, effectively, be saving time by striking.

> Saving time and money! Another thing I said, and this was quite tongue in cheek, was that some artists would certainly find it difficult to restrain themselves from producing art. These artists were to be invited to enter camps, where the making of art is forbidden, and where any work produced is destroyed at regular intervals. In place of the practice of art, such artists could spend time on the numerous

historical, aesthetic, and social issues facing art. It would be necessary to construct more equitable forms for marketing, exhibiting, and publicizing art in the future. They could turn their attention to this, to reimagining how the system itself worked. But nobody was interested. Nobody. Eventually, Stewart Home took it up ten years later, as you know. And eventually some people in America did their own version called "Art Strike" and produced a fascinating journal on the subject. But when I proposed this, there was absolutely no support for the idea.

Although you, yourself, did stop making art during this period. You went on strike.

I did, I went on strike. I also spent six months in the reading room of the Victoria and Albert Museum—a beautiful, quiet spot—producing a large bibliography of articles on art dealers in order to criticize their excesses. But I felt that didn't contradict the idea of striking.

And beyond that, you kept resisting this idea of non-objects becoming objects and thus sellable.

Yes, that's one of the points of a lot of my work—I intended there to be political statements made through my art and for there to be a fusion between the segments that are largely poetical and those dealing with other matters. This was especially true of auto-destructive art, of course, which inhibited the artist's ability to create an object for sale, unless somebody really wants to exhibit all sorts of art in a gallery. There's nothing to stop them, but I would totally oppose that—it's something I would never do.

Do you feel that there's a better understanding of your work today?

The opportunity for understanding my work is greater now than ever before, but there's still an enormous gap, which can be traced largely to people's resistance to the political views I've expressed over the years. They're pretty extreme, and they're disruptive of the way things are. Most people don't want to know about them, which is one major reason why my work hasn't been accepted. If I hadn't been in the political arena, I'd probably have been quite successful by now. Here, we can go back to Tinguely again, as a counterpoint to me. He was an anarchist. But even though he had very strong critical views, he didn't go about writing manifestos or giving lectures. He went on with his work. In contrast, I've always stuck to this attack on society, and people don't

like it. I would rather keep to my ideas and give up art than the other way around.

But now you're returning, slowly and carefully, to participating in exhibitions, launching campaigns, etc.?

Yes, and I feel the future is bright. Especially after some years, as you know, during which I lived very quietly, and then some years where I concentrated on only working with institutions who invited me.

The 1996 exhibition we worked on together in Paris, *Life/Live*, was the beginning of your coming back into the world of exhibitions.

Exactly.

I remember very well how reluctant you were.

After these years of taking part, I now see the need to be the old Metzger, the aggressive Metzger!

You often use lectures as your medium. That's also something I wanted to ask you about, because it seems that they have always been part of your artistic practice.

Oh, sure, and the Lecture/Demonstrations. For me, lectures are the possibility to express what I'm engaged in at the moment. Of course, that changes with time, and with the times. Especially because, as we've just discussed, my contact with society is very seldom, so the lectures are a possibility to communicate with people in a direct way. What I emphasize in my lectures is the necessity for art to deal with important elements and directions in society. And in the center of what's important to me, there's that same old word beginning with c that we've been discussing: capitalism. So constantly making connections between what's happening and the principles of capitalism—that's what's most significant in these lectures and Lecture/Demonstrations. It's very related to the political work we've just been discussing.

Do you feel that your position on capitalism has shifted over the years?

My stand against capitalism as a principal problem in society hasn't changed at all. I'm as opposed to capitalism as ever—even more so. I see capitalism as at least as dangerous as ever, if not more dangerous

than ever. People thought that, after the big crash, capitalism was finished, but I said no, it would just recuperate and get even stronger, and this is what's happening.

Would you say that we're seeing an acceleration?

In as far as there are more galleries than ever, and the power of galleries is greater than ever, and the endless kaleidoscope of fairgrounds, fairs, etc.—one fair succeeding another, almost back-to-back—yes. That wasn't there when I started criticizing the galleries. And I'm still very much opposed to it, this endless need to bring out a new *something* to attract the attention of the curators, or the critics, or the owners of the galleries.

You've been giving a lot of lectures lately. For instance, the Lecture/Demonstration you did for us at the Serpentine Experiment Marathon recently. You also do talks that don't involve experiments, like the one you did for the Extinction Marathon. Can you explain the difference between these—or has one evolved from the other?

The Lecture/Demonstrations began with the auto-destructive art event at the Temple Gallery in London in June 1960. As time went by, I gave several more Lecture/Demonstrations of auto-destructive art. They eventually came to an end, and just became talks without demonstrations. So that's the state I'm in now—the state of talking, rather than talking and demonstrating.

So what you did for the Experiment Marathon was to revisit one of your earlier Lecture/Demonstrations.

That's right. I was re-creating a part of the first Lecture/Demonstration. It was a reconstruction. I showed, at your invitation, a segment of a big table—which, by the way, is now in the Tate collection—including the metal rods that were made over a period of three weeks by a young lady. It was a very, very difficult task. The table had several objects on it and the remnant of an acid nylon painting as a background.

Is there any lecture in particular you'd like to mention—one you feel is particularly significant?

I actually haven't done many. The Tate Archive has manuscripts of some of the talks I've given since 1996 and one of them is *Mad Cows Talk*, which went over to Paris. That lecture is important for me.

That was shown at the Musée d'Art Moderne de la Ville de Paris.

> That's right, at the *Life/Live* exhibition. So that's one I would mention in particular. Especially since, as you noted, the *Life/Live* exhibition was something like a return for me to all these various processes of making.

That talk was a mad cow iconography, one might say, developed from newspaper headlines and clippings. Often your lectures are very encyclopedic. One that has always been a favorite of mine was on Damien Hirst's skull piece, which you gave at Conway Hall in Holborn.

> Conway Hall is a very important place to me. For many, many decades, maybe since the First World War, it has been a place where left-wing people and radical societies and associations gather to talk about their ideas. Some of the DIAS events took place there on several evenings, as you know.

How did you research that lecture?

> I spent weeks trying to find illustrations of the skull, not only at home but in libraries. That was a very interesting time for me, very exciting, and the illustrations are fascinating indeed. I also got direct access to the skull through the Serpentine Gallery and was able to make a very short inspection. To my surprise I found it to be a very beautiful, exciting experience. I thought it was really strong and very moving. It's fairly small—no bigger than my hand. As you know, during the lecture I attacked the art system very intensively.

This leads us to your interview with Andrew Wilson at Tate Modern, where you brought up the idea of the art strike again, and the need to resist the art market. Do you see a return to this as more possible today?

> Oh yes. I see the situation in the art world as separate from the world as it is. I see the possibility that artists will increasingly take over their own lives, their own production, in relation to society in a wider sense, instead of trying to enter existing galleries. I see the possibility of us bringing our work to the public by ourselves, in big halls, in houses, where more people, more artists, can exhibit than would be possible in private galleries. That's part of the attack on capitalism that I've used, as I mentioned, in my lectures. It's coming back to agitation, for me—a return to being an agitator.

Did something prompt this return?

> We've discussed the show on the avant-garde at the British Library before, which certainly prompted me. I was also influenced by the Rodchenko exhibition in London in 2008. In other words, revolutionary art—radical art—that has been highlighted in London has affected me, as I believe it affected the aura and perception in London in relation to radicalism. And to return to the question of the art strike, it's time now to have a fundamental change in the art world—a fundamental change so that artists take over. The difference between when I originally proposed this idea and now is, I suggest, that we're now far wealthier. By having more money, on average, than twenty years ago, and with computers, the internet, and mobile phones, we have the ability to take over the power that lies partly in the hands of the private galleries. I think this is a necessary step.

Have you imagined a path toward changing that system?

> Piece by piece we must take the energy and money and power out of the existing system, and transfer this money and power and these possibilities in a cooperative manner. This can happen globally. As I see it, now is the time, now it is possible. And another thing: through the internet and other means of modern communication, people have the ability to become more intelligent, more informed, to put things into effect more actively and more quickly.

It returns to your work at Gallery House, which was to bring a plethora of information to the general public—"information from below" that can transform into radical thinking from the ground up.

> Exactly. Information is so much more accessible today. You can type in a word on the computer and get a whole page on Lichtenberg or on some obscure philosopher or on me, you, or whoever. You can look up some Greek philosopher whose name has been almost forgotten, and you can start thinking about them and researching them immediately. This just wasn't available a few years ago. At the same time, we're becoming bored with the artist; there's a surfeit of culture and a surfeit of mind, and boredom sets in. We don't like to be bored, so we need something new—something radical. We mustn't remain in a kind of ghetto, on an island of art, where we deal only with art, with art organizers, with money and power. We are marginalized by a world that is totally different, that is extremely brutal, and that deals with tremendous power and enormous financial means.

This implies the disintegration of art and the disintegration of the artist.

That's how I see it. I actually, truly, believe that the idea of taking over the art system is something that can be realized in the coming years. We also need to try and phase out the crazy auction houses, where they think they can spiral up the prices endlessly. That should be attacked as part of this movement. There's a stepladder at the moment: you start there, and then you go up, and then, if you're very, very lucky, they sell your work at auctions. Then suddenly millions come in. But these stepladders are morally wrong. The other thing is, when you read the *Guardian*, the word *ethics* predominates. Well, it's not ethical—the art market is not ethical. Art needs this change—there's a need to introduce seriousness and quality and adventure into art again.

You say there should be new manifestos, that art should be more influential in society. Would you say that artists should cultivate influence rather than affluence?

Exactly, that's part of it. When artists come together in something like cooperatives—we don't even know how it can be done—but when they do, there's already radicalism. Of course, it's not a new idea for artists to exhibit together, but this could be more or less institutionalized: when they leave art school, artists could go into some place where they can exhibit their work and offer it for sale, rather than through the galleries. In the next few years, the challenge will be to solidify these different ideas into proposals, into writing, and to circulate them and stimulate the young people especially to act within the framework of these ideas. This concern of mine is with decanting the art system. It's not a question of destroying it. We don't want to get rid of it, to stand and throw bricks. We want to decant it—take out its energy, the money that's involved, and then start again.

Do you feel that the younger generation of artists is more primed for this kind of work?

Yes, definitely. Let me tell you why I know this. I gave a talk at Beaconsfield, which was the first in a series of three entitled Art & Compromise. It was in a large building as a joint production with the City & Guilds of London Art School. The invitation came, and I asked myself what there was to say on the subject. When I started thinking about it, I realized that you can say everything about it—that in art, especially public art, there must be compromise between the commissioner and the artist. In fact, it occurred to me that you could almost call the series Art Is Compromise. The lecture was absolutely packed out—somehow the word got around, and there were queues around the

block. There were all these young people, and I became rather messianic. Toward the end, I said we artists can take over the art system, and the galleries can close. The public galleries should continue, and the private galleries can be moved out, can move themselves out of the system. When I speak of artists in this context, I mean art historians, curators, organizers, administrators—the whole machinery. I made similar comments during the interview you mentioned with Andrew Wilson at Tate Modern. Again, I became rather fervent in this direction. I believe this is something that's truly feasible, especially if we consider it in relation to the difficulty of realizing a similar idea in the second half of the 1970s. And I could sense that the young people in the audience were perceptive and were waiting for some kind of lead.

That makes me think of a question I like to ask in interviews. As you know, Rainer Maria Rilke wrote this wonderful book of advice to a young poet. What would your advice be to a young artist today?

Well, first of all, I'd recommend seeing the exhibition of avant-garde material at the British Library. The exhibition has ended, but all the material is still available there.

Is there a catalogue?

There's a catalogue, but of course it's not comprehensive. The show was enormous. All the material is there, however, so you can always get a day ticket, or become a member of the British Library.

That's your first piece of advice.

Yes, and then I would advise them to go back to Russian Constructivism. In fact, I would advise young people to go back to Russia from 1900 onward, which would then include socialist realism. It's very important to see all that, to take it in—it's all very fascinating. There's an enormous amount of literature on the subject.

So research is the first step. Gathering information and influences.

Yes, and then I would recommend that they think about building cooperatives, with the aim of moving out of the commercial art galleries. Young people today have an opportunity to think radically. When we see how radically the world has changed in the last twenty years and how the world will radicalize more and more—something the younger generation is very attuned to—I see a concept that can pervade the art

world: we need to radicalize, otherwise we will lose contact with this constantly radicalizing and increasingly dangerous world. We cannot radicalize enough against a radicalizing world. I believe that capitalism has smothered art—and the deep surgery of an art strike, of refusing to work within the existing system or market, that's the only way to give art a new chance. It's something that young artists can do, that they must do, and that I believe they will do.

GALLERY ONE 16 NORTH AUDLEY STREET GROSVENOR SQUARE LONDON W1 HYDe Park 5880

If you are too successful, and have nostalgia for the days when you were not,
if you are unsuccessful, and hope some day success will knock at your door,
if you are too beautiful, and find men in the street are bothersome,
if you are ugly, madame, and wish you were beautiful,
if you sleep profoundly at night, and feel that it is a waste of time,
if you suffer from insomnia, and have time on your hands,
if you have teeth, and no meat,
if you have meat, and no teeth,
if you belong to the weaker sex, and wish you were of the stronger,
if you're in love and it makes you suffer,
if you're loved and it bores you,
if you're rich, and envy the simple happiness of the poor,
if you're poor, and long for la Dolce Vita,
if you're afraid to die, or find no point in living,
if you're a drunkard or a teetotaler,
if you believe in heaven or believe in hell,
if you're satisfied with the colour of your skin, or would rather change it,
if you believe in yourself and are pleased with what you do,
or don't believe in yourself, and wonder what you are doing.
and why

then come to see the
FESTIVAL OF MISFITS

built by people who sometimes sleep soundly, sometimes don't; sometimes are hungry, sometimes overfed; sometimes feel young, rich and handsome, sometimes old, ugly and poor; sometimes believe in themselves, sometimes don't; sometimes are artists, sometimes not.

We make music which is not Music, poems that are not Poetry, paintings that are not Painting, but
 music that may fit poetry
 poetry that may fit paintings
 paintings that may fit . . . something,
something which gives us the chance to enjoy a happy, non-specialized fantasy.

Try it
THE FESTIVAL OF MISFITS

Robert Filliou, one-eyed good-for-nothing Huguenot
Addi Kocpke, German professional revolutionist
Gustav Metzger, escaped Jew
Robin Page, Yukon lumberjack
Benjamin Patterson, captured alive Negro
Daniel Spoerri, Rumanian adventurer
Per Olof Ultvedt, the red-faced strongman from Sweden
Ben Vauthier, God's broker
Emmett Williams, the Pole with the elephant memory

You are invited to the opening between 10 a.m. and 6 p.m. on 23rd October. The Festival will continue until Thursday 8th November. Admission 2s. 6d.

In conjunction with the Festival there will be a special evening at the Institute of Contemporary Arts in Dover Street at 8.15 on Wednesday, 24th October, which will include a 53 kilo poem by Robert Filliou, an Alphabet Symphony by Emmett Williams, a Paper Piece and The Triumph of Egg by Benjamin Patterson and a Do-it-yourself Chorale by Daniel Spoerri.

Flyer for the Festival of Misfits, Gallery One and the Institute of Contemporary Arts, London, October 23–November 8, 1962

Alison Knowles, *Proposition #2: Make a Salad*, 1962. Performance view, Festival of Misfits, Institute of Contemporary Arts, London, October 24, 1962

141

Metzger outside Gallery One during the Festival of Misfits, London, 1962

Metzger at the Festival of Misfits evening at the Institute of Contemporary Arts, London, October 24, 1962

143

Metzger talking to Joseph Beuys at the Tate Gallery, London, February 25, 1972

View of Gustav Metzger's floor in the exhibition *Three Life Situations*, Gallery House, London, 1972. A magazine cover with a portrait of Lenin is under the words SMASH IT

Metzger's *Controlling Information from Below* space during *Three Life Situations*, 1972

144

Poster for the exhibition *Art into Society – Society into Art*, Institute of Contemporary Arts, London, 1974

Jean Tinguely looking for material, Paris, 1960

Metzger giving his Lecture/Demonstration at the Experiment Marathon, Serpentine Gallery, London, October 13, 2007

Gustav Metzger, *Mad Cows Talk*, 1996.
Installation view, Musée d'Art Moderne
de la Ville de Paris

Gustav Metzger, *Beef Linked to Brain Disease*,
slide to accompany *Mad Cows Talk*, 1996

148

Burger King: an announcement about our new beef.

In the light of current events, we have taken the decision to source all beef supplies outside the United Kingdom. This decision has been based solely on our customers' continued concern and apparent lack of confidence in British beef.

Managing Director of Burger King Europe, Craig Bushey, made this announcement:

"As we have stated previously, all Burger King patties are made from beef of the highest quality, taken from prime cuts of forequarter and flank that contain no offal or mechanically recovered meat. In accordance with the latest government statement, we are confident that this beef is safe to consume.

However, our customers' lack of confidence in British beef, the related potential damage to our business and threat to our employees' livelihood has caused us to take the decision to source beef outside the UK until confidence in British beef is fully restored."

From Saturday 30th March, and until further notice, all beefburgers served in Burger King restaurants will be made with non-British beef.

You will still be able to enjoy the BK Chicken Flamer, Chicken Royale, Spicy Beanburger and all other items on our menu. Naturally, should circumstances change in any way, we will keep you informed through the press and our restaurants.

Gustav Metzger, *Burger King: An Announcement about Our New Beef*, slide to accompany *Mad Cows Talk*, 1996

5

Confronting the Past

There's a tension in your work between observing history from a removed, even reverent, distance and engaging with the present tense of history as happening all the time. Central to this is your work with newspapers, which began as early as your exhibition at Gallery House with *Controlling Information from Below*. The whole world, history in the present, can be read from the daily news and yet newspapers are, increasingly, the organs of the corporate interests that you so ardently oppose. Can you talk about how this has affected your own thinking?

> Yes. Like many people, I'm fascinated by newspapers. Newspapers are informative, but they also distort reality, foster illusions, and serve the interests of governments or big business. They record history—and their design, to this purpose, is fascinating. I will often go through a whole variety of journals and newspapers each morning, selecting pages and cuttings.

In your apartment, you have a large archive with piles and piles of newspapers, from all these daily activities. How does this archive function?

> The answer is that it doesn't function at all, because everything is on top of everything else; there's no system whatsoever. To find anything takes me days of ransacking. I don't see it as a problem as long as I can keep it all. But after so many years, it has to stop someday; it's becoming too much. The collection gets too big, and you have to give it up at a certain point—when you move, for example, or because of the risk that the floor will collapse under all the weight.

I've always been fascinated by the *Evening Standard* posters you've made, because, for me, they're London—they encapsulate the daily life of the city.

> The title of that piece is *London a.m., London p.m.* I've made a number of pieces like this. The idea is that you get the first edition in the morning and another edition in the afternoon, and sometimes there are more than two. I'm now speaking of the past, because the format of newspapers has changed a bit, but in the old days the first edition simply had the top line blank and the later editions would have "West End Final." So there's a graphic difference. I decided to make a series of works where you have the morning edition, which had nothing on top, and next to it, on the left, the poster. And then, on the right, you have the latest edition, "West End Final p.m.," with a different poster. This is the idea that's been exhibited at the Generali Foundation.

So there's an interest in difference and repetition—breaking open the authority of the news as a static record.

> From my very earliest days of working with newspapers, difference and repetition have certainly been a theme—across editions and between different outlets. For one show at Alexandra Palace in 1971, for example, I presented daily cuttings side by side, often with a crisp critical comment of mine typed and juxtaposed. But even then, I found that many compositions spoke for themselves. The rather horrifying similarity of content between the *Sun*, the *Daily Mirror*, and the *Daily Mail*—which all displayed near-identical female nudes and advertisements—made further comment superfluous. Here's something I wrote during that time, which sums up my feelings about the role of the news in the 1970s: "It is not true to say that we are living under Fascism. We are living in a state that is a hundred times worse than Fascism. They were prepared to wage all-out war, and kill millions of Jews. We are actively preparing to kill all life on earth. Newspapers are aligned with this society: they help to maintain it and must share the blame for the increasing ugliness of people and cities. The advertisements of the polluters and destroyers keep the presses rolling. Picasso said that art is a weapon to fight the enemy. I have something to say, and I am saying it—and that is politics."

I think it's very interesting, that you relate—and differentiate—what's happening today from what happened in the Second World War. The political act is also an act of memory, both a personal memory and a historical one. Eric Hobsbawm, who I know you appreciate very much, has told me that we should campaign against forgetting. He believes that talking about memory is a necessity. Do you share this concern?

> Oh, I'm increasingly concerned with these issues. Many of my works have been in that field. The room at Cubitt Gallery, for example, was stating that we must remember the ten thousand and more Jewish intellectuals and artists who were forced to flee and who were destroyed. This is one direct line I've been working on as an artist over the past years, and I will continue in that direction.

I'm also thinking about your 2003 piece *Power to the People*. Did you see that as another form of historical record?

> It was a record, yes, of quite an extraordinary event. The war had just been declared.

In Iraq.

> Yes. I was in London, as I often am, in the area near Trafalgar Square. Actually, I was on the Strand and I saw young people coming toward me, almost marching, from the east. I asked what was going on, and they replied, "We're going to a demo at Parliament Square." They had left school and were going to this demo. I thought, "Well, I've got a few more things to do. I'll go and look at it when I'm finished." So I finished my errands, and between twelve and one I arrived at the demonstration. I was amazed by what I saw—thousands and thousands of these young people. I went back the next day to see it again. That day there was a turning point, when the young people rushed into the street, occupying it. Exactly opposite the area they were occupying was the Ministry of Defense, where, in 1961, Bertrand Russell, with the Committee of 100—including me—staged its first sit-down.

Did seeing this protest unfold in the same spot crystallize differences for you, between the methods of today and your own so many decades before?

> Oh yes. It was very different in 1961. Very different. Not in terms of the energy of the crowd—these young people had immense energy, just as we did—but in the treatment of the protesters, who, this time, were left in peace. When I was there in the early 1960s, the feeling was far riskier, let's say. People would be arrested and refused bail, or beaten by the police. Another time, also in 1961, we marched to a Royal Air Force base where construction work had been going on to house a rapid-launch operational ballistic missile with thermonuclear heads. We wanted to talk to the workers there about nuclear disarmament. We waited outside the building while some of the key figures, like Bertrand Russell and others, went inside. Eventually, it got dark, dusk fell. And then they finally emerged from the building smeared in concrete.

By the workmen on-site?

> Yes, the workmen had dunked them into concrete. John Hoyland, who was a painter and a teacher in Chelsea, had his eye damaged. Women were in a desperate state. It felt to me like a reliving of Nazi Germany, when I saw people treated like that. They could have been simply ejected from the worksite but instead they were manhandled in a disgraceful manner. Violated. So there was a big contrast, this juxtaposition was unbelievable. But also there was this beautiful sense of overlap when I saw the protesters in Parliament Square—the fact that we had been

there, demonstrating against a similar issue, against the war machine all those years earlier. And as I was remembering this, a woman who was about thirty years old came with a megaphone and began to chant, "Power to the people!" And everyone sitting there began to chant, "The people have the power. The people have the power. Power. Power. Power." This went on for about twenty minutes or more. It was an unbelievable experience. I was incredibly moved.

Did you film it?

No, I didn't, but that's how the video for my piece *Power to the People* originated—from those two days. I was invited, at very short notice, to contribute to the *Independence* exhibition at South London Gallery, and I initially wasn't sure what to contribute. Then I realized that I could make the video. One of the organizers of the exhibition, Chris Hammonds, actually did the work on the video and helped to find material. We couldn't find the sound of a crowd chanting "Power to the people," but we found some videos of the sit-down and demonstrations. So we used those.

That was about politics in the present moment and the past—your personal experiences and more general, historical, social experiences—overlapping: 1961 and 2003 were overlayed. But you have also used newspapers—the symbol of the immediate present, the historical "now"—in works that deal with collective memory and memorial. I'm thinking of course of *Eichmann and the Angel*, which you mentioned earlier, the Cubitt Gallery show. That piece deals with Walter Benjamin's angel of history—a very interesting figure in this discussion.

Yes, *Eichmann and the Angel* was what I meant—at the Cubitt Gallery in 2005. On the very last day of the exhibition, Adam Szymczyk, the director of Kunsthalle Basel, came by and more or less immediately decided to take it over to Switzerland. It was based on a kind of reconstruction of the structure in which Eichmann was tried in Jerusalem in 1961. It wasn't a copy, but we came pretty close. So that was the central item, and then we had one wall, the end wall, literally covered with stacks of the *Guardian* newspaper. The third big element was a contraption—a metal rolling system used for rolling anything like boxes of beer or bundles of newspapers. So, visually, these were the three key elements. On one wall we had a reproduction of Paul Klee's angel.

Angelus Novus.

Exactly—the work owned by Walter Benjamin. And as you said, Walter Benjamin was at the center of this whole concept. I felt the need to make a kind of homage to Benjamin and to the thousands and thousands of other Jews, exiles, intellectuals, musicians, and artists from Germany and Austria and wherever else in Europe they had to flee from. I had a very strong urge to do that, and so Benjamin became the center of this entire concept. The other key figure is Hannah Arendt, who knew Benjamin and had manuscripts given to her by him. She wrote this major book, *Eichmann in Jerusalem*, which, as you know, started out as five articles in the *New Yorker*. We had a table—a kind of reading area with one or two chairs where we had copied pages from the original publication of her articles. It's quite impressive. Nobody had seen these articles except the people at the time of their publication.

Did you have the original issues from back then?

We had photocopies of the opening pages of each article. On the left-hand wall, we had three texts starting with New York, and then Portbou in the middle of the wall, and, toward the end, Jerusalem. These are the places that are most relevant to the concept: New York, where Hannah Arendt lived and where she published these articles; Portbou, where Benjamin died; and Jerusalem, where Eichmann was tried and eventually executed.

So it was very much an installation about displacement and place.

Yes, indeed. For me, the aim was to interlink these key elements and get as much meaning out of them in interaction and, again, in reference to Benjamin. In a key activity, we asked people to participate by going into what we called "the cage," the structure in which Eichmann was tried. There was a chair in there and visitors could go in and sit down or stand. That was one interaction we offered to the public. In another activity, we invited people to take sheets of newspaper, put them on the roller, and let them roll along. The roller itself made a sort of humming noise, which, to us, was the noise of the carriages taking Jews to the concentration camps.

And that happened continuously?

Continuously. The rollers were on when visitors arrived. As the newspapers rolled along, they would fall off and end up underneath the Klee image. So below Klee's angel you had various newspapers in chaos.

As Benjamin puts it in his essay, "Where we perceive a chain of events, [the angel of history] sees one single catastrophe which keeps piling wreckage and hurls it in front of his feet." The newspapers are the wreckage of a continual catastrophe.

> Yes, those are some aspects.

You're very attuned to the physical material of memory. I'm thinking of *In Memoriam* from the exhibition at Kunsthalle Basel, for example. Was that new work an evolution of *Eichmann and the Angel*?

> Oh yes, indeed. These were new works. It happened like this: I had a letter from David Bussel, the curator, in late spring to do something at Cubitt for the autumn. I had a wonderful collaboration with him and his gallery manager, Charlotte Nourse, at the time. And that Cubitt installation went to the Kunsthalle Basel, where it became part of a three-person exhibition. I shared the whole building with two young artists, Ahlam Shibli and Diango Hernández. But when we started planning the exhibition, I was told there were two more rooms free for me to use, adjacent to the room that was suitable for *Eichmann and the Angel*. So I had a very short time to come up with an idea, and I thought I would never make it. One of these rooms is, as you know, very, very big. It's on the ground floor, the end room, with top light.

It's enormous.

> Enormous. So I started designing something based on a kind of Kleenex box, and I realized that this could be enlarged six times and we would end up with a very powerful form. It connects, in different ways, with Peter Eisenman's Memorial to the Murdered Jews of Europe in Berlin.

It's a blow-up?

> Yes. The boxes ended up being 1.85 meters high. I went there and started working on this show for a few days. On the second day I was there, one young assistant was asked to enlarge the original, which she did within a few hours. It was absolutely amazing. It was a perfect form in cardboard—and the cardboard was ribbed, which reminded me of the grooves in Nazi architecture; the quality of the cardboard she had used reminded me immediately of the architecture of the Third Reich.

That was one of those incredible analogies, like your piece *Après Paolozzi*, which is a section of foam plastic that looks similar to built architecture.

> That's interesting, I hadn't thought of that. Anyway, I was completely knocked out, and so we decided that this was what we were going to do: we would fill two rooms with these structures.

And that traveled from Switzerland to Sweden?

> Yes, then it went to Lund. A Finnish man you may know, Pontus Kyander, who lives in Lund, asked me for two years to work on an exhibition, which I was very reluctant to do. He used a bit of me in a BBC television film and then wanted to arrange an exhibition of my work and of young artists who might relate to me in some way. Eventually we agreed that there would be a one-man show in the Konsthall in Lund. That's how it came about. Pontus came to the opening in Basel, by which time we had agreed to make an exhibition. I think he had already seen *Eichmann and the Angel* in London and wanted it for his exhibition. When he came to Basel and saw the other work with the 110 cardboard boxes, he said, "We'll have that in Lund as well."

Did it travel anywhere else?

> Not the cardboard pieces, but *Eichmann and the Angel* did—to Poland. The Warsaw Jewish Museum bought the rights to reproduce, ad infinitum, this work. It's the centerpiece of their collection, I guess. Certainly in terms of size, it's the biggest work there. That's very satisfying for me.

Is the version in Warsaw done differently from the original?

> It's a copy. They bought the rights to make multiple copies, so they can continue to make them. Which is nice. Let them be made.

In a piece Gerhard Rühm wrote tracing the history of the Wiener Gruppe to its early iteration as an "Art-Club" just after the war, he says, "after seven years of enforced separation, there was an urgent need to recover lost ground and for us, the young ones, to rediscover modern art, which had been largely ostracized up to then. Even before 1938, it had reached merely a small minority, especially in Austria; the big libraries had failed to collect its most important documents, or they had been purged." So the Wiener Gruppe started from a very interesting point of recovery — the recovery of something that had always been absent, in a sense. It's

an appeal to history, but a hidden history. A confrontation with what was missing. This made me think of the various Historic Photographs exhibitions you have worked on over the last couple of decades—which also deal with bringing something perhaps deemed "dangerous" by society into art, in order to confront history.

> You're right to bring this up. These works evolved from an interest in risk, revulsion, confrontation, certainly, but also art history. I was doing research in the Netherlands when I conceived of the Historic Photographs series, and I saw the possibility of enlarging photographs as a step forward from the art historical work I was engaged in at the time.

Was there a particular image that triggered this idea?

> Well, one day in 1990, on the front page of every newspaper in Europe there was a photograph of two Israeli policemen with guns, guarding a group of Arabs lying on the ground. It was the "Massacre on the Mount," and it caused a furor worldwide. It was one of the most intensively discussed events in my lifetime, I would think. And this started me thinking of Historic Photographs.

You used that image as a pairing in the series.

> I hung an enlargement of it behind a sheet, yes, and on the floor beside it placed an image of Jews being persecuted by the Nazis after the Anschluss in 1938—the photograph shows Jews being made to scrub pavements in Vienna. This was covered by a huge cloth. I wanted to make works that would use photographs that the viewer wouldn't initially be able to see. The "Massacre on the Mount" work was called *To Walk Into*, and the Anschluss image *To Crawl Into*.

It destabilizes our typical sense of distance when we approach history. There's something hidden, missing from memory, that one must discover with the body.

> You have to walk into or crawl under the cloths and scrape or feel the photographs physically, which was part of my point. And it also relates to ideas I have always explored—confronting the viewer directly with destruction. The positioning of the two photographs in the pairing was crucial. On the one hand Jews are dominating Arabs, and on the other you have Nazis dominating Jews. It's well known that in Israel there are arguments along the lines that Jews dominate Arabs as a kind of revenge to being dominated by Nazis. So this is the topic for discussion; and it's

> interesting to me that you brought up the notion of something missing from memory, or of something purged by society. Because in Germany there's still a resistance to talking about the Nazi regime and in Israel there's a resistance to talking about the domination of Palestinians. And as a Jew it's important for me to say that Jews shouldn't persecute other people. I stand by that. I think the discussion is so important, and I had planned to go much deeper into it than I have done. I've moved on with other works, but these two works are central for me, because it's absolutely vital to what Israel is, this discussion. But anyway, from this idea I moved on to other forms. Each of the Historic Photographs has its own theme: Vietnam, the Oklahoma City bombing, etc.

And, of course, there's a personal connection with your own history.

> Yes, there's a connection, too, to my experience of coming to Britain from Germany. To the Holocaust: the forced removal of people, which, of course, you see now on a daily basis in Europe. What I experienced as a child will always be visible, and I welcome that. Responsibility is at the center of Jewish life—responsibility and the sharing of experience and the treasuring of life. And I would say that my concern with destruction and memory, which has dominated my lecturing in recent years, must be connected with this Jewish emphasis on the value of life, and the value of every life. So the works in the Historic Photographs are personal, but they're also an arena for people, for everyone, to connect with their life—with uncertainty, facing the unknown, an awareness of an expanding array of risks, feelings of helplessness, and an inability to come up with answers to major social issues. This is the state of the world at present. Until recently, the idea was widely accepted that for every technical problem there could be found an appropriate technical solution, a fix. But with the advent of global warming, the greenhouse effect, and the many other problems facing the world, there has arisen a change of consciousness. We face our helplessness in the face of our achievement. A person entering these works will be taking risks, facing uncertainty, and will experience states of helplessness. Art presents reality, reflects reality, and gives people the opportunity to connect with reality. That's what I wanted to do with these pieces.

You mentioned that these evolved out of your own art historical research—were there specific influences or precedents for you?

> Certainly Yoko Ono and Marina Abramović are influences here. Ono's *Cut Piece*, which she staged as part of our Destruction in Art Symposium,

invites participants to cut into her dress and she has to accept it, just as Abramović accepts being knocked about by the public. She offers people the opportunity of hurting her, so they know there's a risk. I don't challenge people to get hurt physically by crawling into the images in the Historic Photographs—but there's a risk of damaging the photographs themselves. Challenge and risk are integral to the work. And risks are what life is all about: some of them we are aware of; some of them we evade. I think my art is about the offering of complex experiences to an audience. For example, the work *Jerusalem, Jerusalem*, from another iteration of the Historic Photographs, includes an image of the 1967 Six-Day War, printed on transparent plastic; to experience it you literally scrape your whole body against the photographs, which is rather unpleasant, of course, but I want to open up possibilities for the audience to experience the difficult areas of life.

They are very difficult, these pieces. Often your vision is very limited, you are physically uncomfortable. There's an immediacy to the experience that brings you directly into contact—literally and figuratively—with each image. Do you see it in the legacy of Happenings?

It's an attempt to re-create the scene, to actually re-create it in performance, people necessarily re-creating it in performance, imitating it, adjusting to this position that's in front of them. So it's absolutely a performance. I've tried it myself with a cloth many times when installing, and when you're in it you have a very small field of vision. You can only see what's in front of you—if you're on top of the face, you can see the face and hardly anything else because once it's covered and you're in it, well, it's just covered, it's quite tricky. You start by lifting and looking under the cloth, but the idea is that you explore the picture by going right across it—it feels like a vast expanse this way. You keep on pushing your way through. It's a laborious activity—which, obviously, of course not everyone will perform.

Usually there's never one person alone engaging with the works; there's a process where two or three people go in, almost drawing each other in.

Yes, but let me say this: a number of people have told me over the years how much they like it, how highly they rate these exhibits. And when I ask if they have gone in, some say yes. But when I ask, "Did you crawl in?" nobody I talk to actually admits that. There was one person, for example, who rated the Historic Photographs very highly, and I asked him, "Did you crawl in?" He looked at me aghast and said, "There are three things I never do, and one of them is to crawl." He was

an Englishman—middle class, respectable, somebody high up in the art world. I can understand him, but it shows you . . .

Is it about guilt in public space?

> Yes, but it has to do with Willy Brandt kneeling down in Warsaw—very public, as head of the German government. He knelt down in front of this monument. It's world famous. I think what I'm doing is offering everybody the chance to kneel down in front of history.

That's beautiful.

> It's what I'm offering. Just walking in means accepting, confronting, the past. But presenting oneself against that history means that you have a chance to transform yourself. You have a chance to change. This is really what my work is about: offering people the chance to change through a work of art. In that sense, I'm fulfilling a responsibility I took upon myself when I first became an artist. What can I do as an artist to help society? Can I help prevent future wars? Can art do it instead of just politics? And I said to myself, "Art can do it. Art must do it. And I must be one of the artists who do it."

The exhibition of the Historic Photographs at the Museum of Modern Art in Oxford began with an image of Auschwitz. Was that to create an immediate sense of discomfort, of confrontation?

> The basis of that choice was actually technical. There was only one entrance and there was only one exit at the other end of that very large room. From the very beginning, even before this project started, I had the idea that, for the Auschwitz photograph, people would walk along it. Now, the only way people would be forced to walk along it in the Oxford space was if they entered at the quite small doorway, whose shape, by the way, was exactly like one of the gates of Auschwitz—exactly. So we had a picture of Auschwitz that included the gateway, and people who came through, when they saw the photograph, said, "Oh my god—I've just come through that shape." And then they were forced to walk along it. That was the intention, of course, and, at the same time, because it was the most important work in this iteration of Historic Photographs, at least to me, it was right to put it at the beginning.

Have you ever considered presenting a version of Historic Photographs that only deals with Nazi persecution?

I have thought about doing an exhibition only on the Nazi persecution of the Jews, it's quite possible, so, in other words, because I haven't done it doesn't mean that I've excluded or am excluding it; I could well see that this could be a very significant presentation in the future, just as I might make a presentation of the Vietnam War or the Northern Ireland crisis. All that is possible, yes, that one takes the subject and puts it on its own in an exhibition space. But it could all come to an end fairly soon because it's very tiring work, it's a tremendous strain, it's an ongoing strain. One doesn't, one can't, let it go while one is doing it, so I'm not at all sure how long, in fact, I will physically make this kind of work.

The Auschwitz image in the Oxford exhibition was one of the only straightforwardly visible photographs.

Yes, the pictures of the ramp and train arrivals at Auschwitz were very easily visible, and Oxford contained the only modern picture as well, which is of Twyford Down. This is in full color, about two meters across, and not obscured, made out of a half circle of steel with the image in the center. A picture of the road that was destroying nature at Twyford Down—it's called *Till we have built Jerusalem in England's green and pleasant land*, which is a quote by William Blake. You know, it's a cynical title, because you see Twyford Down full of destruction and horror. But the other images in this series are all completely hidden or visible only by crawling into them—or only occasionally, like a flash coming up where you can see the picture. The Vietnam picture works like this— it's only seen every ten minutes because it's lit with a stroboscope, and then it becomes invisible again. Another image from the Oxford exhibition is the Oklahoma bombing—of a fireman rescuing a tiny girl. This was on the front page of the *Times* and all over the world—I think it was shown again and again, especially on American television. This is a really famous image and this one is completely sealed, in a concrete block with a light within—so the image is illuminated within the concrete space, but remains totally invisible in the exhibition. I designed a free sheet to be handed out in the gallery, on which the photographs were produced on a very small scale, like a ground plan. People going through the exhibition could see each picture reproduced as small as possible, but quite clearly identifiable. It's important to me that these pictures will only be seen on a minute scale, a few inches across in the ground plan. That's part of the complexity. Indeed, one of the key drives behind the project of the Historic Photographs is to internalize the image, to throw the image where it is anyway—not in the eye but in the mind. By throwing it into the mind of the spectator, the unpredictable can happen, which is the purpose. It can ricochet and what comes

out is subjective. We don't know—each person may have a completely different response to a blank piece of metal encasing a photograph of Hitler in an exhibition hall. But that's what it's about, and it can be positive, it can be negative, it can be liberating, it can be damaging—I don't know—but one isn't responsible for the subjective response, and at that point the work, the situation, is so complex that my responsibility comes to an end. The work provides a stimulus and I think people should be grateful for that stimulus.

Is a reaction essential?

> If some people don't react at all then it doesn't matter, it doesn't matter at all, because it's difficult. I stress the difficulty that people will have in dealing with this, and the consciousness of this difficulty is one of the objectives of the work, to suggest that the work is difficult. It's difficult for the observer to relate to it. It could make them think that life is difficult, that politics is difficult, that daily life is difficult, and that's exactly the real situation. So that if people say, "Well, I don't know how I'm going to penetrate this," or, "I don't understand it—it doesn't mean anything to me," as far as I'm concerned, it's a success. It relates to the inability of the person to deal with life in a general sense, and so the inability, the frustration, by seeing a blank work that should be a photograph but isn't—all that to me is real, is complex, and therefore presenting this kind of work, difficult work, to a difficult world, is a success. I want people to stretch their minds around the apparent impossibility of penetrating a blank surface behind which there is a photograph of some significance.

So the difficulty of the confrontation is key—it's work that's open to interpretation by each viewer.

> Yes, exactly.

But it also strikes me that many of these images are of historical moments that society wants to erase or ignore. The Historic Photographs are insisting there's a verifiable truth to historical events. These are moments that did happen, and the lessons of history have to be learned—

> And these lessons are ongoing, yes, ongoing—and that's one of the reasons why I included the Twyford Down photograph—to prove that it's ongoing and that great photographs and powerful photographs are being made now. They're not just historic in the sense that one has to dig them out from years and years back. I'm very glad that you bring

this up. Because taking such a stand on history is something I've been conscious of when preparing these, thinking about them, planning them—that this is exactly the position I'm asserting; a stand against the general trend of these last, quite long years actually. It goes back to the 1960s—to the origin of postmodernism, and I'm standing strongly like a rock, if that isn't too bombastic, by saying, with these Historic Photographs, that you can't escape. You can't escape their historical reality, their interaction, their integration in history. That's one of the reasons I'm doing it, yes, to stand against the trend.

The Twyford Down image is very significant for this reason: the history of environmental destruction that you're confronting us with is still present, still unfolding. There is, of course, a lot of hesitation and anxiety around using images of the Holocaust, and the Historic Photographs is the first instance of you using them. Did you feel that a certain amount of time—of historical distance—had to elapse before it was appropriate to work with such images?

Well, the idea of making Historic Photographs came in the latter part of 1990, as I said. It came as something that had to happen—it was a case of my *having* to do it. It wasn't that I sort of looked around and thought, "Now, what shall I do next?" I wasn't even working as an artist; I was researching at the time, I wasn't contemplating making art. But I had this realization that the Historic Photographs could be done, and they were directly linked to the Jewish subject in a broader sense, and in a second sense to the Holocaust, to Poland, the camps and so on, and certainly, had it been possible or necessary, this could have arisen years and years before. So if your question is whether time had to elapse, I would say the answer to that is certainly yes. Just as it took me a long, long time to consider the possibility that my parents died in the concentration camps. For decades I said to myself and to others, "No, it didn't happen like that." Now, I'm prepared to consider the possibility that they did die in a concentration camp. We actually don't know, we don't know precisely what happened to them. But I have finally come to terms with what most likely took place.

So confronting what's missing from your personal history had to happen before you could present what was missing from a collective history.

There may be this link between the two issues, yes. The first versions of Historic Photographs were exhibited at workfortheeyetodo in 1995, and they included the photograph of the boy in the Warsaw Ghetto and Hitler in the Reichstag. These were the very first actual realizations

of the idea. But before that, in 1981, I also photocopied all of the laws passed by Hitler that targeted the Jews, and presented those as a work. Of course, these were text-based works and felt quite different for that reason, but already, in 1981, I was thinking along these lines. I think that was directly connected with my living in Germany, in Frankfurt, where I faced, had to face up to, the past and anti-Semitism in the current Germany in a way I never had to before. Living there, following political developments in the papers and on the radio, forced me to enter this project of photocopying the laws for exhibition in Switzerland in the spring of 1981. Before that, I thought a great deal about this subject and I was obviously very concerned with the imagery that one inevitably sees over a period of time, but I didn't have to confront it in the same way. But it always must have influenced my artistic development over the years, from being a student onward.

Would you ever consider showing the work in Germany?

That will always be an ambiguous situation necessarily, no matter where they are shown. You can never escape certain doubts about displaying such images and you can never escape the possibility of being criticized for using an image of Hitler or any image of the Nazis—as we saw in London with the controversy around the exhibition *The Nazis* at the Photographers Gallery, where stills were presented from Hollywood and British films of actors in Nazi uniform and regalia and so on. So, when using that photograph of Hitler in that first set of works, I was aware that it was a bit dodgy and open to controversy—and perhaps criticism—and that's inescapable. It's interesting to imagine the reaction in Germany, as you say. I think if I had made these works in Germany they would have been even more controversial, there would have been more tension around their use, but of course ultimately it's better to face up to historical fact than to escape it, and here I believe that, in this work, I'm facing up to a very critical phase of European—and, well, world—history, because this photograph we are discussing was taken on July 17, 1941, a day or so after the capitulation of France, when Germany was on the point of conquering the world. So the juxtaposition of that image with the utter defeat of Poland and of the Jews represented by the opposite picture was, for me, a statement that could be fully justified from every possible point of view. The central aim of art is to bring complexity to a height and the pendant to that approach is to say that you will never, ever be able to compete with the complexity that is reality. I think Lenin made a famous statement along these lines—that you can never compete with the radicality of the real. So this is my ideal, to bring together a large number of

>possibly divergent and possibly conflicting positions in a work, in order to increase the potential to maximize complexity, which, hopefully, can stimulate people to an awareness of the complexity of their own reality and perhaps ease their apprehension of this reality through entering a work of art.

Facing up to historical fact means, of course, engaging with the reality of art in Nazi Germany also—that art was central to the Nazi regime, both in its propaganda and its censorship. This is something you've spoken about and studied at length.

>Oh yes. Art, all the different manifestations of it, was central to the conception of the Nazi state. I've been very, very fascinated by the artistic, cultural, and political side of the Nazi machine, and that fed into the idea of having an international conference on Nazi art, which I organized with Cordula Frowein in 1976.

And what was this first conference? We never discussed this before.

>Well, the very first was during DIAS in 1966. But the one I'm talking about, with Cordula Frowein, happened ten years later, exactly ten years later, in London. This was called the AGUN—Art in Germany under National Socialism—conference. But it was restricted to actual scholars of the field. There was no public admittance.

But you curated it.

>Well, we designed it. We got people together to lecture—eighteen people came, a number from Germany.

Who spoke at that conference?

>Different people who knew the subject. Unfortunately, there was no publication. Nothing came out. There's an article of mine introducing the conference in *Studio International*, which was published earlier that year.

And what was the response?

>Harsh. Very harsh criticism. People weren't ready at that time to talk openly about the art produced during the Nazi era. And we opened the discussion to the idea that, to a degree, English and American wartime cultures showed parallels to their Nazi counterparts—insofar as they

were also mobilized in the service of the state, and state propaganda. We didn't say this was a definite relationship, we simply wanted to generate discussion. But people were very shocked by that.

You believe there's a certain responsibility we have to confront these images without denying their power?

>I do. A lot of people want to write Nazi art off as an aberration in history, but I believe that's far more dangerous than confronting its power honestly. Over the course of the AGUN conference, we came to realize we had a position that radically differed from that of many of the people who were there to participate, who, on the whole, regarded Nazi art as kitsch, as something to be relegated to the secondary plane. We, on the other hand, took the line in the conference that this attitude is not acceptable, is neither intelligent nor politically responsible, and so we were prepared to see quality in certain aspects of Nazi art, and that's still my view. That's the case we need to explore—the aesthetic potential in Nazi art—and not just simply say that because it comes from a violent and inhuman society it therefore can't be classified as art. This argument has raged in Germany since and a very large number of studies have been made that reject this wholesale negation of quality within Nazi culture and cultural production. A lot of it, like the posters or the literature or the films, was sheer propaganda, an attempt to dominate their people and to be nasty to their enemies, to be offensive to the rest of the world, to the world that didn't support them.

You told me that the most uncomfortable moments of human cruelty need to be looked at longest, even entered into, as with the Historic Photographs. Do you feel that, in not looking, we are negating or obfuscating further?

>That was exactly the fear I expressed. I appealed specifically to the mostly German people who came to our AGUN conference. I said, "Look, Germany will only succeed in dealing with the Nazi past if it is open, if it is honest, if it is courageous, and if it is prepared to fight." I accused those people—in as far as they weren't doing that. And when we now look at how Germany has developed, the fears that I expressed—that if they didn't exercise courage, if they didn't honestly face up to the Nazi past, there would be a hell of a lot of trouble in Germany—that has come about, hasn't it? The rise of neo-Nazism is the result of people like that, who, when it comes to thinking about the Nazi past, refuse to be either honest or courageous. And the point was that if they faced up to the Nazi past and admitted that there was something in this

Nazi past that is understandable, that possibly can have some kind of value, that it can help us try to understand, as far as we can, rather than just saying, "It's kitsch—because it's Nazi it's not worth bothering with—because it's Nazi it has to be evil." Well, that's not the way for art historians to work, but that's the way they have worked. That was the general trend of art historians in Germany in that period—the 1960s and 1970s, when all this took place—and that meant an escape from reality, from the complexity of reality, and an inability to face up to the truth, and that makes you weak. It means you can't fight politically, and they weren't fighting politically. There were so many Germans at that time who had the chance to turn it around, but because they weren't prepared to really grapple with the past in a deep sense and fight for the future, we now see the result of this.

Do you see the Historic Photographs as continuing a legacy of antifascist art and political art by German artists? Like Rühm said, it's about remembering something concealed by history—I'm thinking also about artists like John Heartfield and George Grosz, who were active between the wars.

Well, Heartfield had an enormous impact in Germany in the 1920s and 1930s. He was at the top of the lists of the Gestapo when they took power, right at the top, and understandably of course, because he was so punchy. His aggression toward the Nazis was nonstop, and he had this medium—the publication *Arbeiter-Illustrierte-Zeitung*, which was his famous left-wing illustrated magazine. Then he had to flee Germany as soon as Hitler came to power. He went straight to Czechoslovakia with his brother. They immediately set up alternative publications and continued the *AIZ*, smuggling it into Germany and distributing it throughout the world. They set it up and it continued to function in Czechoslovakia until it was invaded. And in wartime England, where he eventually fled, he continued being involved with the Communist Cultural Center in Hampstead for the duration of his stay, which went on until the end of the 1940s. Then he went over to East Germany where he continued political activity in some form or another. In fact, the communists over there didn't want him to do much political activity at that point, they rather wanted to push him into a corner. He had outlived his usefulness to the party at that stage, so they thought. Heartfield has been a tremendous concern in my life, especially since the early 1970s—and Grosz, too—so you're very right to pick up on this thread. It's certainly part of the legacy of these works. They both changed the way I understood what art was capable of.

Have you done much research on Heartfield in the past?

> Yes. I studied his work in the 1970s and 1980s and had started to write a book on him, in fact. His entire work could be summed up as a call to arms. Getting people out is a call to arms. This is at the center really of all the political work—the political aesthetic work—that I've been engaged in. And the call to change through shock is a traditional form of action undertaken by artists like Heartfield.

I didn't know you started to write a book on him.

> Yes, yes. With Cordula Frowein.

Is the text available somewhere?

> Well, it's unpublished. But we did work on it extensively and we were collecting books. Heartfield designed the covers of about one hundred books and we were trying to research that. We almost completed the task. And his work is very much in this vein of shock—his book covers and graphic art aimed against the Nazis were intended very much to shock at the time.

So you gathered photographs of all the covers he designed?

> We actually collected the books. The only way to research him was to bring the books together, which we did eventually. But then unfortunately Cordula died some years ago and I don't know what happened to the drafts.

I hope they surface—I'd be eager to see them. But returning to your own work with photography—how does the digital image affect the way you work on the Historic Photographs series? When you began the project, images were distributed physically.

> As you know, I don't have a computer and have no technology, except electric light, heating, and a radio. I don't have a telephone or mobile telephone, and, of course, it's a statement of the way I want to live. So it's interesting to consider a digital image, and it's an important issue that you raise, but I almost never see photos on a screen. I have to reflect that maybe I'm losing out by withdrawing from what's so familiar to most people in London. Maybe I'll start to disintegrate in relation to a world that's being transformed so constantly and consistently. I have to face up to that.

I wanted to ask you about an idea you've mentioned to me before, in previous interviews: the "aesthetics of revulsion," which you related to auto-destructive art. Do you see the Historic Photographs as a continuation in this vein?

> Well, that's part of the intention. What you've said is a part of the intention, but not the whole of it. We could go on looking at different strands of possibilities, but to follow up on what you said, I don't want to go on looking at images of horror. I don't want it and I know a lot of people don't want it either. These works, then, are an expression of that part of me and that urge within others not to go on and on and on looking at horror, looking at the revolting, looking at the extremely dangerous.

It strikes me that the physical barriers to viewing the images in these works—the curtains and floor coverings—actually complicate the viewer's horror and shock even further. There's first a distance and then a closeness that means our relationship to the images is always somewhat unstable.

> That's part of it, but there are so many other objectives in hiding the image, and it connects with the basic view I have about art today, that it needs to be complex in the ever-expanding, ever-more-complex social situation we're in. Art needs to be sensitive to this. Especially because, to some extent, it will never be able to achieve the complexity of reality—never, never, never. Even the greatest artists couldn't confront, couldn't embrace and contain, what's actually happening worldwide today. But the drive within the artist will be to attempt this. So, with these works, what I'm seeking is a range of possibilities that open up to the viewer because that's what it comes down to in the end. I'm hoping that, because they are difficult, because, as you said earlier, they are repellent, they block off the approach of the spectator. Because of so many other things within the works that are different to what has been done before, I'm expecting quite seriously and quite positively that there will be a great range of possible reactions to the work, and that I would regard as successful, because the greater the range of reactions, the more the aim of representing complexity and challenging people to respond to complex reality through art may be fulfilled.

The photographic medium, which presents something we associate with "reality," is essential to that complexity, no? And to shaking a viewer's certainties about the world, about the medium, about reality and history.

That's what I'm working on. My job is to draw people in so they can interact and work toward social change. That's a principle I'm committed to. And yes, the medium is essential to that. Of course, it doesn't mean I won't ever go back to other mediums, like painting, for example, in the future, because I believe—I've always believed—that painting and sculpture make a major contribution. In all my talks to students, all these decades, I've never said anything else. So one day I'm quite prepared to go into some room and see if I can paint. If the paintings aren't good, I don't have to exhibit them. If they are, I will. Any form of art has validity, and I'm open to change in the future.

Would you apply Dick Higgins's theory of intermedia, where everything is in between, to your work?

It's perfectly acceptable, and of course I'm in that position now, influenced by newspapers, historical photographs, current events, and the whole history of art or culture. It comes back to how we started this conversation: the role of the news and the different tempos in which history unfolds. Cosmology, I think, is important to mention here as part of this. Cosmology goes back for tens of thousands of years; it's concerned with the beginning and ending of time and space and life. It's an area I've reflected on quite a bit over the past few years. A large number of people—not just scientists—are learning about this, reading books, watching television, listening to the radio.

This way of understanding the world is very close to auto-destructive art, as well, isn't it?

Yes, exactly. Because now we accept that the world started with nothing and that it will end with nothing, and that everything in between is about it going through enormous transformations that involve destructivity. I see the fact that there's now a world movement concerned with these fundamentals as a powerful confirmation of my position in art. What's so important about this is that people are becoming more honest. And maybe that helps explain how my thinking has progressed over time, too. Because whereas auto-destructive art ends with nothing, the Historic Photographs begin with nothing—this is an evolution I think we all need to consider.

Gustav Metzger, *Daily Express*, ca. 1962

Gustav Metzger, *Eichmann and the Angel*, 2005. Installation view, Centre of Contemporary Art, Toruń, Poland, 2015

Paul Klee, *Angelus Novus*, 1920

Gustav Metzger, *Eichmann and the Angel*, 2005. Installation view, Centre of Contemporary Art, Toruń, Poland, 2015

Peter Eisenman, Memorial to the Murdered Jews of Europe, Berlin, completed 2005

Gustav Metzger, *In Memoriam*, 2005. Installation view, West Den Haag, The Hague, the Netherlands, 2017

Gustav Metzger, *Historic Photographs: No. 1: Liquidation of the Warsaw Ghetto, April 19 – 28 days, 1943*, 1995. Installation view, Serpentine Gallery, 2009

Gustav Metzger, *Historic Photographs: The Ramp at Auschwitz, Summer 1944*, 1998. Installation view, Centre of Contemporary Art, Toruń, Poland, 2015

Gustav Metzger, *Historic Photographs: No. 1: Hitler Addressing the Reichstag after the Fall of France, July 1940*, 1995. Installation view, Centre of Contemporary Art, Toruń, Poland, 2015

Metzger installing *Historic Photographs: No. 1: Hitler Addressing the Reichstag after the Fall of France, July 1940*, with the model for *Earth Minus Environment* in preparation in the foreground, at workfortheeyetodo, London, 1995

View of *Gustav Metzger: History History*, Generali Foundation, Vienna, 2005

The installation of *Gustav Metzger, Historic Photographs: Hitler-Youth, Eingeschweißt* at Kunstraum München, Munich, 1997

Gustav Metzger, *Historic Photographs: Till we have built Jerusalem in England's green and pleasant land*, 1998. Installation view, Lunds Konsthall, Lund, Sweden, 2006

Gustav Metzger, *Historic Photographs: Jerusalem, Jerusalem*, 1998. Installation view, Centre of Contemporary Art, Toruń, Poland, 2015

An excerpt from Metzger's notes about *Historic Photographs: To Crawl Into – Anschluss, Vienna, March 1938*, 1996, and *Historic Photographs: To Walk Into – Massacre on the Mount, Jerusalem, 8 November 1990*, 1996, from his correspondence with Hans Ulrich Obrist, n.d.

Entering the works is facing the unknown: the unknown outside, and within, the viewer. There no guidlines on how to proceed, or how to respond.

My intention is to establish zones of unknowing, where people are confronted – and face up to – the inability to resolve problems of our time. Facing up to our incapacities, to the feelings of helplessness, experienced by a growing number, is more promising than the determined, blind, beliefs in progress which has driven the course of this century so far.

German Chancellor Willy Brandt kneels at the Memorial to the Warsaw Ghetto Uprising of 1943, December 7, 1970

View of *Gustav Metzger: History History*, Generali Foundation, Vienna, 2005. Foreground: *Historic Photographs: To Crawl Into – Anschluss, Vienna, March 1938*, 1996; background *Historic Photographs: To Walk Into – Massacre on the Mount, Jerusalem, 8 November 1990*, 1996

182

Press photograph accompanying an article on the 1990 Temple Mount killings in Jerusalem, used for *Historic Photographs: To Walk Into – Massacre on the Mount, Jerusalem, 8 November 1990*, 1996

Press photograph showing Jews forced to scrub the streets of Vienna under Nazi rule, used for *Historic Photographs: To Crawl Into – Anschluss, Vienna, March 1938*, 1996

6

Damaged Nature

Over the years, when I've asked you about unrealized projects, you've often answered by intimating that all auto-destructive art remains unbuilt. In particular, you mention the long-standing series you have conceived around automobiles—in which the car is transformed into an anti-car monument. The earliest version of this project, *Project Stockholm, June (Phase 1)*, was conceived for the first UN Conference on the Human Environment in Stockholm in 1972. It involved 120 cars but went unrealized. Since then, the works have grown in ambition as more and more versions have been executed at various stages. I'm thinking of the pieces you presented at the Sharjah Biennial and at Lund. Can you tell me about this series and how your idea for the project as a whole has evolved over time?

> Actually, my work with cars and exhaust fumes dates back earlier than the *Project Stockholm* piece. It's my biggest ongoing project. The first idea was to get a lorry with a platform on the back. I wanted to construct a plastic structure on the lorry that would be fed by the exhaust pipe, so that the condensation of the fumes would be visible on the plastic. That concept was around 1964. Then, in 1970, I realized a work called *Mobbile*, which comprised a small car. Its exhaust went into a plastic box on the car's roof, and in the box there were bits of meat hanging and flowers and greenery. The car was driven around near the Hayward Gallery, where there was a show of kinetic art. Then, in 1972, as we've discussed, I was invited to take part in the inaugural show at Gallery House in London, which was part of the Goethe Institute, with Stuart Brisley and Marc Chaimowicz. I was given an entire floor, with five or six rooms, and in the first one I exhibited the model for *Project Stockholm*; it's a version of this particular piece that was realized recently at Sharjah.

You were making art about nature and pollution in the 1970s, when environmental destruction was yet to truly become a topic of conversation in the art world. Many artists were interested in systems and in physical processes, but their focus was narrower. There are some resonances, though; for example, I see similarities between your work and Hans Haacke's early pieces.

> I met Haacke at a private view at Galerie Schmela in Düsseldorf, when he was a very young man, in the spring of 1964. He kindly invited me to his studio, but I couldn't go, as I had to go to Holland early the next morning. But if I had gone, I would have seen his early kinetic works with water running down Perspex boxes. So there's a very direct link with my work and early Haacke. But, I think, my work addressed

pollution in a way that, at least at that point, his work didn't.

Yes, and perhaps this had to do with your intuition, as you told me in one of our early interviews, about the connection between environmental destruction, extinction, and the Nazi death camps. This was something that dawned on you later, but which you felt was a subconscious force behind your work.

> Yes. When I saw Claude Lanzmann's *Shoah* in 1985, I was completely knocked out by a section that dealt with the origins of the concentration camp deaths. It's documented very clearly that the first experiments involved putting Jews into sealed lorries and pumping exhaust fumes into the back. We've discussed this before, as you said—how it came as a deep shock to me to realize there was a connection between the works I had been planning and the original Nazi experiments for gas chambers—but deep down I must have sensed that connection all along.

After *Mobbile*, which only involved one car, you then planned the *Stockholm* model with 120 cars. You proposed another version of this piece for Documenta in 1972 as well. Was that ever realized?

> No, it never was. Let me tell you the whole story. I had two letters from Harald Szeemann inviting me to take part in Documenta. I didn't reply. One day I was talking with artists at the ICA in London, and in walks a man with a beard: Szeemann. We spent the rest of the day talking and eating nice Indian food. I sketched out a proposal for Documenta, titled *KARBA*. It involved four cars positioned around a three-meter plastic cube. Szeemann said that the technicians could execute it and that I didn't need to come to Kassel to oversee the work. But then, this is what happened: I had to very quickly send in a biography and bibliography and a proposal. To give an idea of the project, I sent a photo of the *Stockholm* model, which, as you know, includes 120 cars, just to illustrate the idea and because I had it already on hand. I have a feeling that when I sent it in, Szeemann thought I had suddenly moved from proposing a piece with four cars to something much more ambitious, and he lost interest. I can understand that: it was a very difficult situation. Anyhow, it wasn't made, and so I was never in Documenta, except in the catalogue.

It's a shame it wasn't exhibited at Documenta, as I imagine it would have caused a great stir there. When was the iteration of this piece involving multiple cars first executed?

> Well, I had an exhibition in the magnificent art gallery in Lund where we managed to produce the first version of it with four cars. Are you familiar with the Konsthall there?

Yes, I am.

> Well, as you know, there's an open, outdoor space in the middle. And the curator, Pontus Kyander, was determined to realize *KARBA* within this courtyard. They built a three-meter cube there and just managed to fit these four cars around it. Once every hour, I believe, the motors started running automatically for one minute and the exhaust went into the cube and the water ran down the inside the plastic.

Making visible the pollution we constantly move through but never see. It reminds me of your work *Drop on Hot Plate*—the tension between stasis and dissipation, fixing what should be ephemeral.

> Yes, but the pollution *KARBA* created was so minimal that it lasted for a mere minute and escaped at the top, where there were holes. The fumes had to be pumped in very slowly. The museum discussed this with the health authorities, and they agreed it wasn't a problem if done this way. The spectators were usually in the gallery watching through the glass walls anyway. Of course, for Documenta, the motors would have been running all day—that was the idea. So Lund was a partial realization of the overall plan.

And that plan continued to grow and adapt over time. In 1992, in Rio, the UN held the first ever meeting to address the question of the environment. In response, you wrote to the committee proposing they exhibit a version of this project called *Earth Minus Environment* in a public place to accompany the talks. What was the purpose of presenting a companion piece for the conference?

> This was something very significant to me. Very significant. The conference was meant to produce an Earth Charter that would act as a "blueprint for planetary survival in the twenty-first century." I felt such a conference couldn't live by words alone—it needed a dramatic image, a sign, a symbol, which could convey some of the central issues under discussion. So for this I once again proposed my version with 120 cars, this time to be arranged around a large construction that wasn't a cube, but rather in the shape of an *E*, for "Earth" and "Environment."

Can you tell me how you came to the fascinating name of the piece—I know the word *environment* is very important to you.

> Yes, it's a term I strongly reject. First we had nature. Then came "environment." And "environment" is the smoke screen that humanity has used to cover nature: the people who spoke Latin had no word for "environment"—they only knew *natura*. I see the term *environment* as a word that has been hijacked by the capitalist forces manipulating the world. For example, President Clinton said he would be the first "environmental president"—but what could this possibly mean? Everything and nothing. It's vague enough that it lends itself perfectly to telling lies and giving illusions—to hiding realities and confusing the public.

Another capitalist euphemism.

> Oh yes, and done for the basest of motives: to maintain profits and power. When we now reflect on nature, it's with considerable doubt and hesitancy and uncertainty. A good deal of fear is involved. We constantly ask: What will happen next? What is nature? What is it for us living now? Is it the memory of what it was? Is it the poetry of nature that we have read? And as we immerse ourselves in what nature was, how do we face what nature is—what it is now? You cannot *make* nature, try as hard as technology might—and this is essential to understand clearly—because if you could, it would not *be* nature. You can perhaps make "environment," but not nature. And when we observe nature, in its true state, the guiding feature seems to be a kind of permission to exist, a capacity to coexist among the countless forms of life. This definition of nature is something those in power or with vested interests would like us to forget, because it gives all beings rights alongside us humans.

The permission to exist and capacity to coexist is a beautiful definition. So *nature* is a word that has been intentionally dropped, because it's too concrete, too tangible, and too disruptive to the machine of capitalism?

> Exactly. Because not knowing is a form of erasure. It's quite different to not having.

How can we reactivate our language? Is there an alternative to speaking about "environmental destruction"?

> One way forward, I think, would be to drop the term *environment* and speak instead of "nature" and "damaged nature." Because as biotechnology and pollution continue to grow in affecting all areas of life,

clear thinking and communicating about nature and human nature is literally a matter of life and death. For example, nowadays, forests hardly have a place in public debate. They are overshadowed by bigger dangers and more damage. And that's the tendency of our times—bad news is submerged by worse news, but bad news doesn't evaporate, it's only covered over. In a lifetime, the lifetime of my generation, nature has been turned into this hybrid of "environment." If I were to return to the forest I knew as a child, in the environs of Nuremberg—the forest I missed so much when I came to England as a young refugee—I would react completely differently from how I did in my youth. Instead of the profound calm I knew then, there would be feelings of unease and anxiety, fear even. And in place of the deep colors I once observed, I would be faced with so many sights indicating that some radical change for the worse had occurred. The forest would no longer be nature, but an "environment."

The title of the Rio project, *Earth Minus Environment*, was drawing attention to this distinction?

I wanted to ask questions around this cover-up. I wanted to question what the changes are from nature to "environment," how did they happen and how are people responding?

But this project was never realized? It's really a shame it didn't happen, as it could have had an immense impact. Not just on the conference, but the general public.

No, it wasn't realized. And the conference, in my opinion, on the whole, was a failure. President Bush demonstrated most vividly in Rio that the conference's main goal was to sustain the economy, not ecology. The plan seemed to be, first we'll dirty it up, and then we'll clean it up. As if both would be benefits. It was very cynical.

And *Earth Minus Environment* captures this contradiction as well—as an anti-pollution piece, it pollutes.

Exactly. And I knew this would present a contradiction, a controversy, because of the huge amount of pollution it would generate. But I saw it as a way to challenge, to question, the value of the "normal" use of a car. I've always stuck to this—to my work as an attack on society—and people don't like it, or projects aren't realized because of it. But I would rather keep my ideals and give up art than the other way around.

Can you tell me more about the version of this work that was shown at the Sharjah Biennial?

> Well, exhibiting in that area of the world is very problematic, of course, given the United Arab Emirates' ties to the oil economy and petrol industry. Now, you might say, "How can you talk about ecology and nature in a part of the world where there's so much anti-nature, and which is so dominated by technology, industry, and advanced forms of capitalism?" These are problems, I think, for anybody taking part in the Sharjah Biennial—but, at the same time, one can argue that, if any place needs to think about these issues, it's that part of the world. So it's surely interesting to face up to these challenges. That said, Sharjah was one of my greatest experiences, although I wasn't there in person. Do you know a German critic called Eva Scharrer—she often writes reviews for *Artforum* and other magazines?

Yes, absolutely.

> Well, it all happened thanks to her. She came to the private view of some of my work in Basel, and we happened to sit next to each other at a dinner, more or less by chance. There's always a big dinner at these events. Soon after I returned to London, I got a letter from her telling me that the day after the private view, she received an invitation—quite out of the blue—to become co-curator for the Sharjah Biennial, which she accepted. She immediately thought of putting on either the Documenta piece or the piece with 120 cars. We were then in touch ever since, and she came to the private view of the *KARBA* piece in Lund. We decided that we were going to do everything possible to bring the 120 cars to the biennial, if only for a day. She fought for months to get it through—it was the biggest and most expensive work they staged for the biennial, so I was thrilled when the other curators agreed. However, the site couldn't contain 120 cars, so the number was reduced to 100. Their exhaust was fed into a massive tentlike structure and for the first week the motors ran at certain times. And they sent a helicopter up into the air above this installation, to shoot images and a movie of it from an aerial view. The results are really extraordinary and we've edited them into an eleven-minute film.

Do you feel that the project has been realized at last, then?

> Not exactly. In Sharjah the motors were running for one week. Ideally, though, they should have run for the whole duration of the biennial. That wasn't possible, and also it was only 100 cars, not the original 120.

So in fact the original project hasn't been realized. But this Sharjah piece is just phase one; phase two is when the cars are destroyed, when they destroy themselves. That's still waiting to be realized.

There's a whole second phase—an auto-destructive phase—that you envision?

Oh yes. From the beginning, the project was envisaged as having two phases. For phase one the cars are outside, but for phase two they are to be brought into the plastic container, which by now holds all these exhaust fumes. And if the cars don't combust on their own, then small bombs will be set off to destroy them. That's the project in its entirety, but there was no question of doing the second phase in Sharjah; it remains to be done. So, hopefully, bit by bit, this work will finally be realized one day.

There's a direct resonance with your response in the 1960s to the proliferation of nuclear weapons. At that time, you performed destruction by painting hydrochloric acid onto stretched nylon canvases. And today, in order to address the threat of pollution and the destruction of nature, you perform an act of mass, contained pollution. Do you imagine these works as a *pharmakon*, a poison that cures?

I'm very glad you're entering this area. I relate this link that you've drawn to homeopathy, which puts poison into the system in order to generate energy that could defeat the weakness, or the illness. So, yes, and in this case, it's a homeopathic dose of pollution. But doing all of this is not just a demonstration; it's a form, it's a creation, an attempt to show a visual experience that's unavailable except through destruction or pollution. And it's a very beautiful experience. Beautiful because you see the water, the swirling smoke, and the colors of the exhaust fumes as they enter the sealed cubes, which are made of transparent plastic fabric. This is, for me, very important. It's very important for me to have this experience, and to offer the potential experience to an audience.

Has homeopathy been a concept you connect with your work since the beginning—or at least since the beginning of auto-destructive art?

Around 1961, I began to see it as a tool that could be used. It was all to do with the term *in your face*, which is rather popular in England. The existence of danger is something that has long been excluded from art, and I have felt the need to bring it in.

It's a return to the aesthetics of revulsion.

> Yes. The first reaction to the 120 cars, surely, must be revulsion. How can somebody make something so horrible, something so dangerous, when the world is already so dangerous? How dare this artist say, "Well, I'm going to show you that it's even more dangerous and risky"? And the point behind it all is, I want the viewers to face this reality. These works started by me saying it's not good enough simply to draw the horror of the world. It's necessary to demonstrate the dangers of nuclear war and the dangers of car exhausts. This is the driving force behind this kind of development.

All these works are based on chemical reactions—the acid on nylon, right up through liquid crystal and now the car exhaust that, in theory, leads the cars to combust. You also exhibited another work with a chemical focus in Basel.

> Yes, I went to Basel twice and the director said, "Every so often we change the rear wall." As you probably know, that wall is thirty-seven and a half meters long and five and a half meters high. He said, "We're going to take this huge composition based on ceramic plates off, and we want you to make a proposal to fill that wall." So I went back to London, started designing the wall, and submitted a proposal. I did all this very quickly. The idea is to use refrigerators and put them on the wall to indicate the loss of the ozone layer, with chemicals that are taken out or not taken out. The project is fairly simple, and it should be straightforward because I want young people to understand it without too much difficulty. The design goes like this: we'll start on the left side of the wall with one line of refrigerators, and then we'll have three or four refrigerators that will be attached to the wall above or below each other, and they'll be at an angle.

They'll be slanted.

> Slanted, yes. Then, about five meters further along, we'll have two lines of refrigerators, and so we'll end up with five sets of refrigerators next to and below each other. Then, on top of the first, next to the first line of refrigerators, we'll have a disc made of reflective metal to indicate the sun—the sun's heat, and changes in its intensity. At each step, the sun goes down, down, down, until it reaches the bottom of the last set of refrigerators. The idea, again, is our changing relationship to the sun; the more refrigerators and the more chemicals we use, the more the sun's heat changes in relation to the earth. That's the principle.

Very interesting. And as we've been discussing all these works, I was thinking how you've truly returned, now in a very tangible way, to making exhibitions and campaigns. But in your most recent talks, you've suggested, a number of times, that you're planning on leaving the art world again, despite having recently started some new protests.

>Yes. Well, it depends how those protests go, as I want to see them through.

The first of these was a campaign called *Reduce Art Flights*, to boycott the flights taking place between art fairs and exhibitions, which you addressed during our 2006 Interview Marathon with Rem Koolhaas at the Serpentine. It's since been featured at several exhibitions, most recently at the Fondazione Re Rebaudengo in Turin. What brought you to this idea?

>Reducing art flights is, for me, a very obvious idea. Everywhere, more and more people throughout our world are using the airplane to travel, to transport goods, and to communicate. And particularly in the art world, most of this activity is redundant. It doesn't serve the purpose of evading the collapse of the world. On the contrary, this activity accelerates the collapse of the world, the collapse of nature.

This reminds me of the conversation we had with Marina Abramović at the Manchester International Festival in 2009. You both discussed the idea of waste in the art world, and Marina said something fascinating in relation to both of your work around this topic. Let me quote her directly here: "Artists today make enormous pollution in the world.... I'm always thinking how little we need to actually make art work, how little we can use.... Why do artists, especially our generation, think they need these enormously expensive materials in order to make a work of art? I don't think so.... [There is] a little list, which I always have in my head, ... the guide to Buddhism, for the Tibetan Buddhists: how many possessions do you need in your life? Do you know how many possessions you need in your entire life? There are nine items.... The first item is the summer robe, the second is the winter robe, the third is a pair of shoes, the fourth is the bowl for food, the fifth is an umbrella, to shelter from the sun and the rain, a mosquito net, to be protected from the animals, the scripture that you have to read, then a mat to sleep, and the ninth possession is a pair of glasses, if you need them."

>Oh yes, I remember Marina saying that very clearly. She also spoke about the artist's role in society, which I believe is linked to this understanding of reducing waste, didn't she?

Yes, here, I'll read you what she said just after that. She said, and this was in relation to both of your works that were shown during the festival, "We are here to serve society, like oxygen: to bring new awareness. . . . We always forget about the public, but the public is the one that completes the work. . . . Martha Graham, the great American choreographer and dancer, said once, 'Wherever a dancer stands is holy ground.' I'd like to rephrase this statement and I want to say this: 'Wherever the audience stands to look at a work of art is holy ground.' Without the audience the art doesn't exist. Art is made for the audience, we are made to serve the society." Let's talk more about the *Reduce Art Flights* campaign, as a link between these two points: the artist being aware of their own waste while also acting to serve society.

> I certainly felt that this simple statement needed to be made to the art world, because that's the world in which I move and have my existence, yes. It was made for an audience and for society. There's a statement that I think is helpful here—Eric Gill made it many years ago and, while he was a very problematic figure, I do agree with this one point: "The artist is not a special kind of person. Each person is a special kind of artist." If you follow that up, you simply have to accept that if you read the newspapers, if you listen to the radio, if you vote or if you don't vote, we are, each of us, engaged in some kind of intersocial activity. The artist is simply a person within that general activity—and I see it as my duty to encourage understanding and responsibility as much as I can for that reason. So, with *Reduce Art Flights*, I emphasized the need to reduce this long-term lethal activity by means of a kind of poster campaign, which evidently had a certain amount of limited success in as far as people in different countries have picked up on the idea of the anti-flight poster and spread the word. I think, so far, this is about the best I can do, spread the word—spread the word that there are alternatives to taking flights and that taking flights is, on the whole, a dangerous form of activity, as far as the entirety of nature is concerned. Taking flights is a routinely easy way out, but in the long term it's a deadly activity.

The name of the campaign, *Reduce Art Flights*, can be abbreviated to *RAF*. RAF has a lot of historical resonances, of course.

> That's exactly right. I came up with the slogan "Reduce Art Flights" first and then realized that when you write it down, it's RAF, as in the Royal Air Force, the military part of flying in England. That was, of course, an important term in the war, the Second World War—a terribly important symbol, an image, because the air force played such a

decisive part in that war and the victory over the Nazis. And so there's a link here with the past war, with the dangers of war generally.

There's also the German meaning of RAF, which often stands for the Red Army Faction. Was that double resonance important?

> Yes, the Red Army Faction was the guerrilla movement in Germany and was very important, particularly in the 1970s, when these revolutionaries tried very seriously to damage German political and economic life. So there are a number of echoes within the title. And that was interesting to me, that RAF stands for a multiplicity of historical realities and present-day issues, such as the danger through pollution, in this case, from airplanes, but also broader political issues.

Those echoes were very important to the work you did on the campaign for an exhibition in Münster.

> Yes, for the exhibition in Münster at the Westfälischer Kunstverein. I had been invited to take part in the Münster Sculpture Projects. In connection with that, a few things happened. Before traveling, I was given the catalogue of the previous Münster exhibition, and in that catalogue there was a short sentence that had a big impact on me. It said that Münster was heavily bombed in the last war—it was flattened by about 150 air raids and 80 or 90 percent of the city was destroyed. This was the Allied forces' retaliation for the German wholesale bombing of Coventry, and the Coventry Cathedral, in 1940. So that was the first spark of an idea for me—that I could somehow or other commemorate these two bombing campaigns as my contribution, eventually, to the Münster show.

It was a kind of historical investigation.

> It was. When I arrived in the city, I had a couple of days on my own, and going through the Stadtmuseum there, I came across a black and red Royal Air Force poster from about 1942. That was the second spark: it occurred to me that the *RAF* campaign I put together in relation to Münster could be based on this particular local poster, using the colors and various combinations or meanings of RAF. I wanted to declare it "Münster's Second Bombardment." Of course, as always, I had several concerns in launching this campaign. One was that the leaflet could become a collector's item, and the other was that I still see myself in a state of withdrawal from publicity. I don't like to say, "Follow me"; I find it embarrassing and difficult.

But you were very much encouraged to go ahead with it, no? I remember the Kunstverein director, Carina Plath, said she liked the *RAF* campaign very much.

> Yes, she was very supportive. I mentioned the idea to Carina, especially because it was the RAF that actually bombed Münster. And the idea of doing something around this was accepted. And by the time the show opened, some months later, she had had some very nicely printed leaflets made so they would be available to the visitors. We made an edition of five thousand of these leaflets, in the colors of the Royal Air Force—red, white, and blue—which got people talking.

What did the leaflets say?

> They read, "RAF: Reduce Art Flights," and then, in German, "Münster: Die zweite Bombardierung," which means "the second bombardment." And, again, there was a triple meaning: the bombardment of Münster through the present-day airplanes flying over and polluting the air; the bombardment of Münster by my exhibition dealing with the past; and finally, the bombardment of Münster by these leaflets being distributed to all the visitors to the exhibition. And that, in a nutshell, brings this project together.

You rarely have definitive endings to projects like this. Will you continue the campaign in other forms?

> It has not ended, it goes on. It could go on for years, because I don't imagine we'll give up using airplanes for transportation. And it's kind of like a nudge in the ribs, as it were, to remind people that there's a problem, and that we must talk about this problem of endless flights here and there. And it will definitely continue to be an issue—as you can tell from the statement by the organizers of the Basel art fair, who said that when Basel takes the fair to Miami, everybody can get a 50 percent reduction on the flight there. That particularly annoyed me. I thought that was just over the top, sort of pumping up the possibility of airplane use. So, for me, this has very much to do with rejection of mass transport, and also a criticism of the art world. At that point there wasn't much discussion in the press about flights at all. I don't mind saying that, at different times over the years, I have been a little ahead of events. And I want to add that, of course, I understand there are positive benefits to the new availability of information and art around the world.

It has brought greater awareness in Europe to non-Western art and artists, for example.

> It has. After all, communication and information are at the center of our civilization. But my objection to flights is also an objection to the massive commercial growth of the art industry, the dealers and the auctions. I've talked about this since the early 1960s. This centers on my ongoing and endless opposition to capitalism and my attempt to discuss these issues. I suffer from this not being recognized, which is one reason I have hesitated to launch campaigns in the last few decades. And the other aspect of this is that, when something is happening in society, I don't see the point of me coming in and duplicating it. In my life, my work has quite consciously entered areas that others haven't reached, which others aren't interested in reaching. Now, when everybody is speaking of global warming, I question whether this is something I should be pursuing.

The leaflets in Münster were a great success though.

> Yes, it's true that the campaign worked in Münster. These leaflets were displayed and picked up. And they have now found their way to a large exhibition on ecology in Turin, which a group of young artists living in Barcelona put together. They wanted to adopt the idea, and, on the basis of the leaflet from Münster, they created a leaflet in Italian for Turin. The leaflet had a different text but was identical in appearance to the one in Münster.

So the principle can go anywhere.

> If people want it, it can go around the world piece by piece. And as you say, it's essential to act, even with this modest kind of campaign. Because my argument is—has always been—if we don't wake up now, what is our future? If only for the sake of our own morality, our own moral status, we must act. And I want to bring in occupied Poland during the war here, where Jews decided to make diaries. They wrote handwritten reports and put them into little canisters and buried the canisters in the earth. As an act and a way to preserve their testimony to history, even though these were small actions.

It's about individual acts taking on power by becoming collective.

> Exactly. In the last few years, people in Warsaw have been digging up these canisters and they are forming the most important archive. What

I'm saying is, we're in a situation of extreme radicality, where we've got to push ourselves to face up to the possibility and the necessity of acting, if only to safeguard our own morality. You see my argument? This is the depth of it. In order to say we are humans, we must take these steps to save nature. And on the contrary, nature is just being thrown out, every moment. Every time you pick up a newspaper and you see an advertisement for cars, you are throwing out nature. We must radically change course and work very, very quickly. To at least rebalance.

I'm glad you mentioned advertising, because it's part of an ancillary project of yours. You've begun to compile an archive of all those ads from low-budget airlines that are in magazines and newspapers. It reminds me of what you were working on when we first met: you were busy with an archive that became a great work, *Mad Cows Talk*—an encyclopedia of English newspaper clippings that became a lecture.

> Yes, a lecture with a slideshow of fifty slides. Most of the ads I compiled for *RAF* are from Ryanair, which is the cheapest of the cheap airlines in Great Britain. They're placed systematically in various newspapers.

You came up with the idea of using them as illustrations for our conversation book that we put together for Koenig.

> Yes, thirty pieces, thirty illustrations.

Will the archive continue to grow?

> I suppose our book was about the end of it. I know that *RAF* will continue to grow, though.

While we're speaking about advertisements: I know you feel particularly strongly about the advertisements in art magazines. You object to commercialization and commercial activities in the art world generally, of course, but this focus feels particularly related.

> This is definitely related, definitely linked to all we've talked about. My rejection of the art gallery system goes back to the early 1960s, as you know. And it hasn't actually weakened. And when I now see these big and powerful art magazines like *Artforum*, consisting mainly of advertisements for private galleries, I do get upset. At the same time, of course, one can't resist the seduction—there's so much effort that goes into making each page and of course a vast amount of money in making these products. I was in the library today looking at magazines

and there's a certain appeal—in the color and the invention. But, in principle, I think it's going the wrong way. It's a massive escalation of the capitalist interests in the art market. Every decade, there's more and more advertisement, and more and more galleries—and more power in the galleries. And I'm very upset by all that. Speed is increasingly dominating life and of course the mobile telephone is the chief example of how everything is being sped up. People want everything to be instant—by telephone, by email—and I think all that is really terrible, this instantaneity. Life hasn't been like that before. It contradicts the kind of organic interchange that people should have. And, again, it has to do with commerce—the notion of "let's make the deal and let's make it now." It's all very, very sad.

I know you've expressed both doubt and optimism about artists' campaigns. Do you think they may help change people's behavior—whether in the art world or otherwise?

Quite frankly, I'm not optimistic about actually affecting people's behavior. But I think people's thinking can be changed. And these little printed pieces of paper we made for *RAF* can have a certain impact on the way people think. And, of course, people will relate it to the vast attention given to climate change, environmental dangers, etc. I do think, to be positive, that more and more artists are engaging with these issues. There's no question that in Great Britain there's almost a daily increase in awareness in the art community about problems like this—problems that, historically, have only been dealt with on a world scale by governments or think tanks or scientists. And in that wider movement toward a kind of involvement with political, economic, and world issues, this little contribution can play its part. I expect it will. And of course, these pamphlets that we had in Münster and Turin— the more places this idea turns up, the better. I think it will go on from place to place, being distributed and being considered by the art world.

There was one other project, besides *RAF*, that you worked on in Münster, if I'm not mistaken—also related to the bombing of the city?

Yes, because, you see, the bombing of Münster went on for 109 days. And so for 109 days in Münster I had a series of stones laid, in 109 different places in the city, in commemoration of that bombardment. A forklift truck moved around each day, depositing stones at specific points. We were also trying to get Coventry to do the same.

Why did you decide that a forklift should move the stones?

> I'm fascinated by them. In 2003, at T1+2 Artspace in the East End of London, I had an exhibition that I'm sure you remember, entitled *100,000 Newspapers*. During the show the gallery held the world's first congress on forklift trucks. Ever since, I've wanted to use forklift trucks. They are rather aggressive and have a particular way of behaving.

I remember the show, of course, although I didn't know about the congress on forklift trucks, which is quite an interesting detail.

> I was fascinated by it.

To go back, for a moment: when we discussed *RAF* another time, you referred to the pamphlet *Protest and Survive* by E. P. Thompson.

> Yes. *Protect and Survive*, issued by the British government, had a very wide distribution when it came out some decades ago, and we turned this title around so that it became *Protest and Survive*. It became part of the propaganda of the anti-nuclear campaign in Britain. And this has been a strategy I've employed for a very, very long time in the course of lectures or writing. It's a brilliant way of protesting and presenting alternative points of view.

The idea of protesting to survive is important, especially in relation to your works with cars that we discussed earlier. But I was also thinking this morning about your amazing piece for the Manchester International Festival called *Flailing Trees*. What these pieces have in common is that they suggest it's not enough to talk about pollution and the environment and the dangers, we also need to shock people, to somehow wake them up out of their indifference. I remember what you said is that we need a call to act, to wake people up. And it seems this is what your art has done from the beginning.

> I couldn't agree more. We need to act and to wake people up. We need to. And you're right to bring up the sculptures in Manchester. This was a work of twenty-one willow trees, which I installed between Manchester Peace Garden and the Town Hall.

The trees have their roots pointing into the air and their branches embedded face down in a concrete block, implying that the roots have to be watered from the sky. And what's quite extraordinary is that they do survive.

> Yes—their survival is itself a protest against the increasing brutalization of the natural world. In fact, my first thought for the title was, in German, *Strampelnde Bäume*. Translating that posed some difficulty, but finally all of us agreed that "flailing" was the nearest thing. *Strampeln* is something children do in their prams, when they kick out with their legs against something, and that was actually one of the central ideas of the work. Like children kicking in protest, these roots up there will be surviving in protest—continuously, in fact. The piece was meant, at the beginning, to have a limited lifespan, but the Whitworth Gallery acquired it as a permanent piece. In fact, the contract with Whitworth includes the statement, "should the trees disintegrate or be vandalized or shrink completely, then the Whitworth has the right to replace each tree with new trees," which means that potentially this is an indestructible monument.

The idea of replacing trees continuously brings me back to the conversation we mentioned earlier that you had with Marina Abramović. Marina greatly admires your work, and I remember her commenting about *Flailing Trees* that to cut down and destroy trees in this way was such an aggressive act. In trying to wrap her head around why you would do such a thing, she recalled a quote from Valie Export from the 1960s: "Yes, I'm doing very painful performances, where I really hurt myself, so why am I doing this? If I hurt myself and cause pain in order to liberate myself from the fear of pain, that means pain is OK." Marina saw that, in order to make us aware of what we're doing to this planet, your work needed to actually cause physical harm and destruction to the natural world.

> I support Marina's reading of the piece fully. Of course, I would like the public to feel a sensation of pain, agony, and possibly disgust at what has been done to these trees. I suggest that this is what we do to trees anyhow, because billions of trees are in fact attacked by chainsaws and all kinds of implements, day in and day out, all over the world. So this work is a subversion that's also a wake-up call, as you said earlier. A wake-up call to help us realize that we are finite, that this world we've built can't last, can't go on forever. Because, until very recently, culture was an attempt to escape from this realization that we're finite; culture was the idea that we would have monuments forever and, in turn, that our human world would exist forever.

Like the Renaissance illusion of infinity?

> Yes, exactly. Every great burst of art has been based on the idea that we have made it—that we have achieved the absolute in books, in philosophy, in art. We've created a shield against that through our culture. Isn't that the feeling you get when you look at different major cultures? But today we're thinking that it's all over. It doesn't matter, you see? There was a time a few decades ago when people thought they were all so clever, saying, "We know the earth will be burnt, but we'll escape." Now, slowly, people are beginning to think, "Alright, we can do that, and we'll do that, but wherever we go, we're trapped." Because, in the end, everything will end in nothing. It might not happen for a hundred million years, but we might as well give up now, because we'll never succeed in permanent life. When this idea percolates—and it hasn't percolated yet—people will accept that, and they may begin to think along the lines that I've begun to think: that we might as well abandon all these dreams of permanent life and technology, the escapism they offer us, and just live—live for the present, and not struggle for this ideal of immortality in the art world, but with something more positive and active and present. That's one reason I'm calling for action and for people to wake up. We're in a very fascinating stage in culture where people are finally facing these fundamentals—that we will die as a species. So why not just live for the present? Why not have a good time on Earth rather than keep escaping into space, into some unknown, endless future?

But do you fear that this might lead to hedonism or accelerationism—a further embracing of destruction?

> I think, on the contrary, that when this is realized—in another twenty years or so—the ideals of living on the land, living close to nature, living in a simplified manner, will start to grow. We're becoming more realistic. We're facing up to the dangers of biotechnology. Thirty years ago we didn't do that. Now everybody is talking about it. This facing up to reality—facing up in the right way, in a constructive manner—is essential and is coming. So, in that sense, I feel history is on my side, and it's one of the reasons I have more confidence today than I did twenty years ago.

Constables from the Metropolitan Police entering a mobile gas chamber at East Ham Police Station, London, as part of their training, March 13, 1937

Hans Haacke, *Condensation Cube*, 1963–68

Gustav Metzger, *Mobbile*, 1970/2005. Installation view, outside Generali Foundation, Vienna, 2005

Gustav Metzger, *Project Stockholm, June (Phase 1)* (model), 1972/2015

205

Gustav Metzger, *Project Stockholm, June (Phase 1)*, 1972/2007. Installation views, Sharjah Biennial, Sharjah, United Arab Emirates, 2007

Gustav Metzger, *KARBA*, 1972/2006. Installation view, Lunds Konsthall, Lund, Sweden, 2006

Earth Minus Environment.

In the past few days it has occurred to me that it could be /interesting to place the model on top of a car.

If you agree to this, then I would prefer quite a small car. Preferably not too new.

There are now a vast range of fittings to put on top of cars, to carry things.

We could choose one such fitting and quite easily secure the base of the model with screws from below.

Otherwise you could make a base made of wood or some synthetic material. I suggest something quite straightforward. A kind of box about 1m 20cm high. I leave it to you to make final decisions.

We have agreed that a plastic cover would be made to go over the car.

The box could be painted a neutral colour, grey perhaps — a light grey?

In case the car is used, it would be a good idea to take MDF and make a

Metzger's notes for a new installation of *Earth Minus Environment*, from his correspondence with Hans Ulrich Obrist, n.d.

Metzger with *Earth Minus Environment*
at Galerie A, Amsterdam, 1992

Cover of the British government's public information booklet *Protect and Survive*, 1976

Cover of E. P. Thompson, *Protest and Survive*, published by the Campaign for Nuclear Disarmament, London, 1980

Cover for the program for the 2009 Manchester International Festival. Concept by Gustav Metzger; design by Peter Saville

210

Marina Abramović performing in *Marina Abramović Presents* . . . at the Whitworth Gallery, Manchester, during the Manchester International Festival, 2009

Gustav Metzger, *Flailing Trees*, 2009. Installation view, Manchester International Festival

Gustav Metzger, from the *Extinction Handwritings* made for Hans Ulrich Obrist's Handwriting Project, ca. 2015–17

Gustav Metzger, *Strampelnde Bäume* (Flailing Trees), 2010. Installation view, Haus der Kunst, Munich

Metzger with *Flailing Trees* during the Manchester International Festival, 2009

7

Facing Extinction

I want to talk to you about the latest development in your thinking. We've spoken before about nature versus "environment," but now you've taken up the idea of extinction, over and above a general concern with destruction.

> Extinction is hardwired into the living world. What distinguishes the period since the end of the Second World War is that the rate and volume of extinction has become excessive, and threatens the future of life. Only determined, worldwide action can slow down the advancing destruction. But first we need to understand what's happening—and in doing so, I believe we need to realize that, for the first time, the most pressing issue of our day is extinction. Not just destruction, but very specifically extinction. Environmental degradation, genocide, atomic weapons, threats to small isolated communities, threats to languages, global warming, economics, catastrophes in nature, life wiped out by disease and hunger—all of this demands action. Economics has an important place in extinction, and must be considered, as the search for profit is fueling destruction, but it also must involve the arts, culture, the sciences, etc.

I'd like to ask very bluntly: Are you fearful for the future?

> Oh yes. Machines and weapons are destroying the world, and it seems nothing can stop them. We can only behave intelligently toward this overwhelming power, which, at the center, is nature. But it's hard to formulate a response. We are faced by what appears to be an insoluble task: the need to turn the entirety of civilization toward supporting the overwhelming needs of the nonhuman forms of life on Earth. Such radical social changes have occurred in the past and, at times, have been accompanied by bloodshed.

Can you give me an example of transformation at this scale?

> I have a kind of anti-example, which is the Manhattan Project. That was the secret code name for the American plan to make the first nuclear bombs. Vast resources and huge sums were deployed, with the aim of bringing everything and everyone available in America, in the United States, Canada, and other parts of the world to create the atomic bomb. It brought together scientists and technologists to achieve something that had previously seemed impossible. The race against extinction, as I hope the world will soon envision it, can be presented in comparable terms—except in our case all the aims are strictly peaceful. Facing extinction is a race against time; species are disappearing literally as

we speak these words. And if we lose this race, then we have to face a future that's lost. I'm going to sum up what I've written in the last two years; it's about mobilizing in a comparable manner to the Manhattan Project. I'm arguing that we're now faced with the possibility and the necessity of revitalizing the idea of getting all the capacities of humanity together for a technological aim. The technological aim, in this case, is to preserve life, is to help life to survive. And if it was possible to have the Manhattan Project, it must be easier to achieve this. It must be possible.

It puts it into perspective, to think in these terms. To realize we have already done what seemed beyond the possible at the time.

That's right. This is the point. It's a project facing humanity on a comparable scale as the Manhattan Project was in relation to the atomic bomb. And this is a very relevant argument because the Manhattan Project was, undoubtedly, an attempt to kill off life. And the project we are faced with is to preserve life.

To do so, we must go beyond the fear of pooling knowledge. The scope of the problem is so huge that we need to get artists, architects, designers, politicians, inventors, scientists, lawyers, and all the disciplines, thinking together.

Exactly. Religion, too. And, of course, the arts. These are all stepping stones toward a worldwide goal to impede destruction and encourage creation. This is essential.

To impede destruction.

And encourage creation, yes.

"Impede destruction, encourage creation." This sounds like a manifesto!

It's something I've thought about for a long time now. How to encourage creation, action. For example, it's clear that the legal professions have a key role in turning society around. Laws and procedures need to be changed to keep pace with new developments. We need to construct a range of penalties for offenses against nature. Animal rights and the protection of species and the furtherance of their existence are so crucial to human survival as well. We need to realize this and act upon it.

Do you see this as the major new area of commitment in your practice?

> Yes, I think any new works of mine will inevitably be connected with this theme.

This doesn't surprise me, because we've had many conversations ever since your 2009 exhibition at the Serpentine about this necessity, this urgency—it wasn't always articulated as combating extinction per se but the idea and impetus have been there from the very beginning. In 2014, after many years of discussion and planning, we held the Serpentine Extinction Marathon, following your idea and suggestions. When did you realize the urgency of talking about extinction rather than climate change?

> You're asking me to deal with a very difficult subject of memory. I have a quick answer to this question, but I can't remember when I first became very concerned about extinction, exactly. At least, *extinction* as a specific word to describe this concern. But I do remember an occasion one Sunday afternoon, I believe at the Serpentine Gallery, where we had quite a full house, by the way, for a lecture series. We spent the entire day, and possibly the day before as well, talking about difficult subjects. And toward the end of the presentations, I brought up the subject of extinction. And from then on, almost the entire audience changed gears toward this subject. And that's when I realized there's this big interest and also this controversial issue of extinction. I decided almost immediately to arrange a separate afternoon at another venue, where we would only talk about extinction. And again, this was a very big success in terms of numbers, in terms of excitement regarding the theme. So, that's how it started for me—it was the product of a very hands-on realization, I might say. I felt I was coming to this issue with fresh eyes, seeing the excitement and interest the issue could generate.

I must say, ever since you first began speaking about extinction—at least, as far as I recall—there was definitely a sense of real interest. One presentation on extinction followed another quite quickly.

> And here we are, aren't we? At a peak in interest when the subject is very prevalent in public discussion. I welcome that very much. But every time the word *extinction* comes up, there's always a sadness, a deep sadness and despair linked with the very word itself. And for me, of course, it has a particular significance in as far as almost my entire family was wiped out in the course of the last war, wiped out, extinct. Not forgotten—no, not forgotten—but extinct. So there's an endless gravity to the term, a personal gravity for me. The thread of it, between the horrors of the past and the fears for the future—so it goes on.

I think that's why, even when you speak about extinction in very general or ecological terms, there's an immediate sense of the urgency and importance of what you're saying. There's a resonance because of the link to the personal. Even if the listener doesn't know your history, they can still feel the weight of that link.

> Yes, and today, more than ever, everyone is acquainted in one way or another with extinction. Extinction is the rule worldwide: uncountable and unimaginable numbers of animals, birds, humans—the list is endless—are becoming extinct. Largely through human decision, through human interaction, mind you. And what we're going to do here, I'm sure, is open up areas, vistas, on extinction that haven't been explored or understood before. And so I hope this discussion, as with all of our work during the Extinction Marathon, will extend our capacities to feel and reimagine what humans are doing to animals, to plant life, to nature in the wider sense. I hope it will make a difference, if only in extending the knowledge of what's actually happening in this life-and-death struggle between human beings and the rest of the universe.

I remember also that when we first started talking about this, you mentioned the artist being at the forefront of the struggle and the need to change things. You said, "Nobody acts if we talk about climate change. It doesn't trigger change. We need to talk about extinction to actually talk about change." So it was a very conscious decision of yours to turn from speaking about climate change to speaking about extinction.

> You remember that?

Oh yes, you told us that the phrase *climate change* doesn't make people act. This was still very early on in public discussions of natural destruction.

> Yes, well, I realized that, with the phrase *climate change*, it seems like there's a limit to what can be done to stop it—there's a feeling of passivity and helplessness implicit in it. But you can stop extinction. This is actually the key to the phraseology, because if you analyze the words, they are all about mobilizing. We have a clear sense of what extinction means and there are precedents for trying to stop it.

Dürer said that there is no art without nature. Why do you see the artist at the forefront of this struggle, and how can artistic practices contribute to change?

221

Art, through its history, through its thousands of years, has always been interactive with nature. Without nature coming in and inspiring the artist to create and to flourish with the art, expand with the art, there can be no creation. Without nature, art is superfluous, expendable. Art contains so much that, in fact, our civilization, our particular civilization, doesn't especially want. We live on expenditure, we are dependent on circles of excess. Like in Renaissance Florence—the courts of Florence, for example. The courts of any period in history are dependent on excess. But it doesn't have to be this way. Our task, now, as artists today, is to recall the richness and complexity of nature, to protect nature as far as we can. Here is the opportunity for art to extend its functions, to inspire new fields of action, and, by doing so, enter new territories that are inherently creative and primarily for the good of our world. That's why the art, architecture, and design worlds need to take a stand against the ongoing erasure of species—even where there's little chance of ultimate success. It's our privilege and our duty to be at the forefront of the struggle because we're at the forefront of cultural conversations. There is no choice but to follow the path of ethics into aesthetics.

Am I right to say that this was the impetus for your campaign *Remember Nature*, which took place on November 4, 2015? This was a day of action across the arts, to create an artists' movement against extinction.

Exactly, yes. It was an appeal for the widest possible participation on a single day across the arts—we wanted to start a mass movement to ward off extinction. What we wanted to do—and what still lies ahead for us in the future—is bring together artists, engender creation, and unite in art actions covering the entire country. To create a collective artwork to remember nature. Because we must act against the destroyers of life with all the power and ruthlessness at the command of life. We cannot evade what's happening. We have to hit back. We have to introduce laws. We have to have ongoing conferences. Whatever is available to us at any time. The whole world has to come together and minimize, if not abandon, the destruction.

This was widely successful—and you had a lot of participation from younger artists and students as well. It reminded me in some ways of your newspaper projects, like the one you did at Farnham in 2014, because it really encouraged anyone and everyone to participate. It was a way of saying you can act simply by participating—there's meaning in that engagement. These recent newspaper pieces invite the viewer to come and cut out clippings.

> Things got a bit complicated at the Farnham show you mentioned. I was only present at the opening. But you saw the installation?

Yes, yes. Can you tell me about how it evolved? Because it's obviously connected to earlier newspaper pieces.

> Oh, very much so. It's directly connected with the first time I used newspapers, which was at Gallery House in 1972. And like that first work, anyone who came to the gallery was asked to cut out and pin up newspaper cuttings—this was the principle at Farnham also.

Previously the newspapers and instructions for participation covered all different topics, but in these works the focus was solely on extinction.

> Yes, I did that because I'm arguing that the greatest danger to the world is extinction—it's even more dangerous than climate change, because climate change is now, to a large extent, irreversible. That's the scientific view, which I follow through newspapers constantly—it really would take hundreds of years to begin to reverse climate change for the better, and, as you said, discussions of climate change don't lead to any action. But extinction is in a completely different area. Extinction is almost entirely man-made, human-made. It's 90 percent human-made, so take that away and there'll only be 10 percent left. And that's why the whole world needs to work on it.

You believe that a concerted action to combat extinction still has a chance to make a difference, to halt destruction?

> If the whole world combats extinction, I believe we'll stop it. So, that gives it an advantage over climate change because extinction is reversible. And directly punishable. For example, somebody who is found guilty of cutting down a forest, whether it's in Europe or wherever it's at risk, wherever it's in great danger, that person or those organizations could be brought before a judge or jury and sentenced in such a way as would be comparable to the sentences you would give to someone going to a village and shooting all the inhabitants. This is a comparison that's fully justified, I think. And so the penalty must be severe, should be severe. This is where the work of a very interesting person, Polly Higgins, has become so important. You remember during the Facing Extinction conference she talked about her campaign to introduce an international law making ecocide a crime. If legal penalties can be applied, they should be.

To return to the newspaper work—can you describe how the space at Farnham was set up to encourage participation?

> I'm very happy with how it turned out. The block of newspaper is, itself, a fantastic sculpture. The block in Farnham is actually amazing. Of course, the gallery is a very long, quite long gallery—it's a beautiful gallery. So you came in, and you had a huge pile of newspapers. This was all done by the students, and the students had been invited to take individual newspapers out and cut them up and frame them. In Farnham it was on a very, very large scale. It looked beautiful. And it was very important to me to have this student involvement, to have the project speak to and be taken up by a younger generation.

I feel this has become more and more of a concern for you—speaking to younger generations.

> It certainly has. We're in the middle of a number of paradigm shifts concerning consciousness and the difficulty of going beyond where we are now in understanding our present situation. There's a gap, an enormous gap, between generations, which has exponential aspects. Here, I think, you'll agree. By the way, all I'm talking about is what I read in the media. I'm not a very clever man. I'm responding to and quoting what I read. But let's spend a few minutes on this. You have the older people, who aren't in touch with actual experiences anymore, and certainly not considering the future. So the gap is exponential: every day the young and the very young are moving into it, and their grandparents aren't.

That's certainly true. And perhaps has always been the case, throughout history.

> But it's accelerating recently. This is very important and it relates to the way we—and I mean "we" in a broad sense—look at reality, which is so limited compared to the speed of the changes that are happening today. Our ways of understanding are simply too slow and too limited. This is one of my great interests. I think it has to do with society, especially those elements of society that desire a change of quality and significance—who need to constantly discuss, and to understand and communicate. So I'm very concerned with speaking to a younger generation, as I think they're the ones capable of making change. And at the same time, I'm more and more aware of my age, the longer I go on living—and you'll agree, it's only by the grace of some supernatural beings that I'm still here. I was speaking to someone who deals with these matters recently, and he suddenly asked me, "Well, what's your

age?" And that was a few years ago. I think I said, "Eighty-something." He looked at his document and said, "Statistically speaking, you should be dead by now."

But that's terrible!

> Well, but I have to bear this in mind. I have lived longer than most people and I should be grateful for that, even though it puts me squarely in the older generations I've just been discussing. But what's interesting to me is that, at the same time, I know that having lived that long gives you the opportunity—and perhaps creates the necessity—of being more radical than you have been in the past.

You once said you were becoming the aggressive Metzger again—is this a return to that mode?

> Indeed. I find the more I look at the situation we, and animals, and plants, are in, the more I'm prepared to stop people who vandalize nature, who do this long-term injury, not just to human beings, but to the plants and living creatures of this world. And so, looking forward, I want to make it clear that my agenda will be more radical than ever before. And the explanation is in the inherent historical development. As time passes, as we proceed forward, the world is being transformed in a negative sense. The trend is toward a galloping increase in the rape of nature, in the decimation of living creatures. And as a peak, of course, stands the killing for so-called medical purposes, and for commercial considerations, of animals. I want my work, made more radical by my age, to speak to people who are young and who have a real impetus to change this trajectory.

I should add that A. S. Byatt, the great novelist, told me last week that it's also the small creatures that disappear and no one notices. She said that during her childhood there were all these centipedes, but now she hasn't seen a centipede in years. Bees are disappearing. The unnoticed changes are the most worrying, don't you think?

> Yes, which is why I'm having to put forward views that I wouldn't have dared to ten years ago—because we need to address these issues more aggressively. And that's where the call for action becomes even more urgent. I should put it like that: this call for action will be expressed more urgently, far more urgently, in my work. And we are necessarily forced to be more aggressive toward the aggressors. That is now my view. If we don't do that, we are negating our responsibilities. Because

it's absolutely essential that people act. We have endless talks—there's endless talk among people in the media: "What shall we do?" I believe that unless some kind of action takes place, it's a waste of time. That's why I've made it the center of my most recent campaigns—the need for all of us to act, whether we're artists or students, in the humanities or the sciences or the legal fields. We must act now.

Action is, of course, also a way to assert life in the face of death.

Yes. In the fear of extinction, it's specifically urgent, this call to act. And it's required because the species, the animal and plant species, are being attacked left and right, forward and backward, by the way the world is run. The world is leading nature in ourselves to the point of collapse, to the point where life itself may cease to function on Earth, and there are certain voices calling for us to establish ourselves on other planets, in other solar systems, in order to try and escape the complete collapse of life on Earth. Now this is being put forward seriously by leading thinkers in the world. And it has been taken very, very seriously indeed. But it's absurd—it's an attempt to escape reality. Instead, we must turn this seriousness to the heart of reality, which is my concern and my attempt to bring the attention of the world to extinction. Because what can be more serious than facing the collapse of life on Earth? And with it, the culture, the unbelievably immense culture and art and science that humanity has established. And so what I say is what I think millions of other people feel: let us get on seriously and act in response to this threat to our future. Let us stop extinction.

Cover and weekend schedule in the brochure for the Extinction Marathon, Serpentine Galleries, London, October 18–19, 2014, designed by David Rudnick and Raf Rennie

SATURDAY 18.10.14

PROGRAMME — All times subject to change

12-3pm Serpentine Sackler Gallery

Julia Peyton-Jones, Introduction
Hans Ulrich Obrist, Introduction
Gustav Metzger, Introduction
Cornelia Parker, *Howl: A Tirade*
Jonathan Baillie
Adam Curtis
Gilbert & George in conversation with Hans Ulrich Obrist
James Bridle, *What the Network Teaches*
Jonathan Rosenhead, *Climate Change and Extinction – A Racing Uncertainty*
Marcus du Sautoy, *Death by Mathematics*
Alessandro Bava, *Dialogue between Nature and an Icelander*

3-7pm

Stewart Brand, John Brockman, Richard Prum and Hans Ulrich Obrist, *De-Extinction*
Molly Crockett, Helena Cronin, Jennifer Jacquet, Steve Jones and Chiara Marletto
Georgina Mace, *Are We in the Midst of a Mass Extinction?*
Richard Fortey, *The Long and the Short Stories of Extinction*
Jimmie Durham, *The Family*
Etel Adnan, reading from *The Arab Apocalypse*
Joanne Kyger, read by Etel Adnan
Marguerite Humeau, *Cleopatra 'That Goddess' Recital*

7-10pm

Mette Ingvartsen
Yve Laris Cohen, *Ligusticum Porteri*
Hetain Patel, beMovie 2.0
Susan Hiller, *The Last Silent Movie*
Adam Thirlwell and Daniel Kehlmann, *Conversation with Thomas Bernhard*
Jack Halberstam, *On Being Late, and Other Short Essays on Becoming Ex-Human*
Ed Atkins, *Happy Birthday!! we sang*

10pm, live stream only at thespace.org and EXTINCT.LY

Anna Zett, *This Unwieldy Object*

SUNDAY 19.10.14

EXTINCTION MARATHON

10am, Gate Picturehouse

London premiere of *Seeds of Time* (2014, 77min)
Gate Picturehouse, 87 Notting Hill Gate, W11 3JZ
Free, booking required at seedsoftime.eventbrite.com

12-3pm, Serpentine Sackler Gallery

Julia Peyton-Jones, Introduction
Hans Ulrich Obrist, Introduction
Cary Fowler and Sandy McLeod in conversation with Hans Ulrich Obrist
James Thornton, *Saving Animals in a Lawless World*
Irma Boom in conversation with Alice Rawsthorn, *The Book: A Case for Survival*
Shimabuku, *Can You Clean A Fish?*
Katja Novitskova, *Neverending Story: Patterns of Survival and Expansion Curves*
Korakrit Arunanondchai, *2012-2014 (Trailers)*
Trevor Paglen, *From Fibre-Optic Beings to Fossils in the Sky*
Elizabeth A. Povinelli, *The Three Figures of Extinction*

3-6pm

Eyal Sivan
Anna Zett, *DINOSAUR.GIF*
Franco 'Bifo' Berardi, *WATCH my Future (The techno-media Utopia: pre-scription of our future life)*
Federico Campagna, *The Root of Extinction*
Jesse Darling
Ed Atkins, reading W.S. Merwin, selected by William Gibson
Heman Chong, *A Short Story about the End of the World*
Martin Rees, *Threats to Humanity; or, Will We Survive the Century?*
Lisa Ma, *Dilemmas*

6-8pm

Chris Watson, *Ring Angels*
Jeremy Shaw, *Quickeners* (excerpt)
Sophia Al-Maria, *Whale Fall*
Benedict Drew
Lily Cole, performing Yoko Ono's *Bell for Serpentine*

SERPENTINE MARATHON

Heather Phillipson, *A Whole Lot of Nothingness*, 2014. Stage design for the Extinction Marathon, Serpentine Galleries, London

Metzger at the Extinction Marathon, Serpentine Galleries, London, 2014

Marina Abramović, Metzger, and Hans Ulrich Obrist at the Manchester International Festival, July 5, 2009

Text and images announcing the worldwide campaign and day of action *Remember Nature* in 2015, as published in a special issue of agnès b.'s *Le point d'ironie*, no. 58, a collaboration between Metzger and London Fieldworks

THIS IS A WORLDWIDE CALL BY GUSTAV METZGER TO REMEMBER NATURE.

THIS APPEAL IS FOR THE WIDEST POSSIBLE PARTICIPATION FROM THE WORLD OF THE ARTS.

THE AIM IS TO CREATE A MASS MOVEMENT TO WARD OFF EXTINCTION.

www.remembernaturegustavmetzger.wordpress.com

Gustav Metzger, call to action for *Remember Nature*, November 4, 2015

Bruce Gilchrist and Jo Joelson (London Fieldworks) with Gustav Metzger, handwritten note for *Remember Nature*, 2015

Remember Nature

Students respond to Metzger's worldwide call for a day of action to remember nature, a campaign supported by partners including the Serpentine Galleries, the University for the Creative Arts, Farnham, and Central Saint Martins (shown here), London, November 4, 2015

234

Views of *Gustav Metzger: Decades 1959–2009*, Serpentine Gallery, London, 2009. Left: *MASS MEDIA: Yesterday and Today*, 2009. Below: *Kill the Cars*, 1996/2009

8

Going Back
to Go Forward

Before we start, I can't help but notice that you have a telephone now. That's really new.

> Yes, it's big news. This is my first official telephone in my name. I must say I like it now. It almost makes me wonder how I ever managed without one. I would cross the road to go to the phone booth any time I wanted to call, which is now too dangerous for me to do.

You often called me from subway stations. I remember, I was working in Paris when we met and my secretary would get a call from you. She would rush into my office, even if I was in a meeting, because she knew you were calling from a payphone and time was of the essence. "You have to hurry, Gustav is calling from a booth in the metro," she would say. I would rush to the room where the office phone was and make a call back to whatever number you'd given. But often, by that time, it was five minutes later, and you had already left the telephone booth. So then I was ringing a metro station—the phone was ringing, ringing, ringing, and then sometimes someone else picked up. It was very special.

> It's much easier now, but less charming.

I'm actually very glad we began talking about this, because I was planning to start this conversation with our own history. I wanted to begin at the beginning. We first met in the mid-1990s. Back then, after a long absence from the art world—after your famous art strike—you returned with a small exhibition in a bookshop called workfortheeyetodo. Your Historic Photographs were exhibited for the first time there and a book was published with your texts as part of the project. That was shortly before *Life/Live*, our first collaboration, where you made a large installation at the Musée d'Art Moderne in Paris. Many years have passed since then, and you've taken part in exhibitions consistently, some of which we've collaborated on. And last, but not least, we've had many conversations over the years, starting from when we took the bus from Waterloo to the Cosmo café in London. Today, I wanted to mention all this, because I know you've recently returned to manual forms of making—drawing—for the first time in many years. It's a major shift in your practice and it makes me think of all the intervening stages in your career, but also that there's something very sincere and radical in this return—something almost radically idealistic. You recently had a show called *We Must Become Idealists or Die*, and I wonder if this is all connected, for you—a newfound idealism and a return to drawing?

I want to answer that fully. You're right to bring up the show, which was a retrospective of my work in Mexico City. To explain it, I need to go back all the way to the beginning, even further than our meeting—to when I was a teenager. It was a heady time, I was living in Leeds, having come over as a refugee from the war, and often I would go to Leeds Central Library to read about left-wing politics. Then I came across an author who is completely unknown today but who shaped my life and the way I work: Dr. Edmond Székely. Every book that was available by Székely I would borrow and read. There were several and they were big books.

He was an idealist?

He was. And this recent exhibition you mentioned is absolutely a reflection on my time in that library. Székely's writings and lectures put me in sync with so much: the idea of nature cures, looking after nature, and animal welfare. Then, the story continues rather nicely: in 1944, I went to live in a left-wing commune near Bristol for six months and, afterward, I moved by bicycle—much of my traveling back then was by bicycle—to Champneys nature-cure clinic outside Tring, in Hertfordshire. I've mentioned this before, I'm sure, as the source of my vegetarianism, because everything there was organic. It really opened me up to nature—I see it as a direct precedent to my work on nature and extinction. So that's the first piece of the story.

And that title, *We Must Become Idealists or Die*—where did that come from?

It came from a W. H. Auden quote, it's an adaptation of an Auden quote. But let me go back to go forward first. You see, in the 1980s, I withdrew from artmaking, moved to the Netherlands, and spent around five years on a study of Johannes Vermeer. I suddenly realized that he was, perhaps, the greatest painter and that he had always been important to me. I was hooked on him and on the Netherlands of his time—the art, the religion, the countryside, the people—which was relatively calm, controlled, and, although commercial, within bounds. It offered a counter to the more fevered culture that we are in. Vermeer and the history of that period fascinated and challenged me, and I do like a challenge. I thought the best thing was to write a biography as an act of homage. I had almost finished writing it and then, somehow, the manuscript disappeared, or someone took it. It's very sad.

That's a tragedy, to use one of your words. I would have loved to read it. Was that coming out of the "Years Without Art," the three years in which you didn't produce works?

> It came directly out of that. Because "Years Without Art" instructed artists to not make art, but instead study art, and get to understand what it's all about. So I was following up a demand that I had made in public, and simply applied myself to testing how far a single person like myself can go in understanding this extremely difficult area that is Vermeer. At the beginning of 1990, I moved into a steady research period, where I would endlessly look at his work, and read all the literature I could get hold of. It was a challenge to myself to deal in a new way with an old subject. I was becoming an art historian. I was more or less seeing myself in the tradition of art history. Through the study of Vermeer I was expecting to become a better painter. I thought that if I could penetrate this mystery, then, when I painted again, I could hope to be better.

What was it about Vermeer in particular that interested you?

> Vermeer—and I was thinking of it this morning, well, certainly yesterday morning—was the undiscovered sea. When I asked myself this yesterday, why was it that Vermeer held this fascination for me—a fascination that lasted four, five years—I realized it's because of his mystery.

We know almost nothing about his life. His history is famously blank.

> Almost nothing at all! Nothing in terms of documents, in terms of signatures, transactions. He is an undiscovered island. The literature can't penetrate Vermeer, which means one has a great freedom to have one's own ideas about him, since there's no agreed way of approaching this man. And since it's almost impossible to find documentation on what he did, very little firm evidence, it turned into a great challenge to try and go beyond what has been known about him. And the paintings are simply among the greatest in the world. So I lived with them for half a decade. There are many artists I admire, both old and up to the present day; Rembrandt would be high up, and Goya. But I think that, if I had to choose just one to live with, it would be Vermeer who I would most want to go on being concerned with.

I'm sure many other artists and art historians would give you a similar response.

> It's just so fascinating to speculate on the basis of what we have. We have a certain amount of documents, we certainly have paintings—we think the catalogue of Vermeer is almost complete in as far as he didn't produce hundreds of paintings, like Van Gogh or Francis Bacon, for example. So that's the first fascination that Vermeer has for me. It's a mystery. But the mystery is illuminated by such beauty, such perfection, that many of us, including myself, would say Vermeer is the greatest of all the painters in the Western tradition. Which is saying a lot, because we've had thousands of magnificent paintings and sculptures in Western art alone. He's at the peak. And so all you can do is to sort of kneel before him and say, "Great master, we respect what you have done."

Was your research focused on discovering his biography or concerned more with analyzing the works themselves? How did you approach the vast blank space?

> Well, I tried to write about the key elements as they are transmitted in the literature. As an art historian, all you can do is climb on the shoulders of generations of other art historians. And that's what I did. I had this thought—actually, it came to me in a visit to Switzerland, which might interest you. I had nothing very specific to do at that point, I had just completed the "Years Without Art," as I said. And so I asked for an appointment to talk to the director of a museum who I had already met sometime before. And I came to him with a proposal that art history should be more up-to-date, should include more scientific techniques. And I suggested we arrange a conference in his museum to discuss these ideas. And he was in fact very sympathetic, but nothing came of it. But I stayed on in Zurich and started looking around the art life there, and I realized that Vermeer was perhaps the best subject for this research, partly because so little actual knowledge is available on him. And that's how it started. After about a year doing this in Switzerland, I moved to Holland—it seemed the most obvious place to study Vermeer. I spent another four years in Holland, researching Vermeer almost on a daily basis—his work and his environment. And my research was going extremely well.

And what were the major findings? Do you remember? Because it's amazing that four years of your life have gone missing. It's almost ironic that, in researching a man with a mysterious biography, part of your own gets lost. I'm sure one day your writing and research on this topic will be discovered. It must be somewhere. Things do come to the surface. But it's interesting in terms of memory, so many decades after. What do you remember of the essence of what you found?

> I'm not going to give you the whole, all of it, because other people may get there first. But let me try and give you some answer. Let me try.

Of course, you can't summarize four years in a few minutes. I was just wondering if maybe some sparks come to mind.

> As you say, the manuscript may turn up, and when it does, of course I would want to claim authorship. And if, now, I tell you my theories on Vermeer, doing so could well torpedo my claim to originality. So I can't really answer your question in fairness, but let me give you some response. First of all, in the course of four years, I developed the capacity to read Dutch. And that helped me to develop certain thoughts that aren't open to people who don't speak the language. In other words, I notice most of the research on Vermeer isn't done by Dutch people, but by foreigners. Now, increasingly, as the four years went by before I returned to London, I realized that this knowledge of Dutch is extremely important. It has helped me a great deal to get where others couldn't go before. And so this part is my answer to you.

So, to understand more about the mystery of Vermeer, it was important to understand his language.

> I think so. And also there's literature on Vermeer that's only in Dutch. And my original language, German, was most helpful there.

Obviously I'm extremely eager to find these documents so we could publish them under your name. Is there any hint you could give me on how we could find them?

> Oh yes, I could. But again, not publicly; we may do that privately when we finish the recording. And my manuscript, by the way, is contained—beautifully collected and ready for further research—in a briefcase, in good condition. And so, if somebody comes across it, they will realize it's of some value. As you say, it may well turn up as a result of our interview, if it's published. When it's published.

I find it very interesting that in answering my question about idealism, you wanted to go back to Vermeer, to the mystery of Vermeer's paintings, which must have felt like such a contrast to what you had focused on up to that point—highly technical and scientific works in auto-destructive art. You've said before that you believe there needs to be a return of drawing to art schools, that the future of art is about a return to foundations and to this connection with the body and art. Was

that something you felt during your time studying Vermeer?

> Yes, it's something I feel very strongly about, because drawing is the starting point of an artwork. Paintings begin mostly—not always, but mostly—with a preliminary drawing. People have been drawing for many thousands of years. In the Renaissance, artists and art connoisseurs said that drawing was the basis of art. This is the case not only in the Renaissance, but in other periods as well. That's one reason I wanted to go back to Vermeer. And now, of course, I myself am lucky enough to have a studio in the center of Hackney, where there are six studio buildings in a row. One day I realized that I had to start drawing in this studio, because in one room—the upper room—the light is particularly complex and fascinating. That's where a whole new series of drawings emerged. I'd like to show you some.

Please.

> I've brought along two sketchbooks and a sample of drawings on sheets. You can see that this sketchbook is from 2003, the first one, and this one is up-to-date and includes drawings from the last few months. This sketchbook was made in the park; it has drawings I've been making in London since 2003 or thereabouts.

You said the studio was in some ways the impetus for you to start drawing again—

> Yes, the light there, the exceptional light, and a feeling that I needed to use it.

How did you come to find the studio? Is it a public studio?

> Yes, it is. There are six adjoining studio buildings; it's a terrace of six buildings. They were built by Hackney Council to provide studios for artists and craft workers. I began to realize there was a chance to work in the space, and I started my first drawings indoors, in the studio, and I'm still working indoors mostly, or sometimes outdoors in the park.

After not drawing for such a long time, how did you begin?

> I can't say, exactly, but I believe it was on sheets of paper. I've got some of them here.

It would be great to look at them.

> These are from 2003, outside with trees and landscape. They're variable: sometimes the light would change and I would change them.

Are these drawings related to the light in the studio?

> These are outside. This is the sketchbook for outside, among nature, trees, landscape. You have to consider that I would move.

They're multidirectional.

> It's the pattern I want to draw, rather than the subject matter.

Are they very fast sketches?

> They're all fairly fast.

After starting with drawings in the studio, did you feel you needed to go outside to interrelate the medium with nature?

> I suppose, first of all, I just wanted to be in the open and the sunshine and all that, but also the need to contact nature soon became important, yes.

Are these drawings going to be exhibited individually?

> Well, anything is possible. Ideally, a sketchbook would be kept together, but so often it isn't. It depends. But I'll show you single drawings whenever you're ready. I have a collection of around two hundred single drawings I made in the studio. I've brought some examples.

I'm thinking about that conference many years ago—on the future of art schools, during the 1997 New Contemporaries show. I was one of the panelists, with Gillian Wearing and Sarat Maharaj, and you were in the audience. Toward the end, you stood up and said that the problem today with art schools is that people no longer draw. That it needed to be a daily practice.

> I still believe that, very much. This is essential.

So the activity of drawing is also a form of resistance against technology, a means of insisting on the body in art?

> I was really anti-technical at the time, certainly. I was giving talks at art schools, and I emphasized this very strongly. This is connected

with drawing, too—the rejection of technology, the partial rejection of certain aspects of technology. Some of it, of course, is a good, genuine development, but there's so much going on in this country now. Not only in London, but all over the country there's a vast expansion of artistic activity, manifestations, performances, exhibitions—in places that spring up every few weeks. But I believe that, with this proliferation, there's quite a lot of weakness. When I go around the art school diploma exhibitions, I see a lot of weakness, and a lot of playfulness, which doesn't in the least correspond to the reality of life—neither in this country, nor worldwide.

You find this worrying?

Extremely worrying. Taking the world lightly is just not adequate to the challenge. That's one point of criticism I would make regarding quite a lot of today's art—not just among art students and graduates, but, generally speaking, in exhibitions by younger people. And that was part of my anti-technical stance. I felt that a return to a daily practice that engages the artist directly with the body would help counter that, because it would force an immediacy—you have to aim at portraying and recording what you see. That's how I approach my drawings, at least.

So they're also related to records of what you see, to memory.

Exactly, to memory.

An insistence on art coming from the body is in the spirit of Bomberg.

You can certainly see Bomberg's influence here. He, and especially his students, would sometimes rip the drawings. If you were in his class, you'd often draw and then have the next sketch coming through on the next sheet.

You'd see the imprint on the next drawing.

Exactly. But, of course, I don't mind. Occasionally I put something in between to stop it going through.

So Bomberg is still present.

Oh yes, that's completely true, especially in these landscapes. Of course, he loved painting landscapes. It's a point I hadn't considered until just now.

These are amazing—and they haven't been shown at all?

> No. Only one person has actually looked at all of them, and that's Norman Rosenthal. About two years ago he came to my place and spent quite a bit of time looking at everything. There are more than two hundred drawings, separate from the sketchbooks. One person who strongly influenced this work is Ludwig Meidner. I believe that spirit comes through in my drawings from the past few years. Expressionists have always influenced me, even when I was studying.

Of course, Bomberg was an Expressionist, to some extent. Although his legacy has been somewhat forgotten today.

> That's true. There was a retrospective in Kendal in 2006, but I missed it.

Can we talk about these depictions here of the human body?

> You should see it from this angle. It's like part of a body, which of course it is, because one works with the body, doesn't one? This is the body. This drawing, you will find, comes up again and again on single sheets. You'll see it once more in a moment.

How would you describe it? It's a very blurry zigzag.

> There isn't much of a landscape about it; it's very subjective, and similar to what I was drawing in the studio.

Do you know where a drawing will go when you start it?

> Very often it just happens.

As James McNeill Whistler said, "Art happens."

> Sometimes I don't look at the page while I'm drawing; it's just done. Sometimes I'm astonished myself. I should explain that I used conté pencils during this period—not ordinary pencils.

And I see you're using special notebooks called Bumper Value Jotters.

> They're ideal. I suggest we switch now to the others—the single sheets I've brought.

This conversation is being recorded on the third floor of the National Theatre, I want to note. It's the most unlikely of spaces, which is one of your many London secrets.

> That's right. It takes a long time to find places like this. Here, look at this. The largest collection of my drawings is on single sheets, and it's a different paper. Thin paper. And I'm using wash. They're quite inventive. Let's see what I've got. There should be a general survey.

How do you choose the format?

> That depends on the paper I've found. They're never big. This is the biggest; nothing bigger. I'll leave you to see what we've got.

Unlike the notebooks, there's a little bit of color coming into play here.

> The color, yes, and all kinds of bits and pieces of material, too. These were done in the studio.

These are very architectural.

> Yes. At the time, I was attending the Architectural Association for lectures and exhibitions. These are, as I said, samples. By the way, here I was using wooden forks. You know those wooden forks you get?

Yes.

> You find this coming up again and again, forks used as part of the drawing—in other words, wood and nature coming in.

It's something between a drawing and a collage.

> Interesting point, yes. I'm glad you said that. These are samples. Some are smaller. Again, this is studio work. You see the comb coming in here.

So you use pencil and then you use wooden forks to almost carve into the paper?

> To almost carve, yes. Here you come to the experimental part. I would just pick something up. Oh, I know what this is—this is, in fact, my own make of material. I had supports and turned it into drawing material, and that's what you get here. This means, of course, that some of it got lost in time or dried up.

What's the status of these artworks for you? I ask because you've resisted the art market for such a long time. Will these drawings be sold eventually or will you keep them?

> The answer is quite straightforward. These are potentially for sale. In fact, I intend to sell them, and I want to sell them. In a sense, I need to sell them in order to survive. So these drawings mark a big shift, not only in my making of them but in my attitude to them and my conception as to the future. They will be sold, if it works out.

Will you start to be represented by a gallery?

> I intend to stay out of the gallery system, definitely. It may well be that I have an agent who acts for me, but it wouldn't be a gallery. No. I'm determined to stay out of that. It just doesn't interest me. But why should I just sit on the drawings? I've now got at least three hundred of them. The goal can't be just to accumulate them. Of course, accumulation is a part of this, but I'm open to change, and if I make paintings, they would also potentially be open for purchase—preferably by an institution.

As happened in France when your work was acquired by the French national collection.

> I would prefer that they end up in public collections, if possible, and if the interest is there. I don't know whether you've seen the DVD made by the Arts Council about my work. There are ten sections, and there are two on drawing, where I'm showing these drawings and talking about them.

You had a second notebook, didn't you?

> Yes. I want to show you some more of these.

That would be great. Where will the exhibition be? Has it been decided yet?

> No, there's nothing. As I said, you're the second person to see these drawings. People know I'm drawing, and some have asked if they could see them.

It's extraordinary work.

> A lot of surprise is involved. Have we seen this already?

No.

>Here you see the pencil, or rather, the width of it.

These drawings are more linear.

>True, but you also see this light, which is actually at the center of the drawings I've made in the studio. One day you'll come there, when it's a bit more organized. The studio I'm working in is on the second floor. It's got a large glass door on one side, another large window on the other side, and two top lights. The light in there is literally out of this world, and it's this light which is the center, the inspiration for all this work. You can see the light, can't you, here? This is all about light, isn't it? You ask me why I'm drawing, and it's being in this studio that started it. I thought, "I must sit here." Most of the day, sunlight comes in through the glass doors, and it's the sunlight that's the inspiration for my drawing. When I show you my last sketchbook, this will become even more apparent.

There's an astonishing complexity here.

>This was done without thinking, and very quickly. You see a bit of color comes in, a bit of the rice glue. This is all the rice glue stuff. This, as I look at it, relates to the history of the graphic arts. You can go and see this kind of line, these tones, throughout etchings or graphic arts, back to 1500. Here, the light is coming through and changing the work.

It's almost self-made.

>*Self-made* is a good term. They just appear. There again, you see, you just pick something up and throw it in without planning.

Here, again, we have the Bombergian breakthrough.

>That's right, yes. These are the kinds of drawings that are in the film. This could be a detail from Meidner, couldn't it?

Yes, we're back to Meidner.

>Explosion, chaos. Now I'll show you my latest work. We've got a date. In this sketchbook, I dated the last drawing at the end of the day, so this is March 1, 2006, and then it starts again.

Lyonel Feininger also comes to mind, based on these sorts of constructions, but it's more Meidner than Feininger.

> Oh yes.

The collage enters again in these new drawings. Was that a planned decision or did it just happen?

> This was quite spontaneous. I didn't say, "I want to change," I just had some material and stuck it on without thinking about it. I only realized the potential of the technique after I'd made a few, and then I kept going. These were all made in one go, in one afternoon. But again, it's all about light, the reflection of light, which was central to my work with kinetic art as early as the 1960s. Here you come back to the application of the rice glue that's coming through again, picking up material that's used. And these were all done one after the other—not quickly, but in one go, in one afternoon, and again with intense sunlight. You can see the light coming through.

Is drawing a daily practice for you now?

> No, not at all—on the contrary. There have been months in this sketchbook when I didn't do anything.

Then you suddenly start again. Do you have any unrealized drawings? I suppose there are many.

> Yes, I want to continue. I believe that my future is with drawing. I'll go on working the way I've done for the last decade or two, but I want to make ... I won't say I want to make better drawings, but certainly different drawings, and I want to understand more. Anyway, I think there's a great future in this, if I get the chance to stay on.

What about painting? Can you imagine working on canvas again?

> Yes, but drawing is the beginning, drawing is the start. And then hopefully paintings, too. This is the window in my studio. The door, with the window. You see it further on here: I'm drawing the glass window. The light comes through again. There comes a point when it becomes really abstract—here. And, of course, this relates to Constructivism, which I've been very interested in, the last year or two.

So Constructivism came back, too?

> Russian Constructivism, very much—and Suprematism is something I've been thinking about a lot. Look at this. This is exactly like the painting on Suprematist ceramics, isn't it? It's exactly this language. I studied the socialist ceramics exhibition at Somerset House—I've got the catalogue, it's magnificent. So this certainly is the inspiration for this series of works.

You're often inspired by historical exhibitions in London—there's a constant curiosity and interest in relating to traditions. There were a number of works on paper in that show you mentioned, which I'm sure influenced you.

> Yes. It was a magnificent show. So there's this connection with that and, of course, with Suprematism in general.

Has Alberto Giacometti been an inspiration?

> Oh yes. I spent a lot of time with Giacometti in my life, and I've seen an enormous amount of his work. Now we're coming to something more concrete, bit by bit, in the series. This all has to do with light. Imagine the sunlight coming in as I'm doing this. I only make these works when there's sunlight. The room warms up; it's quite extraordinary.

In this sense, it's very connected to your work in the 1960s; it's not a rupture, but a continuum. Do you see these as portraits of the space?

> I draw bits and pieces. I don't attempt to make a portrait of the studio. I just see something, put it down, and move, every moment the light changes. You see the shadows, the light, and you try and catch it and keep up. It's a miraculous place to be in. This is a response to that miracle of the environment. I wish we had more light now.

Yes, it's a gray day.

> It's a shame, but perhaps we can look at them again.

I would love to visit the studio.

> Definitely, when it's a bit more organized. This one here relates to earlier things. Here I've changed. These are quite different, aren't they? This is a chair, by the way; it's a still life. There's something in front of it.

I get the feeling you're mapping the studio, in a way.

> I am, and it keeps shifting. I don't try and make a copy of the studio, of course; it just filters in, the studio comes in. For me it's the light and creating this light.

The light is really the umbilical cord.

> It's at the very center. But then light is at the center of life, of everything, isn't it?

Which perhaps brings us back to Vermeer—the master of light.

> I hadn't thought of that, but you're right. Absolutely.

These are, in some ways, such a departure from your other work—even as they take up themes of nature, for example. Do you think, as you develop your drawings, you'll keep going with some of the campaigns we've discussed before, like *Remember Nature*? Would you want to broaden the scope of those to include initiatives outside the realm of the art world?

> I don't think I would go in that direction at present. So much is happening in this area worldwide, it would simply be a drop in the ocean. I would rather spend my energy on developing as an artist, and seriously making works of art. I believe it's the duty of the artist to do that, the duty of a person who has certain capacities. Art is at the very center of society, in my view. I've thought that since I started to make art at the age of eighteen. Yet, in the last decades, art was made *for* me, rather than *by* me—by photographers, technicians, and, of course, curators. So now I would very much like to spend time physically with my hands and my body and my feelings. I want to sit somewhere and keep doing drawings—I want to make something that will then stand for me, and next to me. I need to reorganize myself, in order to pursue this.

You've mentioned painting a few times today already. If you were to resume painting after this long layoff, how would you pick it up again—do you think you'd begin more or less from where you stopped?

> Yes, I think that's bound to be the case. What's a few decades? The person remains the same. Art is essentially the same as it was one hundred years ago. And I wish to be within the range, and difficult working tradition, of art. And so, I think, the next paintings would follow directly from what was probably the last painting I did, which is that painting on a large sheet of steel. I can remind myself of where I stopped in, say,

> 1959. There's no one way of painting and this is the great challenge, and the kind of gift, which life makes to a painter or to an artist: the knowledge that it's possible to do something that has never been done before. It's possible to build on what one has done oneself, extend that, and it's possible to take somebody else's art and build on that, like Vermeer. And so, to look forward to all that, of course, is a great joy, even if it's not realized in the end. To feel it's possible gives me a kind of lift. And that's the state I'm in. I don't have to do it, but to contemplate, at some point, seriously going back against that canvas or that board, is something I look forward to when I "retire." Which, of course, may never happen. Or I may say, "To hell with it, let anything happen, anything goes." Who knows? But in that sense, the future is very promising, because it does give you at least the time, the opportunity, to reflect on the possible, or an openness to the future.

I've always been struck by your ability to contemplate the horrors of human nature and still maintain your sense of hope. Your openness to the future. It's a gift. Do you struggle to hold on to the urgency of confronting destruction and maintaining an openness at the same time?

> I think it's terrible if people lose that openness, as so many people do now with the tragedies in the world, with the worldwide wars and famines and natural catastrophes we've been having. When one is in that state and there's no hope—and not only is there no hope, there's no way out at all—this is utterly horrific. And if it's man-made, this is unforgivable. And the pressure of having to live with that knowledge is, for me, at times extremely difficult. One is constantly confronted by people doing people down, or damaging them, killing them, and starving them: crimes of all possible kinds. It's very hard to live through that, but we have the duty to live through it, and to go on, and hopefully in some way to do some good somewhere, even if it's only with a painting or two. Vermeer, to come back to where we began, was very conscious of having to live in the right way, I think. I'm convinced of that: very conscientious in his life, in his practices. In that sense, again, he's an inspiration to many of us who admire this achievement. And it's in connection to my personal resistance to technology that, as I said before, I would like to use my body to make something in art. That's my own sense of having to live the right way, I think.

It's interesting to think that this is a return to handmade art. You're repositioning it as radical.

It *is* radical, in a way. A radical return. I hope to achieve something different, something helpful to me and perhaps to others, through this. We need courage for that. And energy. And love. I realize I never told you the true W. H. Auden line, which is, "We must love one another or die." I think that really is the key. And so, finally, I would like to bring it back to where we started, because this is the line I adapted and that you originally asked me about. Auden said, "We must love one another or die." And for me, now, I believe that we must become idealists or die. That's what I want to go on working for. That, for me, is the future. Both my future and the world's future.

Thank you, Gustav.

The Cosmo Restaurant, Swiss Cottage, London, 1965

Title page of *Cosmos, Man and Society: A Paneubiotic Synthesis* by Edmond Székely. Ashingdon, UK: C. W. Daniel, 1948

Edmond Székely, ca. 1950s

255

Metzger's handwritten note that gave the title to the exhibition *We Must Become Idealists or Die*, Museo Jumex, Mexico City, 2015

Views of *We Must Become Idealists or Die*,
Museo Jumex, Mexico City, 2015

258

Gustav Metzger, untitled drawings, ca. 2003–6

Gustav Metzger, untitled drawings, ca. 2003–2006

Gustav Metzger, untitled drawings, ca. 1956–58

Gustav Metzger, *Untitled Painting (Abstract)*, ca. 1958–59

Gustav Metzger, *Painting on Plastic*, ca. 1958–60

Gustav Metzger, study for paintings on mild steel, 1958–59

Nikolai Suetin, Suprematist plateware, 1922–28

266

Ludwig Meidner, *Apocalyptic City*, 1913

Gustav Metzger, *Painting on Galvanized Steel*, 1958

Chronology

Gustav Metzger as a child

1926 Born on April 10 in Nuremberg, Germany, to Orthodox Jewish Polish parents.

1939 After witnessing his father's arrest by Nazi soldiers, travels to the UK as a Polish citizen with his elder brother Mendel, under the auspices of the Refugee Children's Movement.

1941 Begins a course in cabinetry at the ORT Technical Engineering School in Leeds.

1942 Following the technical college's closure, takes a job in a furniture factory in Leeds and starts reading communist literature.

1943 Begins working at the Harewood Estate in the joinery department.

1944 Relocates to Bristol, working on nearby farms and living for a period in an anarcho-Trotskyist commune in Clifton.

Decides to pursue a career as a sculptor rather than as a full-time revolutionary.

Begins working as a gardener at Champneys nature-cure clinic near Tring, in Hertfordshire, where he takes an interest in organic food, becomes a vegetarian, and starts to make his first sculptures.

Meets Henry Moore at the National Gallery, London, and asks to be his assistant, but instead takes Moore's advice to study life drawing.

1945 Attends life-drawing classes twice a week with his brother, at the Cambridge School of Art.

Moves with his brother to London (where Mendel is known as Max) to study sculpture and drawing at the Sir John Cass Technical Institute in Aldgate. Attends classes until summer 1948.

Begins evening life-drawing classes under the tutelage of David Bomberg at Borough Polytechnic.

1946 Joins Bomberg's daytime composition class in addition to the life-drawing class, and moves to Camden.

Awarded a Haendler Trust grant alongside his brother to fund full-time study at art school. The grant is renewed the following year.

1947 Uses a studio shack off Commercial Road for his paintings.

1948 Shows a large triptych as part of *Spring Exhibition: Paintings, Sculpture, and Drawings by Contemporary Jewish Artists* at Ben Uri Gallery, and includes it in the London Group exhibition at Academy Hall, on Bomberg's suggestion.

Travels to the Netherlands, Belgium, and France on a stateless passport. Studies under Gustaaf De Bruyne at the Royal Academy of Fine Arts in Antwerp, where he draws and paints from a model every day, and, in his spare time, draws children in the streets.

1949 Returns to England and has his Haendler Trust grant extended on the recommendation of Jacob Epstein, thanks to Lord Arnold Goodman's introduction.

1950 Continues his studies under Bomberg at Borough Polytechnic (until classes end in 1953) and also attends Oxford School of Art, Central School of Art, and Hampstead Artists House.

Exhibits three paintings in the *East End Academy* exhibition at Whitechapel Gallery.

1951 Works as a casual laborer (until 1954), first in Royston and then in Kings Langley, Hertfordshire.

1953 Begins working from a studio near Mornington Crescent, London, which he will pass on to fellow students Leon Kossoff and Frank Auerbach.

Helps form an exhibiting society, the Borough Bottega, and exhibits two paintings in *Drawings and Paintings by the Borough Bottega* at the Berkeley Galleries.

Moves to King's Lynn, Norfolk.

Resigns from the Borough Bottega and subsequently receives a letter from Bomberg breaking off all communication. Ceases art-making for three years.

1954 Rents a house in King's Lynn and works at the Tuesday market, selling secondhand books, furniture, and junk.

1956 Begins painting again and organizes exhibitions at a local shop in King's Lynn, showing work by Anthony Hatwell, Eduardo Paolozzi, and William Turnbull, among others.

1957 Joins the King's Lynn Committee for Nuclear Disarmament and becomes secretary of the North End Society, taking an interest in architectural preservation and protesting local redevelopment projects.

1958 Experiments with painting on cardboard, plastic, and steel.

Becomes involved with the Direct Action Committee Against Nuclear War (DAC) and takes part in marches protesting the US Thor Rocket Base at RAF North Pickenham.

1959 Returns to London and begins spending time at the 14 Monmouth Street coffee shop run by kinetic artist Brian Robins.

Stages two exhibitions at 14 Monmouth Street, *Three Paintings by G. Metzger* (July 30–August 19) and *Cardboards Selected and Arranged by Gustav Metzger* (November 9–30).

On November 4, writes "Auto-Destructive Art," the first manifesto of auto-destructive art, iterations of which will follow until 1964.

1960 On March 10, writes his second manifesto, "Manifesto Auto-Destructive Art."

On June 22, stages his first Lecture/Demonstration, at the Temple Gallery, London, introduced by the art critic Jasia Reichardt. This is followed in September by a solo retrospective exhibition at the same venue.

Is a founding member of the Committee of 100, a British anti–nuclear war group, founded by Bertrand Russell and Reverend Michael Scott. Designs its founding statement, *Act or Perish*, which is issued as a double-sided pamphlet.

1961 On June 23, writes his third manifesto, "Auto-Destructive Art, Machine Art, Auto-Creative Art."

On July 3, publicly stages a work of auto-destructive art on the South Bank, London, using hydrochloric acid on three nylon canvases, and glass sheets suspended above concrete by adhesive tape.

In September, along with Bertrand Russell and thirty other members of the Committee of 100, refuses to withdraw a call for mass peaceful protest and is imprisoned for one month.

1962 His proposal for a newspaper installation is rejected by Robert Filliou and Daniel Spoerri, organizers of the Fluxus Festival of Misfits in London.

On October 24, distributes his fourth manifesto, "Manifesto World," at a Festival of Misfits event at the Institute of Contemporary Arts (ICA), London.

Lectures on auto-destructive art at Ealing Art College, London, where Pete Townshend of The Who is a student. Townshend will later credit Metzger's lectures as the inspiration for The Who's onstage destruction of its instruments.

1964 Begins experimenting with liquid crystals and other forms of projecting movement in material.

Over the summer, Harold Liversidge shoots the film *Auto-Destructive Art – The Activities of G. Metzger*, in which Metzger enacts an acid painting on London's South Bank.

Fifth and final manifesto, "On Random Activity in Material/Transforming Works of Art" (dated July 30), published—along with the first three manifestos—in *SIGNALS: Newsbulletin for the Centre of Advanced Creative Studies* 1, no. 2 (September 1964).

1965 On February 24, gives a lecture on auto-destructive art at the Architectural Association, London. An expanded version (including the first publication of "Manifesto World") is published by the AA in June.

On October 11, first shows his work with liquid crystals as part of the Lecture/Demonstration "The Chemical Revolution in Art" at the Society of Arts, Cambridge University.

1966 Shows *Art of Liquid Crystals* in the window of Better Books, London, and, on January 8, stages "An Evening of Auto-Destructive and Auto-Creative Art," featuring his second public demonstration of liquid crystal projections.

In September, with Irish poet John Sharkey, co-organizes the month-long Destruction in Art Symposium with an organizing committee of Mario Amaya, Roy Ascott, Enrico Baj, Bob Cobbing, Ivor Davies, Jim Haynes, Dom Sylvester Houédard, Barry Miles, Frank Popper, and Wolf Vostell. A three-day symposium at the Africa Centre in Covent Garden (September 9–11) is followed by events

Stills from Harold Liversidge, *Auto-Destructive Art – The Activities of G. Metzger*, 1964

and performances at venues including Better Books, Conway Hall, the ICA, London Free School playground, and the Mercury Theatre. As a result of Hermann Nitsch's action *Abreaktionsspiel No. 5*, staged at the St Bride Institute on September 16, is summoned to appear before magistrates for presenting an "indecent exhibition contrary to common law."

On December 30–31, provides "psychedelic lighting effects" (liquid crystal projections) at the Double Giant Freak-Out Ball at the Roundhouse, London, featuring Cream, The Move, Pink Floyd, and The Who (technical issues prevent the projections from working during The Who's set on December 31).

1967 Gives the lectures "Destruction in Art" at the Exeter Festival of Modern Arts (April) and "The Aesthetic of Revulsion" at Bristol Arts Centre (May).

Stands trial with John Sharkey for three days (July 17–19) at the Old Bailey, London, on charges relating to Nitsch's action (which involved the mutilation of a lamb carcass and the projection of images of male genitalia). Found guilty and fined £100 (Sharkey is put on probation).

1968 *Extremes Touch: Material/Transforming Art* exhibition in the newly built Filtration Laboratory in the Department of Chemical Engineering at University College Swansea (January 22–February 4), as part of the Swansea Arts Festival.

1969 Is first editor of the newly formed, London-based Computer Arts Society's journal, *Page*. Stays on as editor until 1972 and shifts the journal's focus from technological messianism toward a critique of science and technology.

Participates in *Event One*, the first Computer Arts Society exhibition, at the Royal College of Art, London, with a model for *Five Screens with Computer* (a computer-controlled auto-destructive monument).

1970 Begins working with automobiles and exhaust fume pollution, creating *Mobbile*, a car modified to trap and store its own emissions, shown publicly—driven around Waterloo Bridge and Bond Street—during *Kinetics: An International Survey of Kinetic Art* at the Hayward Gallery.

In October, organizes the London demonstration for the International Coalition for the Liquidation of Art; around sixty people take part in a sit-down strike both inside and outside the Tate Gallery.

1971 Creates work with newspapers called *Mass Media Today* for *Art Spectrum London* at Alexandra Palace, part of the largest exhibition of contemporary art held nationwide since 1945, with exhibitions organized under its umbrella by multiple regional arts councils.

1972 In February, during Joseph Beuys's first visit to London, attends his *Information/Action* at the Tate Gallery and takes part in the filmed and recorded discussion, criticizing many tenets of Beuys's work.

Conceives *Project Stockholm, June (Phase 1)* for the first United Nations Conference on the Human Environment, but the project—which involves trapping the emissions from 120 cars—goes unrealized.

Creates an interactive environment as part of *Three Life Situations* (with Stuart Brisley and Marc Chaimowicz), the inaugural show at Gallery House, a temporary alternative art space directed by Sigi Krauss in premises belonging to the Goethe Institute (then the German Cultural Institute), March 29–April 15. Occupies the second floor and offers a separate experience in each room: the model for *Project Stockholm, June (Phase 1)*, designs for realized and unrealized projects, and the mass-media work *Controlling Information from Below*, with a final room used for preparing this work, and for private group discussions. Both the bathroom and kitchen are available for visitors to use.

Invited by Harald Szeemann to participate in Documenta 5, but the proposed project, *KARBA* (involving four modified cars), isn't realized.

Unrealizable Disintegrative Architecture and Other Projects, exhibition and talk at the Architectural Association, London, in April.

Executive Profile, exhibition at the ICA, London, November 24–December 22.

Elected deputy chairman of the Artists' Union.

1974 Invited to participate in *Art into Society – Society into Art: Seven German Artists* at the ICA, but declines. Instead, he is a consistent presence in the gallery, taking part in individual and group discussions, and contributes to the catalogue, using the space to advocate for other artists to join him in "Years Without Art," an art strike planned for 1977–80.

Meets the German artist and art historian Cordula Frowein, with whom he begins a long collaboration.

1976 Publishes "Art in Germany under National Socialism" in *Studio International* 191, no. 980 (March/April).

Organizes, with Frowein, Art in Germany under National Socialism (AGUN), the first international symposium on National Socialist art and design. For three days (September 17–19) scholars meet in closed sessions at the School of Oriental and African Studies, University of London, and the Drill Hall.

1977 Begins his planned three-year art strike, despite having received no support from fellow artists.

Takes part, with Frowein, in the conference *Faschismus – Kunst und visuelle Medien* at the Historisches Museum, Frankfurt, October 8–10.

1981 Lives in Frankfurt and participates in the group exhibition *Vor dem Abbruch* at the Kunstmuseum Bern, exhibiting photocopies from National Socialist publications listing all the laws passed against Jews from 1933 to 1943 (later titles this work *Faschismus Deutschland: Darstellung Analyse Bekämpfen*).

Together with Frowein and Klaus Staeck, organizes the exhibition *Passiv – Explosiv* at the Hahnentorburg, Cologne, as a protest against the exhibition *Westkunst: Zeitgenössische Kunst seit 1939*.

Over the next decade, is active in research in various areas, attending conferences and exhibitions throughout Europe, with very little time spent in the UK between 1984 and 1994.

1983 Extensive documentation exhibited at the Gardner Arts Centre, University of Sussex, Brighton, May 16–21. Gives a Lecture/Demonstration on his work, May 19.

Initiates the group Artists Support Peace, active through 1984.

1990 Lives in the Netherlands and studies the work of Johannes Vermeer. Remains distant from the world of galleries and exhibitions, despite having completed his "Years Without Art" a decade earlier.

1992 Proposes the project *Earth Minus Environment* for the United Nations Conference on Environment and Development ("Earth Summit") in Rio de Janeiro; the proposal—which requires the

emissions from 120 cars to be fed into a large transparent enclosure in the shape of an *E*—is rejected.

1994 Gives the lectures "Johannes Vermeer and Cesare Ripa" at Utrecht University (August) and "Vermeer and Freud's Fetish Theory" at University College London (December).

Returns to live in London and begins to formulate the Historic Photographs series.

1995 In April, first interview with Hans Ulrich Obrist, at the Cosmo café, London.

Damaged Nature: Two New Works and Documents, exhibition at workfortheeyetodo, London, September 29–December 2—his first UK exhibition of new work since his art strike ended in 1980, and the first time the Historic Photographs are shown. The accompanying publication, *Damaged Nature, Auto-Destructive Art*, features selected writings by Metzger.

1996 On June 10, gives the illustrated lecture *Mad Cows Talk* at East West Gallery, London.

Participates in the *Life/Live* exhibition at the Musée d'Art Moderne de la Ville de Paris at the invitation of Hans Ulrich Obrist.

Participates in the exhibition *Made New* at City Racing, London, with a reconstruction of *Cardboards*—the exhibition that accompanied his first manifesto of auto-destructive art in 1959.

1998 *Gustav Metzger*, a major retrospective at the Museum of Modern Art, Oxford, October 25–January 10, 1999. Includes ten of the Historic Photographs as a large installation.

2000 Included in *Protest & Survive* at Whitechapel Gallery, London.

2003 *100,000 Newspapers*, a "public-active installation," is the inaugural show at Wolfe von Lenkiewicz's T1+2 Artspace, London, January 21–23.

Participates in the Venice Biennale project Utopia Station, at the invitation of Hans Ulrich Obrist.

Participates in *Independence* at the South London Gallery with the video piece *Power to the People*.

2005 *Gustav Metzger: History History*, a survey exhibition at the Generali Foundation, Vienna, May 11–August 28.

Exhibits *Eichmann and the Angel* at Cubitt Gallery, London, September 7–October 23.

2006 *Gustav Metzger: Works*, exhibition at Lunds Konsthall, Lund, Sweden (May 20–August 27). Features *Eichmann and the Angel*, the Historic Photographs and the first realized version of *KARBA*.

Participates in the Interview Marathon, speaking with Rem Koolhaas and Hans Ulrich Obrist, at the Serpentine Gallery, London, July 28–29.

2007 Initiates the campaign *Reduce Art Flights* (*RAF*) to advocate for carbon neutrality in the art world. Distributes flyers for the campaign as part of Skulptur Projekte Münster 07 alongside an exhibition, *Gustav Metzger: Models*, at the Westfälischer Kunstverein, June 17–September 30.

Participates in the 8th Sharjah Biennial, *Still Life – Art, Ecology and the Politics of Change*, where a version of *Project Stockholm, June (Phase 1)* is realized using one hundred cars.

On October 13, gives a Lecture/Demonstration as part of the Experiment Marathon at the Serpentine Gallery, London.

2008 On February 6, gives the first lecture in the Art & Compromise series at Beaconsfield, London.

On March 29, is interviewed by Andrew Wilson as part of the series *Talking Art* at Tate Modern, in association with *Art Monthly*.

2009 Participates in the fourth Tate Triennial, *Altermodern*, at Tate Britain, London.

Participates in the Manchester International Festival with the work *Flailing Trees* (July 4–20) and, on July 5, a public conversation with Marina Abramović and Hans Ulrich Obrist.

Gustav Metzger: Decades 1959–2009, retrospective exhibition at the Serpentine Gallery, London, September 29–November 8.

2011 *Gustav Metzger: Historic Photographs*, first solo museum exhibition in the US at the New Museum, New York, May 19–July 3.

2012 Participates in Documenta 13 in Kassel, with sixty works on paper and a selection of paintings on steel. First showing since the Temple Gallery show in 1960 of his pre–auto-destructive works.

Participates in *Null Object: Gustav Metzger thinks about nothing*, in collaboration with London Fieldworks (Bruce Gilchrist and Jo Joelson) at WORK Gallery, London, November 30–February 9, 2013 (a sculptural, "null" object was carved in stone by a robot following instructions derived from EEG readings of Metzger's brainwaves as he attempted to think about nothing).

2013 *Supportive, 1966–2011*, exhibition at the Musée d'Art Contemporain de Lyon, France, February 15–April 14.

2014 *Lift Off!*, exhibition at Kettle's Yard, Cambridge, May 24–August 31.

Co-organizes and participates in the Facing Extinction conference at the University for the Creative Arts, Farnham, UK, June 7–8.

Participates in the Extinction Marathon at the Serpentine Galleries, London, on October 18–19, after suggesting the idea to Hans Ulrich Obrist and assisting in its planning.

2015 *Gustav Metzger: Towards Auto-Destructive Art 1950–1962*, display at Tate Britain, London. Includes works not shown since the Temple Gallery show in 1960.

Gustav Metzger: We Must Become Idealists or Die, solo exhibition at Museo Jumex, Mexico City, July 19–October 25.

Act or Perish! Gustav Metzger – A Retrospective opens at the Centre of Contemporary Art, Toruń, Poland, on March 27, and travels to Kunsthall Oslo and Stiftelsen Kunstnernes Hus, Oslo, in November.

Begins composing the *Extinction Handwritings*, a collection of drawings and notes for Hans Ulrich Obrist's Handwriting Project.

On November 4, instigates the annual day of action *Remember Nature*, which calls for artists to create work that addresses extinction, climate change, and environmental pollution.

2017 Dies at the age of ninety on March 1 at his home in London and is buried in Highgate Cemetery.

Acknowledgments

Gustav Metzger, from the *Extinction Handwritings* made for Hans Ulrich Obrist's Handwriting Project, ca. 2015–17

This book would not exist without:

• the artistic vision of Gustav Metzger, which continues to inspire all who encounter his work and boundless imagination

• the enthusiasm and ambition for publishing of Iwan and Manuela Wirth, Marc Payot, Ursula Hauser, and Michaela Unterdörfer

• the unrivaled editorial acumen of Karen Marta, with a helping hand from India Ennenga, Alexander Scrimgeour, and the whole editorial team at Hauser & Wirth Publishers

• the support of Corinne Bannister, Aileen Corkery, and their colleagues at Hauser & Wirth

• the sensitive design of Garrick Gott

• the tenacious research of Miles Champion and the generous sharing of biographical and bibliographic information by Simon Cutts and Andrew Wilson

• the dedication of Ula Dajerling and Leanne Dmyterko at the Gustav Metzger Foundation

• the pioneering spirit of Walther and Franz König, who published my early interviews with Metzger as part of the Conversation Series

• and the tireless archival research of Max Shackleton and Lorraine Two Testro.

A very special thank-you to Marina Abramović, Maja Hoffmann, Yoko Ono, and Connor Monahan, as well as to Arthur Fouray, Koo Jeong A, Vassilis Oikonomopoulos, Suzanne Pagé, Julia Peyton-Jones, and Norman Rosenthal.

Hans Ulrich Obrist

Index

Page numbers in *italics* refer to illustrations. Page numbers in **bold** refer to the chronology. All works are by Gustav Metzger unless otherwise indicated.

#

14 Monmouth Street, 37, 54, 55, 129, **271**
100,000 Newspapers (2003), 52, *73*, 201, **277**

A

Abramović, Marina, 17, 160–61, *194–95*, 202, *211*, *229*, **278**
Abstract Expressionism, 31
Act or Perish! Gustav Metzger – A Retrospective (Centre of Contemporary Art, Toruń, 2015), *174*, *175*, *177*, *178*, *181*, **279**
Actionism, 17, 68
activism. *See* agitation; environmentalism; nuclear weapons; protest; *Reduce Art Flights*; refusal; "Years Without Art"
Adorno, Theodor, 35, 51, 63
advice, 139
aesthetics, 20, 107, 127, 222; rejection of, 35; of revulsion, 71, 170–71, 193
agitation, 69, 132, 136
Amaya, Mario, 67, *84*, **272**
Angelus Novus (Klee), 155, 156, *174*
Antwerp, Belgium, 33, 34, 94, 96, **270**
Antwerp After a Nuclear Attack (1948), 33
Antwerp drawings, *44*
Après Paolozzi PN004886402 (1997), 158
architecture, 56–57, 62, 157–58, 222
art: cooperatives, 138–39; and fetishism, 63–64; and labor, 138; market, 57, 124, 136, 138, 140, 200, 240, 248; and the state, 131–32, 167–68; strike, 129–30, 132–33, 136–37, 140, **274**; as weapon, 33, 57, 153. *See also* auto-creative art; auto-destructive art; kinetic art; Land art; public art; "Years Without Art"
Art and Artists, 67, *84*
Art in Germany under National Socialism (AGUN) (University of London, 1976), 167–68, **276**
Art into Society – Society into Art (ICA London, 1974), 17, *146*, **275**
Art of Liquid Crystals (Better Books, 1966), **272**
Artist Placement Group, 125–26
Arts and Crafts, 102
atomic bomb. *See* nuclear weapons
Aubertin, Bernard, 68
Auden, W. H., 239, 254
Auerbach, Frank, 30–32, *43*, **270**
auto-creative art, 54–55, 59, 62–63, 71, 94, **271**
auto-destructive art, *16*, 17, 36–38, 51–72, 76, 77, 82, 83, 84, 92, 102–3, 124, 133, 135, 171, 172, 173, 186, 192, 242, **271**, **272**, **277**, **279**; beginnings, 72; as boycott, 60; discovery of, 53–55; as therapy, 60
"Auto-Destructive Art" (1959), 77, **271**

B

Bacon, Francis, 18, 241
Bauhaus, 102
Benjamin, Walter, 156–57
Better Books, 103–104, 105–106, **272**, **274**
Beuchat, Carmen, 57
Beuys, Joseph, 124, *144*, **275**
Blake, William, 163
BLAST: Review of the Great English Vortex, no. 1 (Lewis), *43*
Bloch, Ernst, 51
Bomberg, David, 26, 28, 30–32, 35–36, 55–56, 64, 69, *81*, 95, 245–46, **269**, **270**; *David Bomberg*, *43*; *Sappers at Work: A Canadian Tunneling Company, Hill 60, St. Eloi*, *81*; *Vision of Ezekiel*, *81*
bomb sites, 29
Borland, Christine, 17
Borough Bottega, 35, *36*, 64, **270**
Borough Group, 35
Borough Polytechnic, 30, **269**, **270**
Bossé, Laurence, 21, 65
Brandt, Willy, 162, *182*
Brisley, Stuart, 126, 130, 186
Bristol, UK, 27, 107, 239, **269**
Buchanan, Roderick, 17
Burri, Alberto, 68; *Il Grande Cretto*, 68
Bussel, David, 157
Byatt, A. S., 225

C

Cambridge University, 29, 30, *115*, **272**
Campaign for Nuclear Disarmament, 17, *210*. *See also* Committee of 100
capitalism, 57–58, 60, 66, 92, 131, 134–35, 136, 140, 189, 191, 198
Cardboards Selected and Arranged by Gustav Metzger (14 Monmouth Street, 1959), 54, *74*, *75*, 129, **271**, **277**
Caro, Anthony, 100
Chaimowicz, Marc, 126–27, 130, 186, **275**
"Chemical Revolution in Art, The" (1965), *115*, **272**
childhood, 18, 24, 35, *39*, *40*, 60, 225, *268*
Cobbing, Bob, 105, **272**
Committee of 100, 53, 71, *76*, 79, 154, **271**
computers, 54, 65–66, 92–94, *110*, 137, 170, **274**
confrontation, 19, 66, 124, 159, 162, 164
Constructivism, 29, 139, 250–51
Controlling Information from Below (1972), 128, *144*, 152, **275**
Conway Hall, 136, **274**
Cosmo café, 18, 238, *255*, **277**
Cream, 104–5, **274**
Cubism, 70
cybernetics, 93

Auto-Destructive Art – The Activities of G. Metzger (Liversidge), 103, **272**, *273*
automobiles, 25, 29, 34, 186–201 (passim), **274**, **275**, **277**, **278**

D

Dadaism, 29, 70
Daily Express (ca. 1962), *173*
death, 25, 26, 35, 53, 56, 60–61, 187, 190, 221, 226, **279**
death drive, 60. *See also* Freud, Sigmund
de Kooning, Willem, 31
demonstrations, 51, 56, 72, *80*, *83*, 102–103, 134–35. *See also* Lecture/Demonstrations; protest
destruction, 126, 131, 159, 160, 163, 165, 186–87, 192, 202, 203, 218–19, 221–23, 253, **279**; of civilization, 59; environmental, 165, 186–87, 189, 218. *See also* auto-destructive art
Destruction in Art Symposium (Africa Centre, 1966), 17, 18, 20, 66–68, *85*, *86*, *87*, *88*, *89*, 95, 104, *111*, 126, 136, 160, 167, **272**
dialectical materialism, 107
Documenta, 131, 187, 188, 191, **275**, **279**
Dorner, Alexander, 99–100
Downey, Juan, 57
drawing, 26, 28–30, 34, 56, *70*, 93–94, 96, 107, 238, *242–43*, *244*, *245*, *246–50*, **269**
Drop on Hot Plate (1968), 97, *113*, 188

E

Earth Minus Environment (1976), 19, 188, 190, *209*, **276**; notes for, *208*
Eichmann and the Angel (2005), 155–58, *174*, *175*, **278**
Eisenman, Peter: Memorial to the Murdered Jews of Europe, 157, *176*
environmentalism, 20, 27, 32, 125, 189–90. *See also* nature
Epstein, Jacob, 32, 96, 270
ethics, 20, 60, 138, 222
Experiment Marathon (Serpentine Gallery, 2007), 135, *147*, **278**
Expressionism, 31
extinction, 25, 35, 53, 187, 218–26, 239, **279**
Extinction Handwritings (ca. 2015–17), 20, *212*, **279**, *280*
Extinction Marathon (Serpentine Galleries, 2014), 20, 135, 220, 221, *227*, *228*, *229*, **279**
Extremes Touch: Material/Transforming Art (University College Swansea, 1968), *112*, **274**. *See also Drop on Hot Plate*

F

fascism, 31, 153, 169. *See also* Nazism
Feininger, Lyonel, 250
Festival of Misfits (ICA London, 1962), 124, *141*, *142*, *143*, **272**
Filliou, Robert, 124, **272**
Five Screens with Computer (1969), 93, *110*, **274**
Flailing Trees (2009/2010), 201, 202, *212*, *213*, *214–15*, **278**
Fluxus, 124, 126, **272**
Foerster, Heinz von, 93
Fogarty, Adrian, 109
Fontana, Lucio, 68
Frankfurt, Germany, 166, **276**

282

Freud, Sigmund, 60, **277**
Frowein, Cordula, 167, 170, **276**
future, 20, 52–53, 56, 60, 109, 133–34, 169, 172, 198, 203, 218–20, 226, 242, 244, 248, 250, 253–54
Futurism, 29, 70

G

gallery: as system, 58–59, 135, 137, 199, 248
Gallery House, 18, 126–30, 137, *144*, *145*, 152, 186, 223, **275**
Gaudier-Brzeska, Henri, 32
Gesamtkunstwerk, 107, 127
Giacometti, Alberto, 251
Gilchrist, Bruce, 93–95, *230*–31, **279**
Gill, Eric, 102, 195
Glissant, Édouard, 56–57
Goethe Institute, 129, 130–31, 186, **275**
Goodman, Lord Arnold, 95–96, **270**
Gordon, Douglas, 17
Goya, Francisco, 240
Graham, Martha, 195
Greenberg, Clement, 126
Grosz, George, 169
Guernica (Picasso), 71
Gustav Metzger: Decades 1959–2009 (Serpentine Gallery, 2009), 20, *234*, *235*, **278**
Gustav Metzger: History History (Generali Foundation, 2005), *178*, *182*, **278**
Gustav Metzger: We Must Become Idealists or Die (Museo Jumex, 2015), 238, *239*, *256*, *257*, **279**; note for, *256*
Gustav Metzger: Works (Lunds Konsthall, 2006), **278**

H

Haacke, Hans, 186; *Condensation Cube*, *204*
Harewood Estate, 27, 28, 29, 107, **269**
Head of a Man (ca. 1952), *43*
Heartfield, John, 169–70
Hepworth, Barbara, 28
Hernández, Diango, 157
Higgins, Dick, 124, 172
Higgins, Polly, 223
Hirst, Damien, 98, 136; *For the Love of God*, 136
Historic Photographs, 19, 159, 160–65, 168, 169, 170, 171, 172, 238, **277**, **278**
Historic Photographs: Hitler-Youth, Eingeschweißt (1997), *179*
Historic Photographs: Jerusalem, Jerusalem (1998), 161, *181*
Historic Photographs: No. 1: Hitler Addressing the Reichstag after the Fall of France, July 1940 (1995), 165, *178*, *179*
Historic Photographs: No. 1: Liquidation of the Warsaw Ghetto, April 19 – 28 days, 1943 (1995), 165, *177*
Historic Photographs: The Ramp at Auschwitz, Summer 1944 (1998), 163, *177*
Historic Photographs: Till we have built Jerusalem in England's green and pleasant land (1998), 163, *180*
Historic Photographs: To Crawl Into – Anschluss, Vienna, March 1938 (1996), 19, 159, *182*, *183*; notes for, *181*
Historic Photographs: To Walk Into – Massacre on the Mount, Jerusalem, 8th November 1990 (1996), 19, 159, *182*, *183*; notes for, *181*
history, 19, 20, 24, 32, 152–72 (passim), 178, 222, 238, 240. *See also* memory; monuments
Hitler, Adolf, 164, 165–66, 169, *179*
Hobsbawm, Eric, 153
Holocaust, the, 34–35, 160, 165, 187
Hoyland, John, 154

I

Institute of Contemporary Arts, 50, 131, *141*, *142*, *143*
In Memoriam (2005), 157, *176*

J

Joachimides, Christos M., 131
Joelson, Jo, 21, 93, *230*–31, **279**

K

KARBA (1975/2006), 187, 188, 191, *207*, **275**, **278**
Kill the Cars (1996/2009), *235*
kinetic art, 24, 60–61, 70–71, 186, 250, **274**
King's Lynn, UK, 36, 53, *80*, **270**
Knowles, Alison, 124; *Proposition #2: Make a Salad*, *141*
Koolhaas, Rem, 19, 194, **278**
Köpcke, Arthur, 124
Kossoff, Leon, 31, 32, **270**
Krauss, Sigi, 129, **275**
Kunz, Emma, 107
Kyander, Pontus, 158, 188

L

Laboratorium (1999), 94
laboratory work, 95, 97–99, 103, **274**
Land art, 68
Latham, John, 19, 68, 125
Lecture/Demonstrations, *16*, 51, *80*, *81*, *82*, *83*, 103, *115*, 134–36, *147*, **271**, **272**, **276**, **278**; notes for, *84*
Leeds, UK, 17, 25–27, 29, 35, 107, 239, **269**
Lenin, Vladimir, 26, 107, 128, *144*, 166
Lewis, Wyndham, 29, 30, 32, *43*
life drawing, 26, 28–30, **269**
Life/Live (Musée d'Art Moderne de la Ville de Paris, 1996), 19, 64–65, 134, 136, 238, **277**
liquid crystals, 50, 99–100, 101, 102, 103–109, 116–17, 120–21, 127, 193, **272**, **274**
Liquid Crystal Environment (1966/2021), 116–17, 120–21
Lissitzky, El, 102
London, UK, 18, 19, 25, 29, 33, 53–55, 68, 137, 152, 154, 166, 170, 193, 238, 245, 247, 251, **269**, **271**, **277**, **279**
London a.m., London p.m. (2005), 152
London Fieldworks (Gilchrist and Joelson), 93–95, *230*, *231*, **279**

M

Mad Cows Talk (1996), 135, *148*, *149*, 199, 277
Maharaj, Sarat, 244
Manhattan Project, the, 218–19. *See also* nuclear weapons
"Manifesto Auto-Destructive Art" (1960), *77*, **271**
"Manifesto World" (1962), 127, **272**
manifestos, 17, 32, 36–38, 53, 55–58, *77*, 127, 219, **271**, **272**, **277**. *See also* "Auto-Destructive Art"; "Manifesto Auto-Destructive Art"; "Manifesto World"
Marx, Karl, 26, 107
Mass Media: Today and Yesterday (1971/2015), 128
MASS MEDIA: Yesterday and Today (2009), *234*
Matisse, Henri, 33
Matta-Clark, Gordon, 57
McAlpine, Alistair, 50
Medalla, David, 19
Meidner, Ludwig, 246, 249–50; *Apocalypse City*, *267*
memory, 24, 25, 153, 155, 157, 159–60, 189, 220, 241, 245
Metzger, Erna (Esther) (sister), *39*, 40
Metzger, Feige (Fanny) (mother), 24–25, *39*
Metzger, Juda (father), 24, 25, 27, 35, *39*
Metzger, Klara (Chaja) (sister), *39*, 40
Metzger, Mendel (Max) (brother), 18, 25, 29–30, 33, *39*, 40, *41*, *42*, 95, **269**
Mobbile (1970), 186–87, *205*, **274**
Moholy-Nagy, László, 70, 102; *Light Prop for an Electric Stage (Light Space Modulator)*, 114
Mondrian, Piet, 70
Montañez Ortiz, Raphael, 68
monuments, 51, 53, 56–57, 60–62, 64–66, 68, 162, 186, 202, **274**
Monument to Bloody Sunday (1972), 50
Moore, Henry, 17, 28, **269**
Move, The, 104, 105, **274**
music, 26, 61, 66, 96, 104, 108

N

nature, 21, 27–28, 59, 60, 66, 71, 107, 163, 186–215, 218–19, 221–22, 225, 226, *230*, *231*, *232*–33, 239, 244, 247, 252, 253, **269**, **277**, **279**. *See also* environmentalism; *Remember Nature*
Nazism, 24, 34, 159, 166, 168–70, 196, **269**

New Realism, 130
newspapers, 50, 51, 52, 73, 100–101, 127–28, 130, 136, 152–53, 155, 156–57, 159, 172, 195, 199, 201, 223, 224, **272**, **275**, **277**
Nietzsche, Friedrich, 34
Nitsch, Hermann, 95–96, **274**; *Abreaktionsspiel No. 5*, *111*, **274**
nuclear weapons, 36, 53, 66, 92, 192, 218–19. *See also* Manhattan Project, the
Null Object (Gilchrist and Joelson), 93, **279**
Nuremberg, Germany, 17, 24–25, 27, 61, 190, **269**

O

obscenity trial, 95, *111*, 274
Ono, Yoko, 20, 66–67, *86*, *88*, 160; *Cut Piece*, *67*, *89*, 160–61; *Whisper Piece*, 67

P

Page (Computer Arts Society Journal), 92, **274**
Page, Robin, 124
Pagé, Suzanne, 21
painting, 26, 33, 37, 58, 71, 106, 129, 172, 250–53
Painting on Galvanized Steel (1958), *47*, *267*
Painting on Plastic (1958–60), *264–65*
Paolozzi, Eduardo, 29, 158, **270**
Peyton-Jones, Julia, 19, 21
photography, 170
Phillpot, Clive, 102
Picasso, Pablo, 33, 71, 153; *The Charnel House*, 33; *Guernica*, 71
Pink Floyd, 104, **274**
Piper, John, 26
Plath, Carina, 197
politics, 20, 24, 26–27, 31–32, 153, 155, 162, 164; anarchism, 27, 133; and art, 27, 33, 52; communism, 26, 169; left-wing, 26, 239; revolutionary, 26–28, **269**
Pollock, Jackson, 54
pollution, 20, 34, 186–90, 192, 194, 196, 201, **274**, **279**
Popper, Frank, 103, *115*, **272**
Power to the People (2003), 153, 155, **277**
Price, Cedric, 108
Project Stockholm, June (Phase 1) (1972/2015), 186, *205*, *206*, **275**, **278**
propaganda, 167–68, 201
protest, 58, 154, 194, 201–2, *210*, **271**, **276**. *See also* refusal; "Years Without Art"
public art, 17, 57, 58, 138

R

Raft of the Medusa (Géricault), 69
Rainbow (1968/2015), *112*
Reclining Figure (ca. 1946), *42*
Reduce Art Flights (RAF, 2007–), 194–97, **278**
refusal, 35, 58, 132. *See also* protest;

"Years Without Art"
religion, 54, 94, 219, 239
Rembrandt, 240
Remember Nature (2015), 201, 222, *230*, *231*, *232–33*, 252, **279**
Restany, Pierre, 130
Rilke, Rainer Maria, 139
Robins, Brian, 37, 54, 55, **271**
Rosenthal, Norman, 17, 21, 131, 246
Rowe, Beverly, 93, *110*
Rühm, Gerhard, 158, 169
Russell, Bertrand, 53, *76*, 154, **271**

S

Scharrer, Eva, 191
Schlieker, Andrea, 21
Schneemann, Carolee, 68
Schwitters, Kurt, 129, 130
science, 20, 55, 60, 92–93, 94, 101–3, 218, 226, **274**
Scott, Michael, 53, **271**
sculpture, 27, 29, 37, *42*, 53, 55, 57–59, 61–62, 64–66, 93, 100, 172, 201, 224, **269**
Serpentine, 18, 19–20, 21, 100, 109, 126, 135, 136, *147*, *177*, 194, 220, **227**, **228**, **229**, *234*, *235*, **278**, **279**
Sharkey, John, 67, *85*, *86*, 95, **272**, **274**
Shibli, Ahlam, 157
Shoah (Lanzmann), 34–35, 187
Sigg, Uli, 101
Sir John Cass Technical Institute, 29, **269**
Spoerri, Daniel, 124, **272**
Steveni, Barbara, 19, 125
stone carving, 28
Sturtevant, Elaine, 93
Supportive, 1966–2011 (Musée d'Art Contemporain de Lyon, 2013), 108, *118*, *119*, **279**
Suprematism, 251, 266
Sutherland, Graham, 26; *Devastation, 1941: An East End Street*, *42*
Sylvester, David, 18
Szeemann, Harald, 131, 187, **275**
Székely, Edmond, 239, *255*
Szymczyk, Adam, 155, 193

T

T1+2 Artspace, 73, 201, **277**
Table (1956), *45*, *46*
Take Me (I'm Yours) (Serpentine Gallery, 1995, and other venues), 18, 21, 126, 128
technology, 55, 58, 60, 65, 66, 92, 94, 107, 189, 191, 203, **274**; rejection of, 170, 244, 245, 253; violence of, 92
telephones, 92, 170, 200, 238
Temple Gallery, 73, *81*, 135, **271**
Temple Newsam (Leeds), 26
Thompson, E. P., 201, *210*
Three Life Situations (Gallery House, 1972), 18, 126, *144*, *145*, **275**
time, 57, 61–62, 172
Tinguely, Jean, 56, 130, 133, *147*

Townshend, Pete, 66, 104, **272**
tragedy, 62, 70, 104, 105, 240
Trotsky, Leon, 107
Turner, J. M. W., 99

U

Unrealizable Disintegrative Architecture and Other Projects (Architecture Association, 1973), 129, **275**
unrealized projects, 50–51, 66, 93, 108, 127, 186, 250, **275**
untitled drawings (ca. 1956–58), *262*
untitled drawings (ca. 2003–6), *258–61*
utopia, 51–52
Utopia Station (Venice Biennale, 2003), 52, **277**

V

Vanderlinden, Barbara, 94
Van Gogh, Vincent, 241
Varela, Francisco, 94–95
Vasari, Giorgio, 18
Vautier, Ben, 124
vegetarianism, 27, 239, **269**
Vermeer, Johannes, 239–43, 252–53, **276**, **277**
Vorticism, 32

W

war, 18, 24–26, 32, 33, 58, 61, 70, 153, 163, 195–96, 239, **271**
war in Iraq, 154
Whistler, James McNeill, 246
Who, The, 104–5, **272**
Wilson, Andrew, 19, 136, 139, **278**
Wilson, Harold, 92
woodworking, 25
World War, First, 32, 136
World War, Second, 18, 24, 32, 71, 153, 195, 218

Y

"Years Without Art" (1972), 35, 130–32, 240, 241, **275**, **276**, **277**. *See also* refusal

Z

Zbąszyń, Poland, 39
Zen Buddhism, 94

A Note on Sources

This book is based on a series of interviews with Gustav Metzger by Hans Ulrich Obrist that took place between 1995 and 2017, which have been rearranged and edited to create a continuous narrative. The first two interviews took place at the Cosmo café in London in 1995 and 1996, the third at the Extremes Touch Laboratorium in Oxford in 1999. Additional interviews took place in London in 2006 (twice, once joined by Julia Peyton-Jones), 2007, 2008 (twice), 2009, 2012, 2013 (twice, once joined by Bruce Gilchrist), 2014 (three times), 2015 (twice), 2016, and, lastly, on February 23, 2017, shortly before the artist's death. Further interview sources used include a conversation between Metzger, Obrist, and Yoko Ono that took place at Metzger's home, a conversation with Metzger, Obrist, and Alex Poots in Manchester in 2009, and various public conversations, including a panel discussion with Metzger, Obrist, and Rem Koolhaas at the Interview Marathon, Serpentine Gallery, London, on July 29, 2006, Obrist and Metzger's conversation at the Berlin Interview Marathon, Buchhandlung Walther König, Berlin, on July 6, 2008, and an interview and panel discussion featuring Metzger, Obrist, and Marina Abramović at the Manchester International Festival, Whitworth Art Gallery, Manchester, on July 5, 2009.

Supplementary sources—primarily Metzger's published writings—were used occasionally to fill out information familiar to both speakers.

Among the published materials that were helpful in the editing and fact-checking of this book are the following:

Abramović, Marina, and Hans Ulrich Obrist. *Hans Ulrich Obrist & Marina Abramović: The Conversation Series, Volume 23*. Cologne: Walther König, 2010.

Amaya, Mario, ed. *Art and Artists* 1, no. 5, "Auto Destructive," August 1966.

Baird, Nicola, ed. *Becoming Gustav Metzger: Uncovering the Early Years, 1945–59*. London: Ben Uri Gallery and Museum, 2021. Text by Nicola Baird, Stephen Bann, Mathieu Copeland with Ula Dajerling, Leanne Dmyterko, Elizabeth Fisher, and Andrew Wilson.

Breitwieser, Sabine, ed. *Gustav Metzger: History History*. Ostfildern: Hatje Cantz, 2005. Text by Sabine Breitwieser, Justin Hoffmann, Kristine Stiles, and Andrew Wilson.

Jones, Alison. "Introduction to the Historic Photographs of Gustav Metzger." Forum for Holocaust Studies. Accessed June 5, 2024. https://www.ucl.ac.uk/forum-for-holocaust-studies/metzger.html.

McMullen, Ken, dir. *Pioneers in Art and Science: Metzger*. DVD. Commissioned by Arts Council England, 2004.

Metzger, Gustav. *Gustav Metzger. Debemos convertirnos en idealistas o morir / We Must Become Idealists or Die*. Mexico City: Fundación Jumex Arte Contemporáneo, 2016. Text by Ula Dajerling, Samuel Dangel, Leanne Dmyterko, Daniela Pérez, Sören Schmeling, and Andrew Wilson.

———. "Influences." *Frieze*, no. 178, April 2016. https://www.frieze.com/article/gustav-metzger-influences.

———. Interview with Alison Jones, August 14, 1998. Forum for Holocaust Studies. https://www.ucl.ac.uk/forum-for-holocaust-studies/metzger_interview.html.

———. Interview with Anna McNay. *Studio International*, July 28, 2014. https://www.studiointernational.com/index.php/gustav-metzger-interview-kettles-yard-auto-destructive-auto-creative-art-liquid-crystal.

———. Interview with Emma Ridgway, April 2009, "I thought one could fuse the political ideal of social change with art." *RSA Arts & Ecology*. http://www.artsandecology.org.uk/magazine/features/interview--gustav-metzger2.

———. Interview with Emma Ridgway, February 13, 2008. Reduce Art Flights. https://reduceartflights.lttds.org/#interview.

———. Interview with Mark Godfrey, "Protest and Survive." *Frieze*, no. 108, June–August 2007. https://www.frieze.com/article/protest-and-survive.

———. "A Terrible Beauty: Interview with Andrew Wilson." *Art Monthly*, no. 222 (December 1998–January 1999): 7–11.

———. *Writings 1953–2016*. Edited by Mathieu Copeland. Zurich: JRP|Editions, 2019.

Metzger, Gustav, and Hans Ulrich Obrist. *Hans Ulrich Obrist & Gustav Metzger: The Conversation Series, Volume 16*. Cologne: Walther König, 2009.

Metzger, Gustav, Andrew Wilson, and Clive Phillpot. *Damaged Nature, Auto-Destructive Art*. London: Coracle@workfortheeyetodo, 1996.

O'Brien, Sophie, and Melissa Larner, eds. *Gustav Metzger: Decades 1959–2009*. Cologne: Walther König, 2010. Text by Sophie O'Brien, Clive Phillpot, and Norman Rosenthal.

Obrist, Hans Ulrich. *Lives of the Artists, Lives of the Architects*. London: Penguin, 2016.

Rosenthal, Norman, and Christos M. Joachimides, eds. *Art into Society – Society into Art: Seven German Artists*. London: Institute of Contemporary Arts, 1974.

Stiles, K. "Synopsis of the Destruction in Art Symposium (DIAS) and Its Theoretical Significance." *The Act* 1 (March 1987): 22–31.

Weibel, Peter, ed. *The Vienna Group: A Moment of Modernity 1954–1960 / The Visual Works and the Actions*. New York: Springer, 1997. Text by Friedrich Achleitner, H. C. Artmann, Konrad Bayer, Gerhard Rühm, and Oswald Wiener.

Image Credits

Cover: © Staatsgalerie Stuttgart. Photo: Hanns Sohm
Front endpapers: Tate; © David Mayor. Photo: David Mayor / Tate
2–12: From *Art and Artists* 1, no. 5, "Auto Destructive," August 1966, p. 23. Photos: John Cox
16: Keystone/Hulton Archive via Getty Images
22, 73 (bottom), 142, 80 (top): © National Portrait Gallery, London. Photos: John Cox
39, 40, 41 (top right, bottom), 268: Courtesy Déborah Metzger
41 (top left), 42 (bottom right), 43 (top left), 44, 45, 46 (top), 74, 76 (bottom), 77, 78–79, 82, 83 (top), 84 (top), 144 (bottom), 145, 184, 212 (top), 256 (top), 264–65, 266 (top): Courtesy The Gustav Metzger Foundation
42 (top): Tate, Presented by the War Artists Advisory Committee 1946. Photo: Tate
42 (bottom left): Collection Déborah Metzger, France © Mendel Metzger. Photo © 2024 Guillaume Leingre / ProLitteris, Zurich
43 (top right): © National Portrait Gallery, London
43 (bottom): © Wyndham Lewis and the Estate of Mrs G A Wyndham Lewis by kind permission of the Wyndham Lewis Memorial Trust (a registered charity). All rights reserved 2024 / Bridgeman Images. Photo: Tate
46 (bottom), 47, 263, 267 (bottom): Courtesy The Gustav Metzger Foundation. Photo: © Damian Griffiths
48, 83 (bottom): Tate; © Keystone Press Agency. Photo: Tate
73 (top images): From *Gustav Metzger: 100,000 Newspapers* (2008), dir. Martin Pickles. Courtesy Martin Pickles
75: Courtesy Andrew Wilson / The Gustav Metzger Foundation. Photo: John Cox
76 (top), 234 (bottom): PA Images / Alamy Stock Photo
80–81 (bottom three images): Staatsgalerie Stuttgart, Archiv Sohm. Photos: Cyril Wilson. © Staatsgalerie Stuttgart
81 (top left): © Imperial War Museum (Art.IWM ART 2708)
81 (top right): Tate; © Tate
85, 89: Courtesy Fondazione Bonotto
86 (bottom right), 87 (top): © Staatsgalerie Stuttgart. Photos: Hanns Sohm
86 (top), 86 (bottom left), 87 (bottom), 88, 111, back endpapers: Tate, Presented by Tom Picton's family; © The Estate of Tom Picton/Tate. Photos: Tom Picton / Tate
90, 120–21, 178 (top), 182 (bottom), 205 (top): Photos: Werner Kaligofsky, Vienna, 2005 © 2024, Prolitteris, Zurich
110 (top): Generali Foundation Collection–Permanent Loan to the Museum der Moderne Salzburg, © Generali Foundation. Photo: Werner Kaligofsky, Vienna, 2005 © 2024, ProLitteris, Zurich
112, 113: Photos courtesy Oslo Kunsthall
114: Courtesy Harvard Art Museums/Busch-Reisinger Museum, Gift of Sibyl Moholy-Nagy. Photo: © President and Fellows of Harvard College
115 (middle and bottom): Photos: Richard Gloucester
116–17: Photo: Ken Adlard
118, 119: Collection macLYON, Inv.: 2011.8.1. Photos © Blaise Adilon
141 (bottom): © 2024 Photo Scala, Florence. The Gilbert and Lila Silverman Fluxus Collection Gift, The Museum of Modern Art, New York. Photo: Bruce Fleming. Digital image, The Museum of Modern Art, New York / Scala, Florence
141 (top): © 2024 Photo Scala, Florence. The Gilbert and Lila Silverman Fluxus Collection Gift, The Museum of Modern Art, New York. Digital image, The Museum of Modern Art, New York / Scala, Florence
143: © 2024 Photo Scala, Florence. The Gilbert and Lila Silverman Fluxus Collection Archives, The Museum of Modern Art, New York. Photo: Bruce Fleming. Digital image, The Museum of Modern Art, New York / Scala, Florence
146: Tate. Copyright and courtesy Institute of Contemporary Arts, London. Photo: Tate
147 (top): © Museum Tinguely, Basel
147 (bottom): Stills from *Experiment Marathon 2007 – Gustav Metzger Lecture/Demonstration*. Serpentine Gallery, London / YouTube
148 (bottom), 149, 122, 144 (top): Tate. Photos: Tate
148 (top): Musée d'Art Moderne de la Ville de Paris. Photo: André Morin
173, 174 (top), 175, 177 (bottom), 178 (bottom), 181 (top): Courtesy The Estate of Gustav Metzger and CoCA Toruń. Photos: Wojciech Olech
174 (bottom): Photo © The Israel Museum, Jerusalem, by Elie Posner
176 (top): Photo: EmmePi Travel / Alamy Stock Photo
176 (bottom): © Jhoeko / West Den Haag
177 (top), 234 (top): Courtesy Serpentine. Photos © Jerry Hardman-Jones
179 (left): Courtesy Simon Cutts. Photo: Erica Van Horn / Coracle
179 (three images on right): Courtesy Kunstraum München. Photos: Pia Lanzinger, © 2024, ProLitteris, Zurich
180, 207: Photos: Lunds Konsthall / Terje Östling
181 (bottom), 208: Courtesy Hans Ulrich Obrist
182 (top): Photo: INTERFOTO / Alamy Stock Photo
183 (bottom): Photo: Smith Archive / Alamy Stock Photo
183 (top): Courtesy The Gustav Metzger Foundation. Photo: Menahem Kahana / AFP FILES / AFP
204 (top): Photo: David Savill, Hulton Archive via Getty Images
204 (bottom): MACBA Collection. MACBA Foundation. Gift of National Comitee and Board of Trustees Whitney Museum of American Art © Hans Haacke / Artists Rights Society (ARS), New York / VG Bild-Kunst, Bonn / © 2024, ProLitteris, Zurich. Courtesy the artist and Paula Cooper Gallery, New York. Photo: Steven Probert
205 (bottom), 206 (bottom): Images courtesy Sharjah Art Foundation. Photos: Peter Reidlinger
206 (top): Courtesy West Den Haag
209: Courtesy Harry Ruhé, Galerie A, Amsterdam. Photo: Harry Ruhé
210 (top left): © Imperial War Museum (LBY K. 20 / 123)
210 (top right): Courtesy the Bertrand Russell Peace Foundation
210 (bottom): Concept: Gustav Metzger. Design: Peter Saville & Music.Agency. Photo: Karen Wright
211: Marco Anelli © 2009
212 (bottom), 280: Courtesy Hans Ulrich Obrist
213: Photo: Marino Solokhov
214–15: Photo © Kristian Buus
227: Courtesy David Rudnick
228: © Heather Phillipson / 2024, ProLitteris, Zurich. Courtesy Serpentine. Photo: Lewis Ronald
229 (top): Courtesy Serpentine
229 (bottom): Photo: Andy Miah
230–31: Image © London Fieldworks, courtesy London Fieldworks
232–33: Courtesy Serpentine. Photo © 2015 Tristan Fewings / Getty
235: PA Images / Alamy Stock Photo. Photo: Johnny Green
236: Photo: Michaela Unterdörfer
255 (Székely title page and portrait): Courtesy Rancho La Puerta
255 (top): © Marion Manheimer
256 (bottom), 257: Photos: Moritz Bernoully
258–61: Photos: Theo Niderost
262 (top, bottom): Courtesy The Gustav Metzger Foundation and Dvir Gallery. Photos: Elad Sarig
266 (bottom): From *Circling the Square: Avant-Garde Porcelain from Revolutionary Russia*, exh. cat. London: Fontanka, 2004. Photo: Yury Molodkovets
267 (top): LWL – Westfälisches Landesmuseum, Münster, Germany / Bridgeman Images. © Ludwig Meidner Archive, Jewish Museum of the City of Frankfurt am Main
273: Courtesy Contemporary Films, London
287: Courtesy Hans Ulrich Obrist. Photo: Hans Ulrich Obrist

Cover
Gustav Metzger speaking at the opening of the Destruction in Art Symposium (DIAS) at the Africa Centre, London, September 9, 1966

Front endpapers
Participants in the Destruction in Art Symposium, London, 1966. From left: Kurt Kren, Otto Mühl, Juan Hidalgo, Hermann Nitsch, and Metzger

pp. 2–12
Metzger rehearsing for an acid nylon painting demonstration in King's Lynn, UK, 1960

p. 16
Metzger with a gas mask preparing to spray hydrochloric acid onto nylon canvases as part of a public demonstration of auto-destructive art, South Bank, London, July 3, 1961

p. 22
Metzger in King's Lynn, 1960

p. 48
Metzger demonstrating his auto-destructive art, South Bank, London, July 3, 1961 (cropped image; see p. 83)

p. 90
Gustav Metzger, *Liquid Crystal Environment*, 1965/2005. Installation view, Generali Foundation, Vienna, 2005 (cropped image; see pp. 120–21)

p. 122
Metzger talking to Joseph Beuys at the Tate Gallery, London, February 25, 1972 (cropped image; see p. 144)

p. 130
Metzger with *Historic Photographs: To Crawl Into – Anschluss, Vienna, March 1938*, 1996

p. 184
View of *Gustav Metzger: Flailing Trees*, Manchester International Festival, 2009

p. 216
Gustav Metzger, ca. 2000s

p. 236
Gustav Metzger at Kunsthalle Nürnberg during his exhibition *Ein Schnitt entlang der Zeit* (A Cut Along Time), Nuremberg, Germany, 1999

Back endpapers
A policeman talking to Metzger before his arrest at St Bride Institute, London, after Hermann Nitsch's *Abreaktionsspiel No. 5* had been staged as part of the Destruction in Art Symposium, September 16, 1966

Gustav Metzger photographed by Hans Ulrich Obrist, February 9, 2013

Gustav Metzger: Interviews with Hans Ulrich Obrist
© 2024 Hauser & Wirth Publishers
www.hauserwirth.com

Editor: Karen Marta
Publisher: Michaela Unterdörfer
Managing editor: Alexander Scrimgeour
Associate editor: India Ennenga
Copyediting and research: Miles Champion
Editorial support: Rosa Bacile, Corinne Bannister, Florence Cobben, Ula Dajerling, Leanne Dmyterko, Jana Horn
Indexer: Sarah Osment

Book design and typography: Garrick Gott
Prepress: Prints Professional, Berlin
Production coordination: Christine Stricker
Printing: Offsetdruckerei Karl Grammlich, Pliezhausen, Germany
Silk-screening (cover): Graffiti Siebdruck, Reutlingen-Altenburg, Germany
Binding: Josef Spinner Großbuchbinderei, Ottersweier, Germany

Papers: Surbalin Kaffeebraun 115 gsm (cover),
Arena White Rough 120 gsm (interior and endpapers)
Typefaces: Moderat and Excelsior

All works by Gustav Metzger © 2024, ProLitteris, Zurich / The Estate of Gustav Metzger and The Gustav Metzger Foundation. Certain illustrations are covered by claims to copyright noted in the Image Credits on p. 286.

All rights reserved. No part of this publication may be reproduced in any form or by any electronic or mechanical means (including photocopying, recording, or information storage and retrieval systems) without permission in writing from the publishers.

Every effort has been made to trace copyright ownership and to obtain reproduction permissions. Corrections brought to the publisher's attention will be incorporated in future reprints or editions of this book.

Distribution:

Europe and the UK
Buchhandlung Walther König
Ehrenstrasse 4
50672 Cologne, Germany
www.buchhandlung-walther-koenig.de

All other territories
ARTBOOK | D.A.P.
75 Broad Street, Suite 630
New York, NY 10004
www.artbook.com

ISBN: 978-3-906915-92-0
Library of Congress Control Number: 2024941770

Printed and bound in Germany